The Yucatán Peninsula

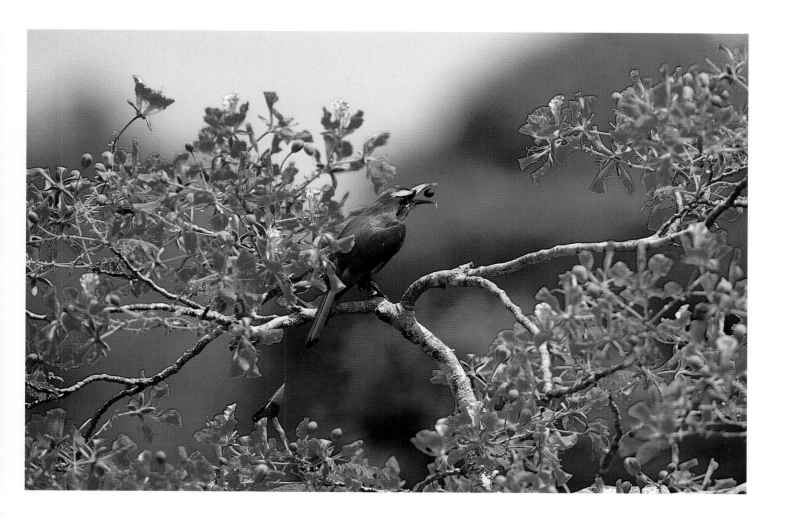

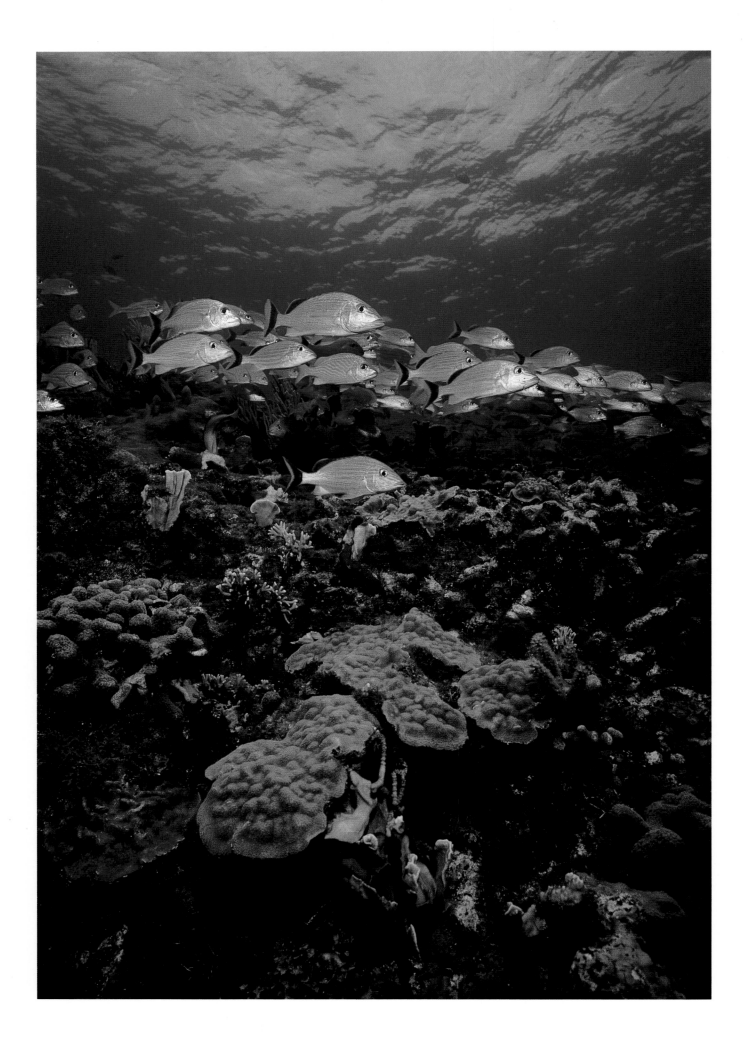

THE YUCATÁN PENINSULA

Photographs and Text by

C. C. LOCKWOOD

Louisiana State University Press

Baton Rouge and London

To the Maya Who Lived and Live
So Closely with the Wildlife of the
Yucatán Peninsula

Other Books by C. C. Lockwood

Atchafalaya: America's Largest River Basin Swamp

The Gulf Coast: Where Land Meets Sea

Discovering Louisiana

98 97 96 95 94 93 92 91 90 89 5 4 3 2 1

Designer: Albert Crochet
Printer and Binder: Toppan Printing Company, Tokyo, Japan
First Printing

LIBRARY OF CONGRESS CATALOGING-IN-PUBLICATION DATA

Lockwood, C. C. 1949–
 The Yucatán Peninsula.

 Bibliography: p.
 Includes index.
 1. Natural history—Yucatán Peninsula—Pictorial
works. 2. Yucatán Peninsula—Description and travel—
Views. I. Title.
QH107.L63 1989 508.72'6 88-27260
ISBN 0-8071-1524-X

Contents

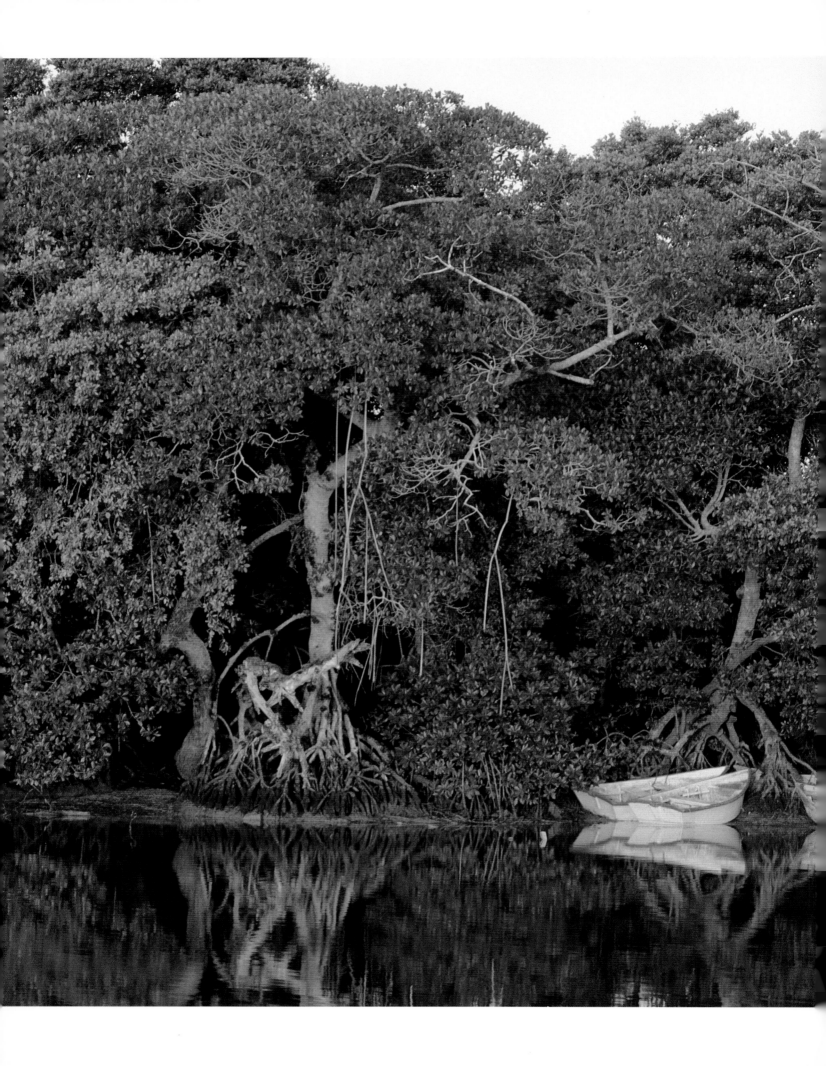

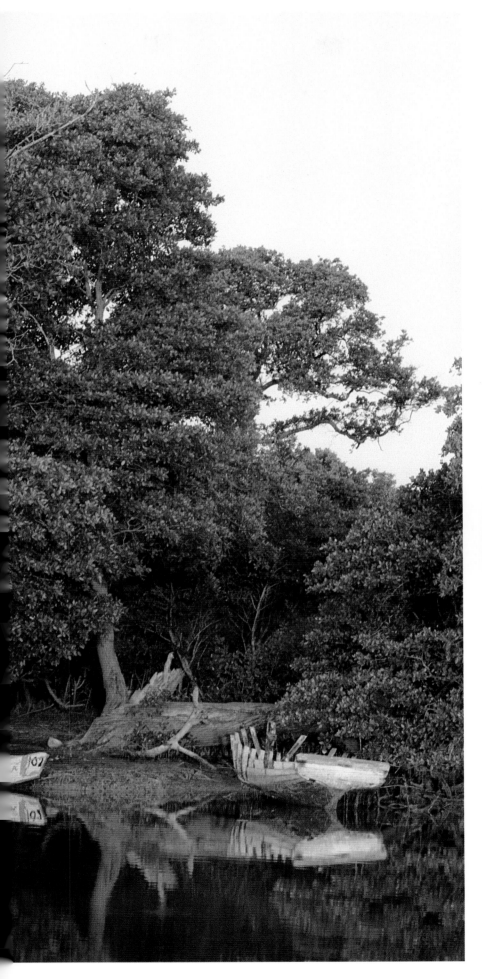

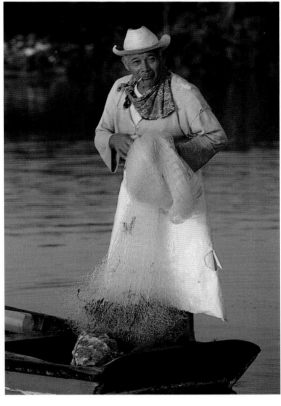

Shrimpers' dinghies await their captains under massive red mangrove trees at Celestún (left). Similar craft are used for cast netting in Rio Lagartos (above).

An October moon casts its silvery glow over the calm waters of Akumal Bay, a small but popular resort south of Cancun (overleaf).

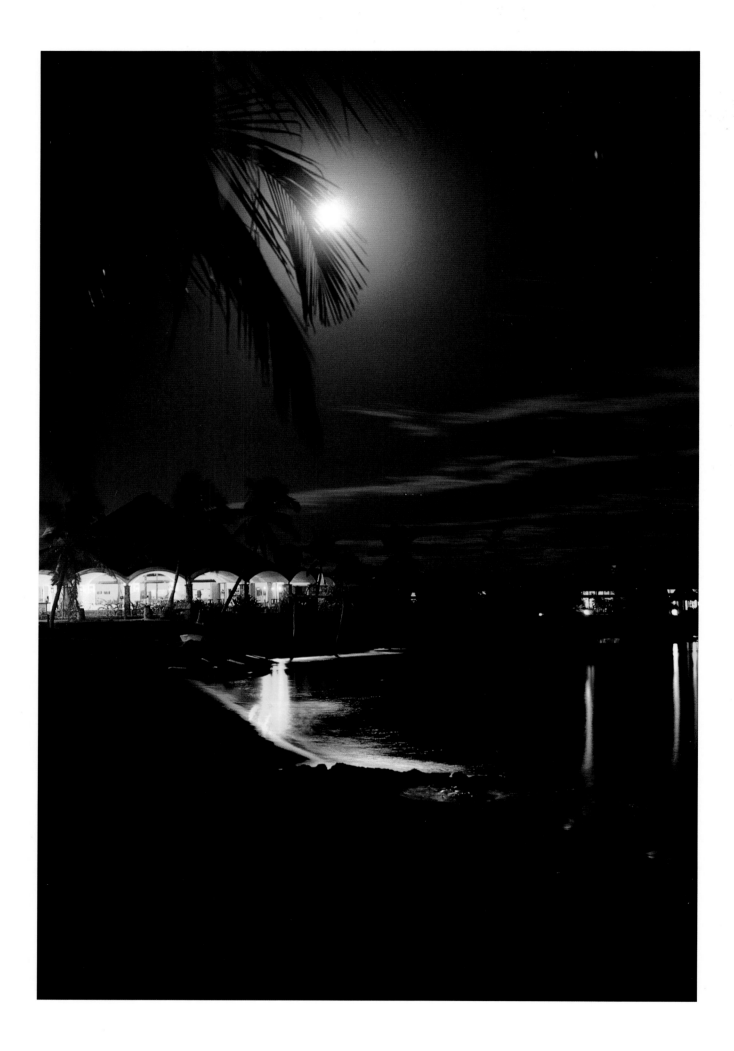

Acknowledgments

Mexico was a new experience for me, different but extremely enjoyable. In the last seventeen years I have been able to visit many places around the world, but usually only for short trips. The majority of my time has been spent in the USA, and chiefly in Louisiana and other Gulf Coast states. The Yucatán Peninsula certainly changed that. During the last several years, I have spent 243 days exploring and photographing its animals, its people, its culture, and its natural treasures.

Many people here and there played an important part in the creation of this book. I would like first to thank Nigel Calder and Terri Frisbie. But for our two sailing voyages to Isla Mujeres, I might never have become interested in the project. Then there is Joann Andrews, who took me into her Mérida home almost as a member of the family. She provided not only a lot of knowledge, but also considerable inspiration to help me over some of the harder parts of this adventure. Barbara Montes, another Yucatecan, provided much insight into the environment of the peninsula.

Dick Blanchard and Gonzalo Ivan Arcila, along with their crew of divers, especially Jim Coke and Richard Ribb, got me started on the underwater portion of this book. Governor Victor Manzanilla, Abraham Jorge, and Wiggie Andrews arranged that special trip to Alacrán. Stephen J. De Carlo flew me for aerial photographs.

Back home I owe special thanks to my researcher Kathy Rhorer Wascom, and to my staff—Lizzie Stagg, Tamiko Bodin, Fernando Vargas, and especially to Caron Colby Whitesides, who had to organize my jumbled legal sheets of hen scratch.

Of the many others who lent a helping hand, I list a few: Carlos Abraham, Tundi Agardy, Isabel Aguirre, Nancy Albritton, Mikael Alexander, Mauricio Gurduño Andrade, David Andrews, Tony Andrews, Will Andrews, Gordon Archer, Marcella Avanda, Antonio Rogel Bahena, Carlos Barrera, Oscar Barrera, Jesus Garcia Barron, Ricardo Espino-Barros G., Wayne Bettoney, Sue Billings, Eckart Boege, Anne S. Bradburn, Cliff Brown, John Buie, Lawrence Burr, Rafael Castillo Bussio, Ligia Carbo, Archie Carr, Jr., Bruce Childers, John R. Clark, George and Janet Cobb, Lorie Conlin, Jorge Correa, Kevin Cuccia, Dr. William Davidson, Cathy Day, John Day, Johanna de Groot, Terry J. Donaldson, Enrique Duhne, David Dzul, Edilberto Ucan Ek, Perez Encalada, Dr. J. Michael Fitzsimons, Janet Frerichs, Jose del Carmen Pech Gomez, Cy Goulet, Bart and Bill Guynes, Craig Hanson, Suzanne Hedges, Pablo Gonzoles Hernandez, Rob Hernandez, Francisco R. Vera Herrera, Sam Holder, Dan and Jake Kennedy, Susan Kepecs, Michelle Kramer, Ed Kurjack, Denis Lafoy, Stu Lenard, Maureen Limond, Kris Lohmann, Arturo Lopez, Mike Madden, Ruben Maldorado, Silvia Manzanilla, Shirley McDonald, Judy McKilroy, Antonio Mendoza, Darrel Mince, Alejaudro Mirabent, Emmanuel J. Mirabent, Dave Morgan, Jeff Mueller, Ingrid Olmsted, John O'Neill, Enrique Martinez Osequeda, Jose Perez Palma, Ignacio Pedroza, Elisa Guerrero Ponce, Merle Greene Robertson, Fernando Robles, Jim, Susan, and Jason Roland, Fernando Romero, B. J. Rose, Douglas A. Rossman, Peter Scott, Barbara Sheffer, Bob Singleton, Myra Slab, Sandy Sprunt, Rodolfo Elorduy Stadeler, Joe Stancampiano, Manuel Tamargo, Dr. Bruce Thompson, John D. Thompson, Suzette Tixier, Dr. J. W. Tunnell, Jr., Luciano and Trancito Varquez, Louis Verner, Dr. Bay Watts, Walter Witschey, and Tom Young. I know I have forgotten a few, especially many in Mexico whose names I never learned but who deserve my heartiest thanks.

Last but not least, I thank the staff of Louisiana State University Press for their continued interest in my photographs, especially my editor Beverly Jarrett, my designer Al Crochet, and the Press's director Les Phillabaum.

THE YUCATÁN PENINSULA

LEGEND
- ▲ Ruins
- ⊏▭⊐ Roads
- - - - Jeep trail
- ■ Cities
- ✈ Airports
- Reefs

UNITED STATES

ATLANTIC OCEAN

GULF OF MEXICO

MEXICO

PACIFIC OCEAN

CARIBBEAN SEA

AREA OF MAIN MAP

Arrecife Alacrán

GULF OF MEXICO

Río Lagartos Estuary

Isla Contoy

Río Lagartos
Holbox
El Cuyo
Isla Mujeres

Progreso

▲ *Dzibilchaltun*

Tizimin
Luis Rosada Vega
Cancun

Mérida ✈

295

Celestún Estuary
Celestún

Y U C A T Á N

180

Nuevo Xcan

Puerto Morelos

180

261

▲ *Mayapán*

Valladolid
▲
Chichén Itzá

Playa del Carmen

▲ *Cobá*

Cozumel

▲ *Uxmal* Ticul

Akumal

302

Isla Cozumel

M E X I C O

184

▲ *Zayil*

▲ *Tulum*

50 Mi

50 Km

Campeche ✈

Punta Allen

Felipe Carrillo Puerto

Ascensión Bay

Sian Ka'an Biosphere Reserve

Espíritu Santo Bay

Q U I N T A N A

R O O

307

Champotón

C A M P E C H E

261

Banco Chinchorro

Ciudad del Carmen ✈

Laguna de Terminos

Escárcega
186

Becan ●

Kohunlich
▲

Chetumal ✈

Chetumal Bay

Candelaria

▲ *Chicanna*

Río Azul

C A R I B B E A N S E A

Calakmul Reserve (Proposed)

▲

Villahermosa ■

River

22°

20°

18°

▲ *Río Azul*

El Mirador

Belize City

G U A T E M A L A B E L I Z E

▲ *Tikal*

90°
88°

Introduction

I was introduced to the Yucatán Peninsula from the deck of a thirty-nine-foot ketch. Four of us set sail from Louisiana for the 650-mile journey across the Gulf of Mexico. The Isla Contoy lighthouse was our first sighting of land after five days at sea. The birds circling this pinnacle of light beckoned, but we had to check into Isla Mujeres first. The customs men were humored by the name of our vessel, which had been hand-built by Nigel Calder and his wife Terri Frisbie. Terri and Nigel were unable to agree on a name, so they painted *Nada* on the stern, which means *nothing* in Spanish.

It was a good trip—complete with whales, dolphins, flying fish, and many seabirds—and especially meaningful to me, because I was just finishing a book on the American Gulf Coast. I was excited by the prospect of seeing the other side of the world's largest gulf. Two weeks later I was pleased with what I had seen.

This book was conceived on the return voyage, as I recalled snorkeling with rainbow-colored parrot fish on the reefs around Isla Mujeres, viewing the thousands of seabirds at Isla Contoy National Park, and watching graceful flocks of flamingos, in their reddish splendor, fly across the setting sun at Río Lagartos. That day, when I decided to do this book, I knew very little about the interior of the peninsula, its history or its people. Once I got to know them, they became just as important to me as the seacoast and wildlife.

Readers of this book will notice that I spend a lot of time re-creating the hard days. Those with rough rides, extreme heat, big waves, or multitudes of mosquitoes stand out in my mind. These are the events that are easier to write about because I recorded them in my journal. When conditions were good I was taking pictures. The majority of the time conditions were pleasant; and being more the photographer than the writer, I find those easy times more difficult to evoke with words.

I spent eight months, spread out over two years, on the peninsula. Many times I went back to the same places. Readers must bear with me in sections like the one on flamingos, as I bound back and forth between El Cuyo and Celestún. I have followed a topical rather than a chronological organization.

The Yucatán Peninsula juts into the surrounding seas like a giant, flat, limestone thumb. Its eastern side is bathed in the warm waters of the Caribbean Sea. With the exception of three big bays and a few islands, this coast is characterized by alternating rocky points and sandy halfmoon beaches. Offshore is the northern end of a barrier reef that extends into Belize. The Gulf of Mexico fronts the northern and western sides of the thumb. Its waters are cooler and much shallower, for the Campeche bank descends slowly two hundred miles offshore. The coast here has long barrier beaches planted with coconut palm plantations. Behind the beaches are numerous lagoons, most of them saltier than normal seawater. To the south are Belize and Guatemala.

Although the northern portions of these two countries are considered part of the peninsula, I have restricted my coverage to the Mexican states of Campeche, Quintana Roo, and Yucatán.

Diego de Landa, a Spanish priest who was the bishop of Yucatán in the late 1500s, described the land thus: "Yucatán is the country with the least earth that I have ever seen, since all of it is one living rock." He made a pretty fair description as the peninsula's 220,000 square kilometers is a flat plain of limestone and dolomite, hundreds of feet thick. Both of these substances are largely composed of the calcareous remains of marine organisms like coral and mollusks.

But even with this rocky base, the Yucatán is well forested in second-growth deciduous rain forests. It is deciduous because the winter dry season so stresses many trees that they lose their leaves even though it's warm enough to keep them. Once the rainy season starts in June, the jungle immediately comes back to life. It's a beautiful jungle that instantly turns green. Flowers are blooming and birds start nesting as insects, reptiles, and amphibians come out of their subterranean homes. The difference in animal life made by a little water is astonishing.

The forest is dotted with villages and *milpa,* more so in northern Yucatán and parts of Campeche, as these areas have been settled for over three thousand years. A *milpa* is a family corn and bean patch that has been cleared by slash-and-burn style agriculture. Other agriculture includes citrus, rice, bananas, and the one-time money crop of henequén. Henequén comes from a yucca plant and is used to make hemp rope. At the turn of the century, northern Yucatán had a monopoly on the world hemp trade. This made Yucatán the richest state in Mexico, and Mérida supposedly had more millionaires per capita than any other city in the world.

It was a two-class society—the Maya workers and

the ruling-class Castilians. The Mexican Revolution in 1910 instituted some changes, but slowly. Because of the independent Yucatecans and the geographic distance, it took twenty-seven years for serious changes to be completed. General Salvador Alvarado's troops in 1915, the socialist leadership of Felipe Carrillo Puerto, and finally stern measures by President Lazaro Cardenas ultimately broke up the hacienda system and established *ejidos*. These collective farms allowed the Mayas to work the land for themselves. This, along with the development of synthetic rope, left the haciendas in ruins.

Mérida was founded in 1542 by Don Francisco Montejo, just thirty-one years after the first Spaniard set foot on the peninsula. These first records of Spanish contact were in 1511, when two men survived a shipwreck and lived with the Mayas. One Gonzalo Guerrero, a soldier, married a Maya woman and turned on the Spanish, helping the Mayas fight them. The other man, Jerónimo de Aguilar, remained loyal to the king and later joined Hernán Cortéz. Aguilar's language skills helped Cortéz conquer Mexico City.

Francisco Hernandez de Córdoba came to Campeche in 1517. Juan de Grijalva followed the next year and began a long string of Spanish *conquistadores* who sought riches and found much bloodshed. Those years were the start of many battles between the Maya and the Spanish—battles that lasted up to the Caste War in 1847.

Today there is a tourist invasion; these invaders do not come with cannons and sabers, but with money to spend. In U.S. dollars 550 million (or 1.25 trillion pesos) were spent by over a million visitors in 1987 according to the Mexican Department of Tourism. Tourism is the fastest-growing industry on the peninsula.

This is particularly true in Cancun, the rising star of tropical vacations. Eighteen years ago it was a desolate barrier island. The few tourists who visited came for a picnic on a snorkeling tour with fishermen from Isla Mujeres. Now Cancun is fifteen kilometers of highrise hotels, numerous restaurants, and miles and miles of fancy gift shops. One can disco, eat, drink, and shop in first-class style, or participate in any sport that has to do with water. It is a beautiful island, but according to many it has reached its developmental limits.

The Yucatán Peninsula was fascinating to me in all respects. I hope this book may provide an opportunity for others to see some of the hidden secrets that the average visitor does not have time for.

You would think that an area that has been continuously inhabited for over three thousand years would have been tamed, leveled, domesticated. Not so in the Yucatán Peninsula. There are still large chunks of terra firma that are hard to get to, near impossible to penetrate, and lacking in fresh water. There are also reefs and islands without amenities and far enough offshore to make them just as difficult to visit. The main reason these are still wilderness is because other areas are more suitable to human habitation.

I was able to visit four of these places: Arrecife Alacrán, Banco Chinchorro, Sian Ka'an, and Calakmul. I call them the jewels of the Yucatán. Each involved tough journeys to remote chunks of densely vegetated jungle or desolate islands; all were exciting and some were dangerous. We suffered through long distances on roads one could only call trails, not to mention heat, cold, giant waves, insects, and lack of proper food stuffs. But I have no complaints and would gladly make each expedition again.

Two people standing on the limestone rim of a cenote, as seen by the photographer from the crystal clear water thirty feet below. This cenote was named Temple of Doom because this is such a difficult and exciting cave-dive. It is a mile west of Tulum.

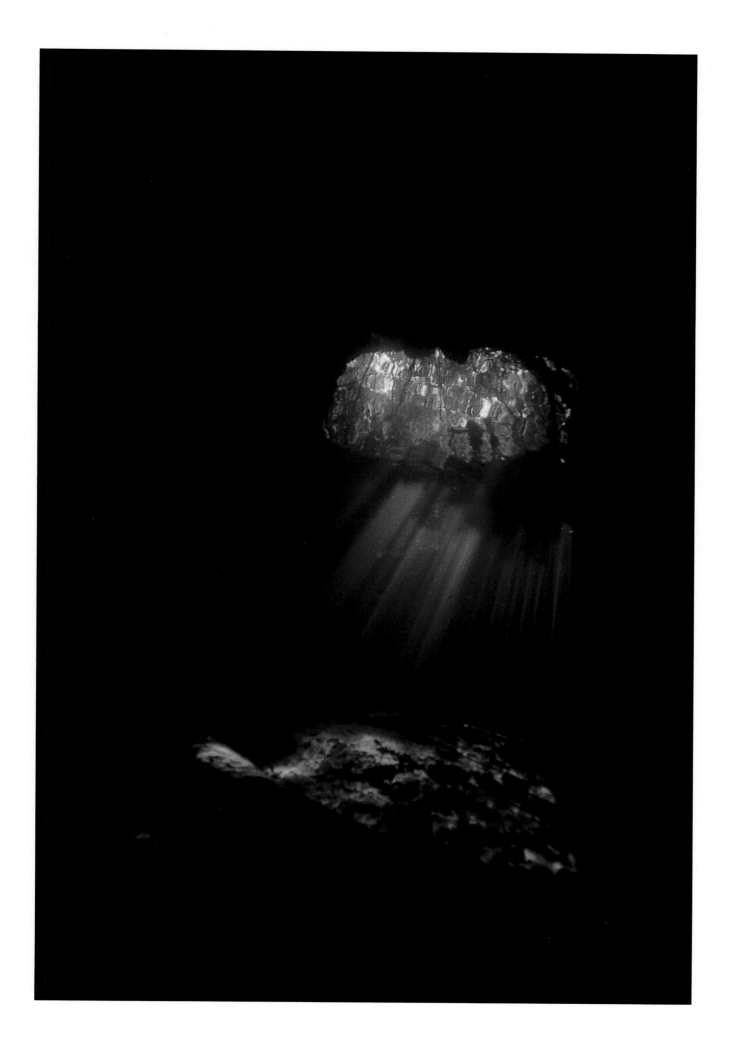

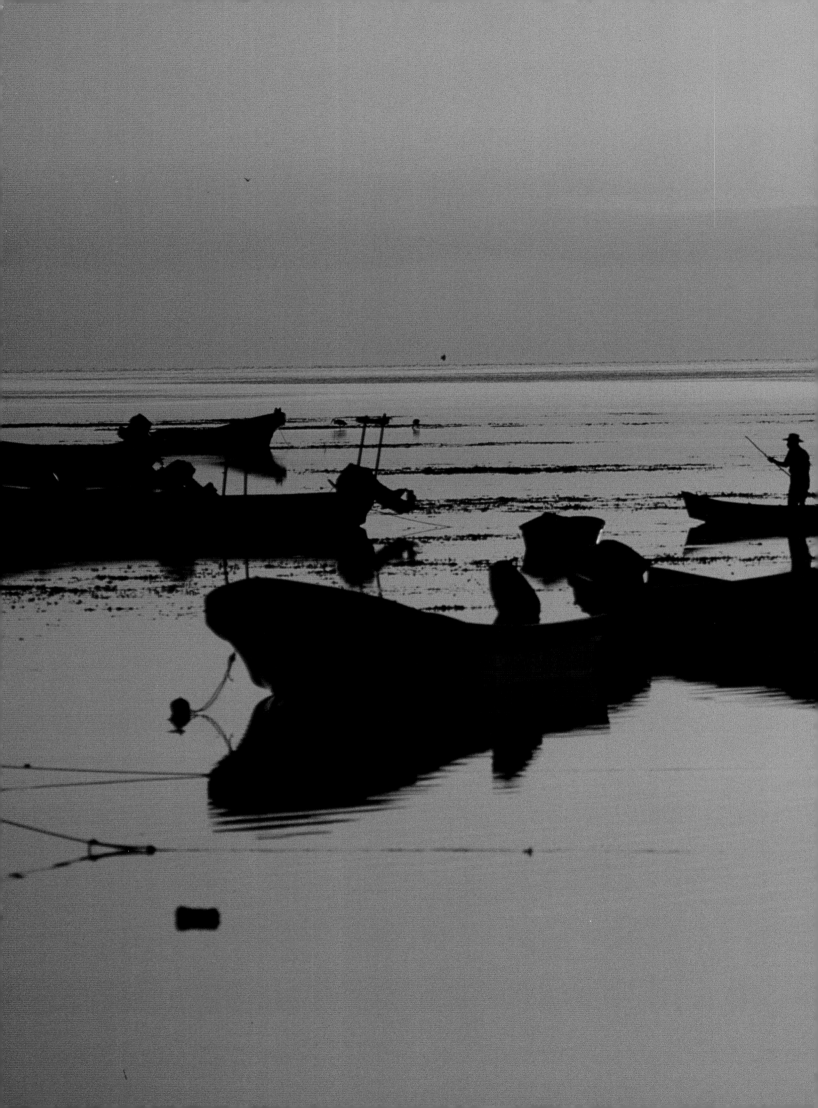

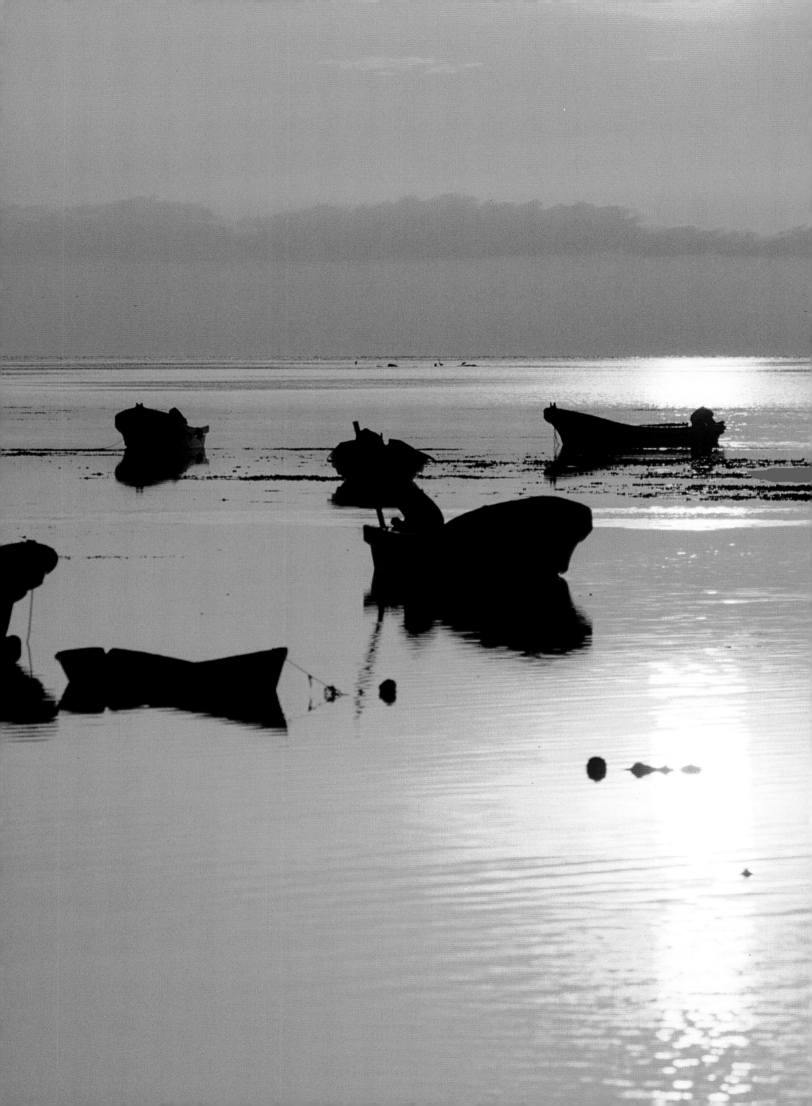

The last fisherman poles home as the sun sets over San Felipe harbor (overleaf).

The Mayas are a hard-working and friendly lot. Their palapa houses, like this one near Calakmul that Pablo Gonzales owns, are usually stocked with all sorts of fruits and vegetables (above right). Stone workers take a break near Mérida (right). Most of the world's hemp rope used to come from the Yucatán Peninsula's henequén plantations. Nowadays, synthetic fibers are used for most ropes (above).

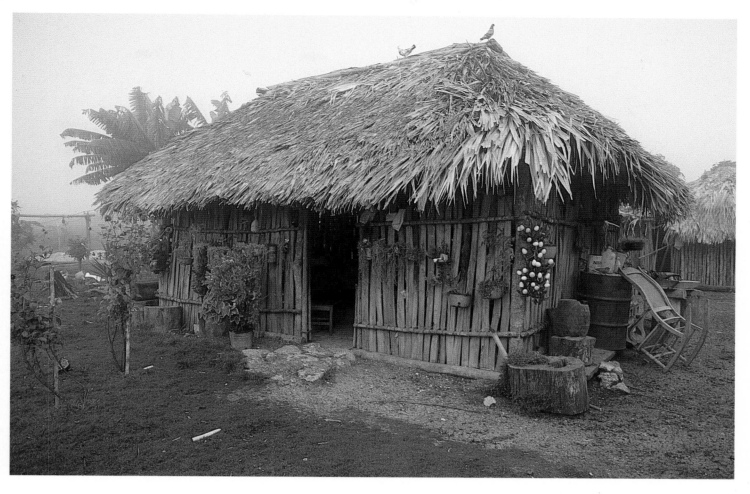

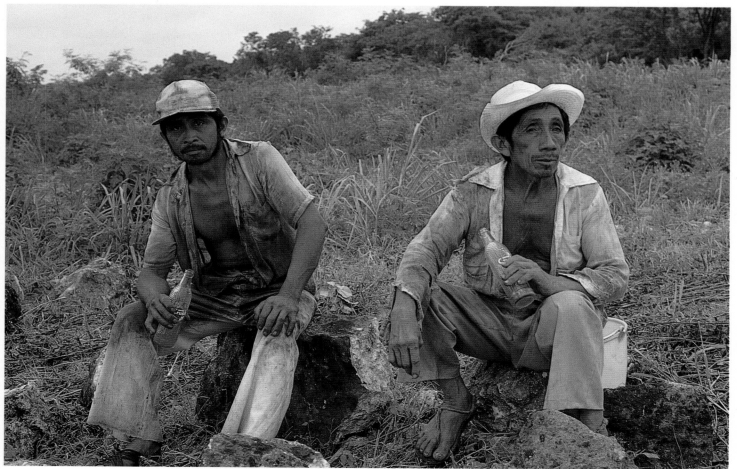

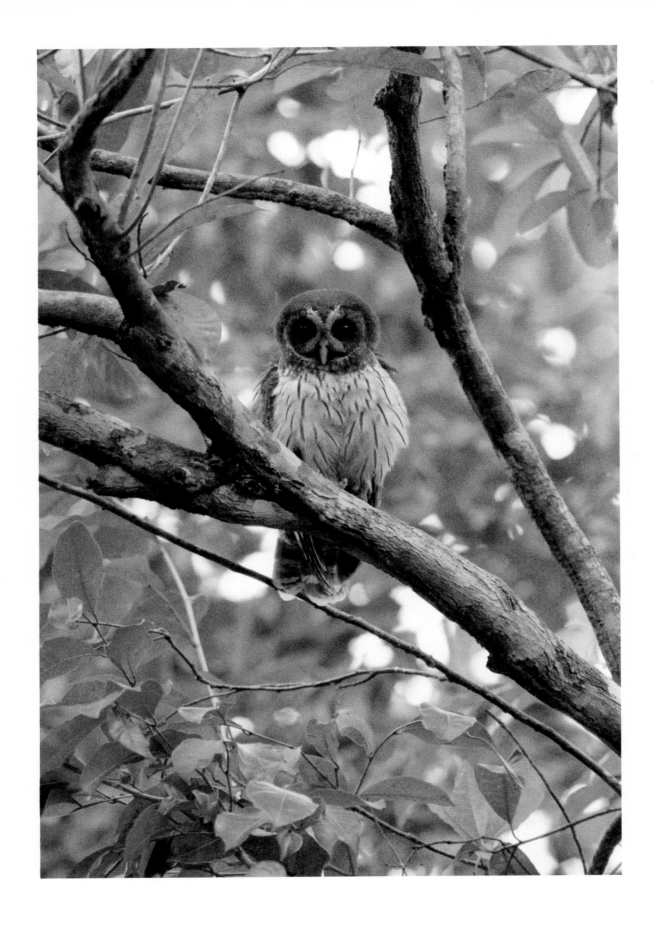

The Yucatán Peninsula has numerous species of wildlife, particularly birds like the mottled wood owl (above) and sooty terns (top right). Harder to see is the banded basilisk, a lizard (bottom right).

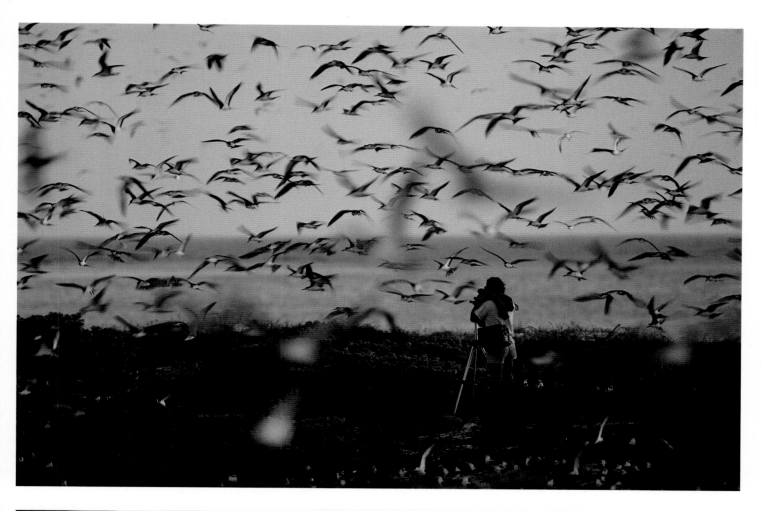

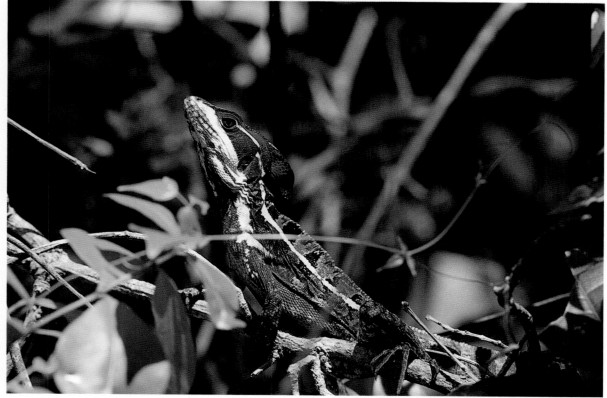

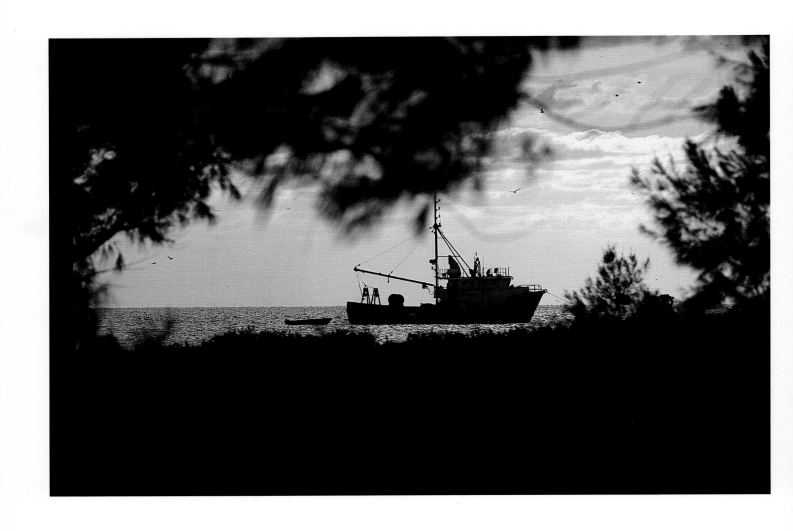

*Research vessel B.I.P. X, at anchor off Isla Pérez,
Alacrán Reef.*

ARRECIFE ALACRÁN

Alacrán was the hardest trip to arrange, for it is a major reef jutting out of the Campeche bank sixty-two nautical miles north of Progreso. Its five islands and one tidal spit are contained in a reef system that is seventeen miles from north to south and thirteen miles from east to west. Most of the reef is subsurface, although at low tide, a few coral heads stick out of the eastern edge where the southeasterly winds bang them with incessant waves.

To transport food, water, cameras, tanks, compressor, and self sixty-two miles offshore is no small task. These 130 acres of sand, shells, coral rubble, and dune vegetation offer no fresh water and very little shade; however, they do provide great habitat for thousands of seabirds. But getting there for seven days of photography, diving, and research was clearly going to be tough.

My good friends Joann Andrews and her daughter Wiggie of Mérida, knowing the importance of Alacrán to the fish and avian ecosystem, took on the task of organizing the expedition. Through the graciousness of the governor of Yucatán and his aides, a PESCA (Secretariat of Fishing) research trawler was obtained and outfitted with supplies by ProNatura.

Within a few weeks we were ready to set out. With high expectations Captain Fernando Villamor pulled out of Progreso harbor at 1400 hours on Easter Sunday, April 3, 1988. Our ship, the *B.I.P. X*, was a shrimp trawler converted to an oceanic research vessel; it had plenty of room for our group of twelve scientists and photographers. John Clark, a coastal scientist with the United States Park Service, was the only other American aboard. There was excited chattering in both English and Spanish as the *B.I.P. X* broke out of the harbor into the open Gulf.

Expertise abounded among the ten Mexicans, mainly Yucatecans, such as with hard corals for Enrique Martinez, fish for Mauricio Gurduño, algae for Antonio Mendoza, birds for Jorge Correa, social anthropology for Eckart Boege, planning protected areas for Carlos Barrera, natural area management for Enrique Duhne, marine mammals for Silvia Manzanilla, shells for Wiggie Andrews, and underwater video for Gonzalo Arcila. I was thrilled to see so much enthusiasm in these scientists voyaging out to gather data on all aspects of Alacrán and to formulate a plan for protecting its resources.

Alacrán is a contrast in terms—desolate, forbidding, and distant but also beautiful, bountiful, and magical. You can get a good feel for it from the top of the lighthouse at Isla Pérez, looking out over the 76,000 acres of reef. Layers of color, especially the blues, are visible where various depths of water show shades of green, aquamarine, and deep blue—all offset by the ivory sand, puffy white clouds, and foamy surf.

This is not a place everybody can go, for it is too far out with too little land. But it is a place that exists in everybody's mind. I remember when I was a child reading of Robinson Crusoe and the Swiss Family Robinson and then dreaming of desert islands, mangos, starfish, pirates, and cannibals. At that time I just dreamed, not knowing that my adult occupation would give me the opportunity to see places like this, but it was still important to me to know that places like Alacrán were out there somewhere in the seven seas. Not every island needs a condominium. Some should be saved for dreams, wild creatures, and mysteries. Such a place is Alacrán.

I think it is important to most other people, too— children and adults alike. Of the thousands of people who come to Cancun, Mérida, and Chichén Itzá, most will be satisfied with a walk up a pyramid, a snorkel over a shallow reef, and a trip through a museum. But deep down in their imaginations, part of the reason they came is the knowledge that there are still desolate islands and wild jungle out there.

Alacrán presently has wild creatures both above and below. We were treated to multitudes of gulls, terns, and boobies during our sixty-two-mile voyage. At that special time of day, twilight, and as if on cue, a school of porpoises joined our bow wave and led us into our anchorage just south of the reef in 120 feet of water. At dawn we would tread our way into a safe anchorage by Isla Pérez.

It was a rough night as the boat rocked from port to starboard. The wind and the current must have been going in different directions. But it was the excitement of landfall that kept me from a good night's sleep more than the pitch of the boat. My expectations were justified when the sunrise and the first view of Isla Pérez greeted me with a blurred vision of ten thousand sooty terns providing a cacophony of sound as they hovered over the northern tip of the island. Take me ashore! I could not wait!

Pérez is the largest island at Alacrán, the only one

with trees and the only one with inhabitants. The trees are mainly Australian pines, not native to the island. Of the two inhabitants, one is the lighthouse keeper and the other a navy radio man. Besides the small residences of these two men, the only structures are the lighthouse and a few uninhabited buildings in various stages of disrepair. Vegetation includes a few sea grapes, two species of mangrove, a dense patch of prickly pear cactus, and dune shrubs.

Three of our group chose to sleep aboard ship, but most of us set up camp in the old lighthouse building. After we made camp, Gonzalo and I rushed out to photograph the sooty tern colony. The others did a survey around the perimeter of the isle, noting birds, coral, shells. Because of the difficulty involved in getting here, very little research has been done on Isla Pérez.

Early that first morning I had estimated ten thousand sooty terns hovering over the island. Now, after walking around the colony, I upped my estimate to twenty thousand. There were just as many birds on the ground courting and making nests as I had seen flying. That night the lighthouse keeper told me he had watched egg snatchers take fifteen thousand eggs off the island a few years back. We were told that this practice has been stopped, but I am sure it still goes on, though on a smaller scale. Most of the terns were still courting so only a thousand or so eggs had been laid.

The sooty tern, as well as the other colony-forming birds out here, are not afraid of man. You can practically walk right over their nests without scaring them. Because these islands were predator-free for thousands of years, the birds evolved with nothing to fear.

Isla Pérez also had about two thousand nesting brown noddies. The noddy is a tern, brown with a white cap and black bill. Its feathers look silky. They nest in a haphazard pile of sticks in the pine trees. Theirs is the same sort of nest a mourning dove makes, one that you just wonder how it can possibly stay together. Some were nesting in the sea lavender as they all must have before the Australian pine was introduced here.

I set up a remote camera about eight feet from a nest that had one adult sitting on an egg. Then I moved back twenty-five feet and hid in the bushes with my binoculars. The birds were not afraid of me but I wanted a more natural look. I watched her stand up over the egg every ten minutes and open her mouth wide, exposing her orange yellow tongue; then she'd ruffle up her breast feathers and sit back down. When the male came back (I am assuming it was the male because they look alike) he did a little head bobbing then regurgitated a fish for her. During a two-hour period they twice traded places incubating the egg.

Sunset was near so I packed up my gear and went to the northeastern corner of the island to view the terns hovering in the sunset. It was a meditative sight: ten thousand birds and the evening light, a flamingo red

sunset with hovering black silhouettes. The afterglow was dessert for a deliciously productive and beautiful day. It changed color second-by-second as I walked along the leeward side of the island. The mauves, pinks, yellows, oranges, and pastel blues reflected from the sky to the still waters gently lapping on the sandy shore.

Over the next six days we visited all the islands and the sandy spit. First we stopped at Desertora, which was oblong and very flat with sparse dune vegetation. The magnificent frigate birds nested in the shrub *Suriana maritima*, and the masked boobies laid their eggs on the sand. The big booby is an appropriate name for this goofy-looking bird that is so awkward and clumsy on land. But put them in the air, and how they can fly! These birds are the least afraid of man. You can almost get eyeball to eyeball with them.

That day we made an unusual discovery, a red-footed booby's nest up in the shrubs near the frigate's nest. This is the northern-most breeding record for this bird. The closest red-footed booby colony is in Belize. Perhaps this pair had gone astray, or possibly these birds were scouts looking for new breeding territory.

Our next stop was Desaparecida, which means *disappearing* in Spanish. It is not truly an island, but a tidal sand spit that builds up each winter with the north winds and erodes again each summer with the southeasterlies. That April day it was pretty enough to be the perfect location for a *Sports Illustrated* swimsuit issue shoot.

The only thing on the ivory-colored sand besides a few shells was the skeleton of a sea fan that had washed ashore. Its black form offered stark contrast to the aquamarine waters. Since there was not much to study here, we moved on, noticing a number of barracuda in the shallow clear water.

The north island, Desterrada, is the second largest of the reef. It was breached by a hurricane in 1946, but has since merged again. This banana-shaped isle is 2,700 feet long and has the most extensive dune system on the Alacrán complex. Toward the northwestern end of the island is the lighthouse, 46 feet tall.

We landed here at midday, with the sun beating down incessantly—harsh, hot, and bright on the white sands. We found a small colony of brown boobies and guessed there would be more later, as well as royal, least, and Forster's terns. Part of our group found a sick little blue heron that rode around the island perched on Enrique Duhne's arm.

The last two islands, Pájaros and Chica, are much smaller and basically flat. Pájaros had a few boobies nesting, and both islands would probably have tern colonies later in the season. Large semisunken freighters were the only other landmarks above water. The steel monoliths were slowly rusting away in the surf on the windward side of the reef. One, we were told, hit the reef on purpose to collect its insurance; but

many other modern-day tankers, as well as Spanish galleons, had been bashed against the reef in hurricanes and other terrible storms.

Our diving group was not lucky enough to happen upon a chest of pirate's gold, but seeing the snapper, grouper, moray eels, and turtles was just as rewarding for us. Our first dive was at the southern end of Isla Pérez where the coral was in pretty bad shape. Enrique Martinez told us that a 1964 hurricane had done quite a bit of damage to the reef. Later, on shore, he showed us piles of staghorn coral rubble from the same storm.

The coral here wasn't as abundant or as pretty as that we would see in Banco Chinchorro, because of the colder water temperatures found at Alacrán. One spot really caught my eye, though. It was an entire field of mushroom-shaped pinnacles of coral, that vision being enhanced by the presence of many big groupers. I am always happy when I am swimming with a big grouper.

Our evenings were spent taking notes, rehashing the day's finds, and discussing the future of the reef ecosystem. We shared compressor duty and took a lot of artsy-groovy time exposures around the lighthouse. At bedtime you could still hear the twenty thousand sooty terns squawking and flying around their rookery. They never all settled down at once.

The sunrises were perfect, especially one morning when I watched the last few turns of the powerful lighthouse shine out into a burgundy sunrise dotted with dollops of tiny cumulus clouds. Scenes like that, as well as the rich marine and bird life, are what I will remember about this reef. Arrecife Alacrán is truly a jewel of the Yucatán Peninsula, one that should be set aside and maintained as a wilderness area.

Tranquillity at its utmost is dawn on Isla Pérez. The lighthouse shines its last beam and the sun will soon take over to guide mariners through the reef (overleaf).

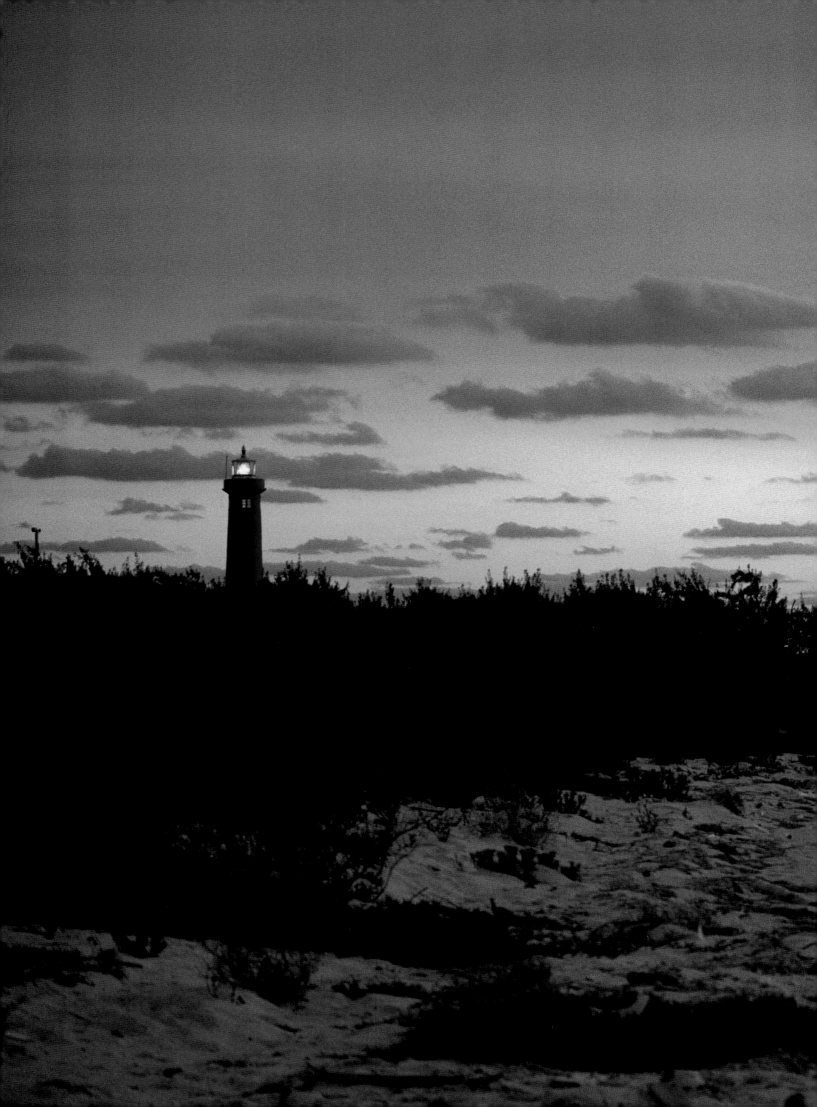

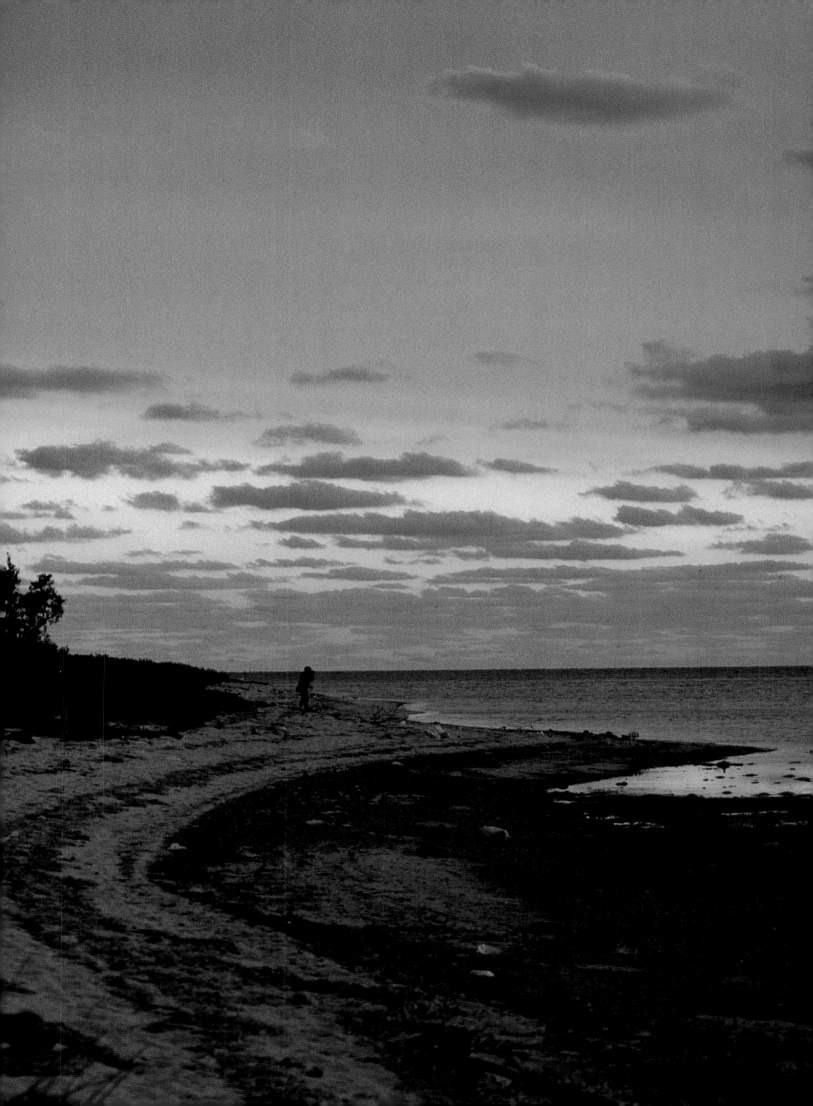

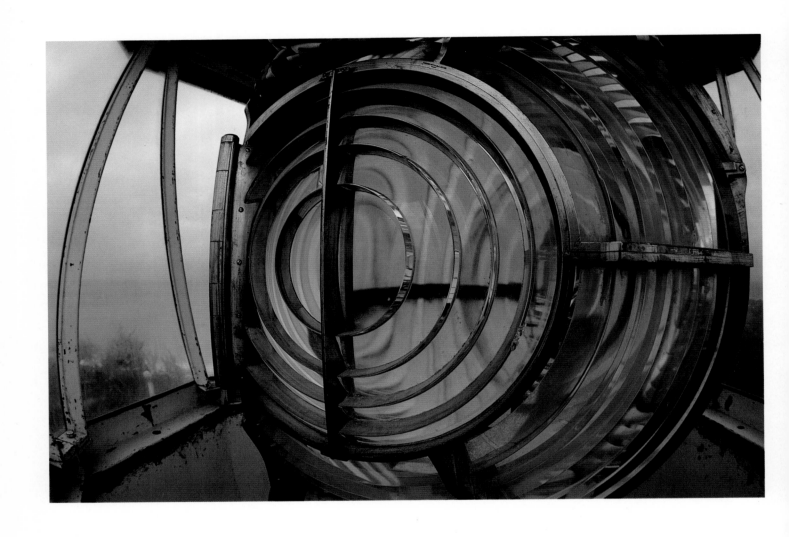

A Fresnel lens (above) sits atop the Isla Pérez lighthouse,
framed by a cactus, Nopalea qaumeri, *whose red fruit
mimics the handsome color of the tower* (right).

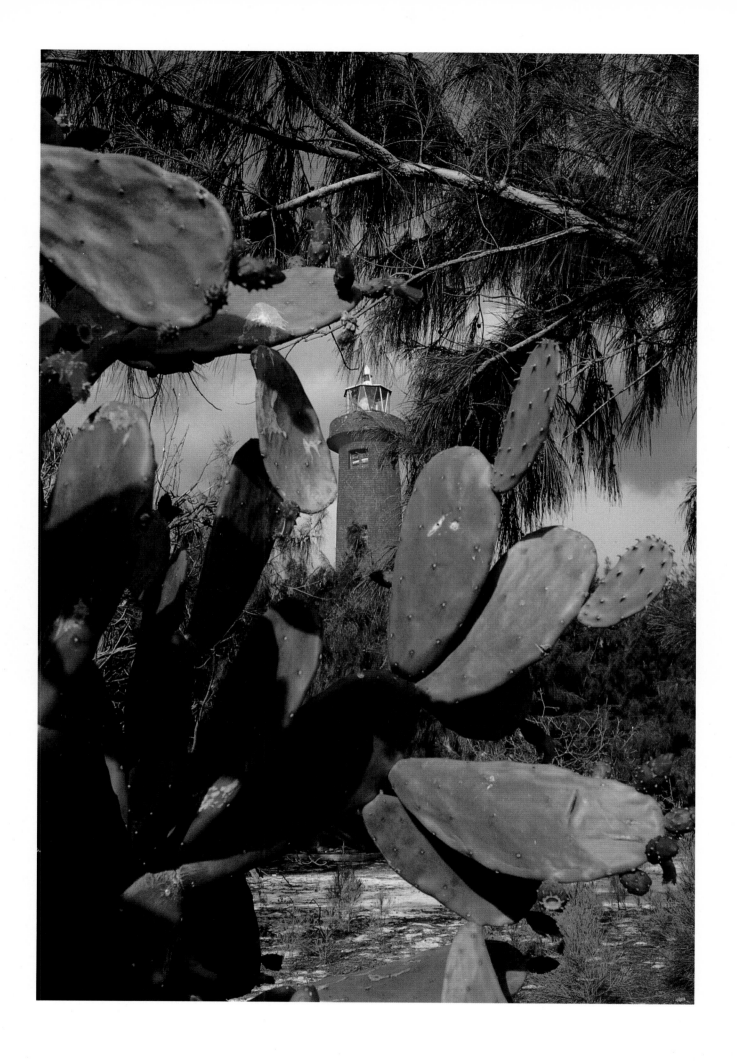

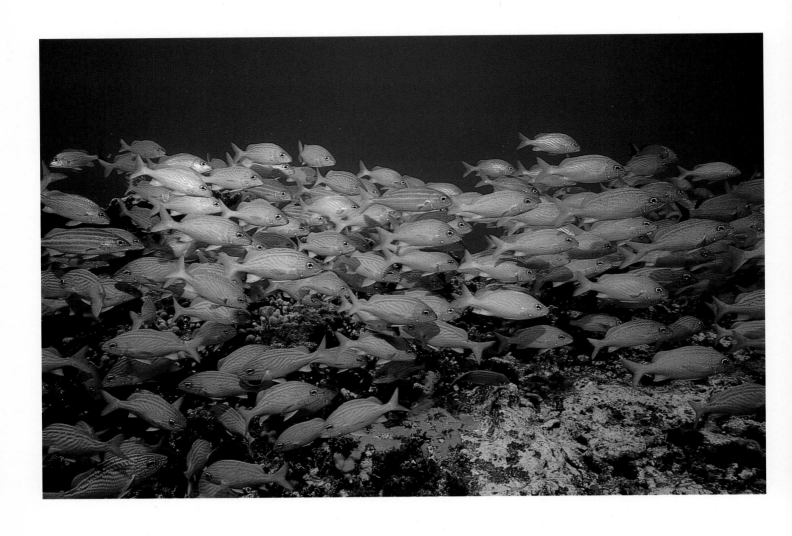

A rainbow of blues caused by the various water depths and reef contrast (above), *with a mixed school of French and blue-striped grunts* (left).

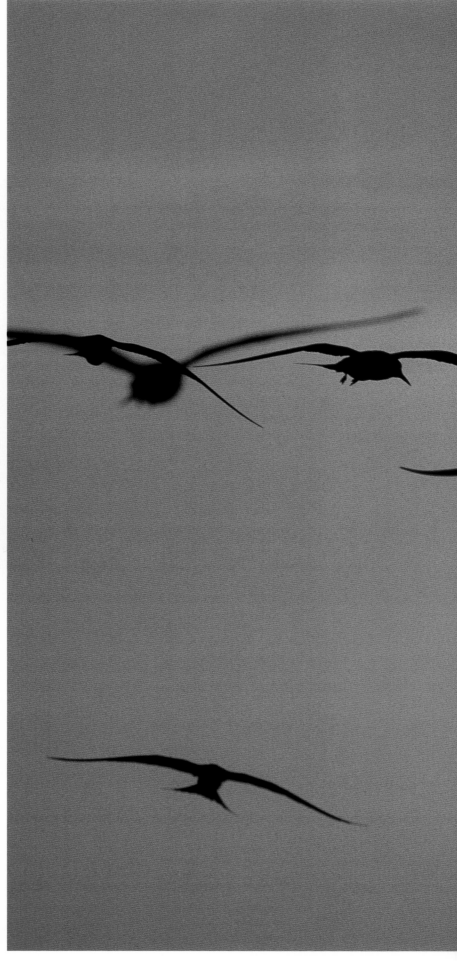

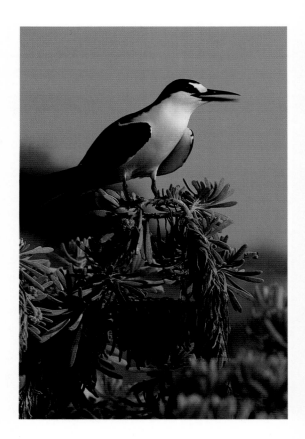

Up close, the black and white plumage and streamlined body give the sooty tern a racy look (above). Late in the day they are poetry in motion as a few of the twenty thousand birds fly across the setting sun (right).

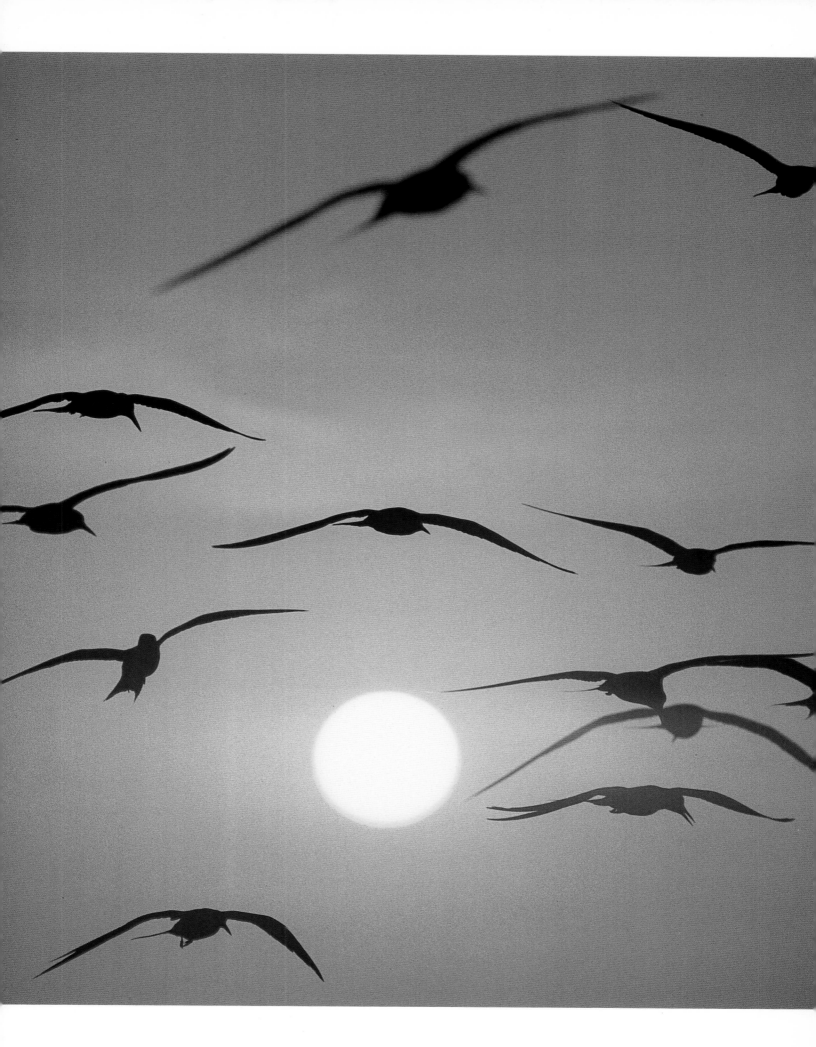

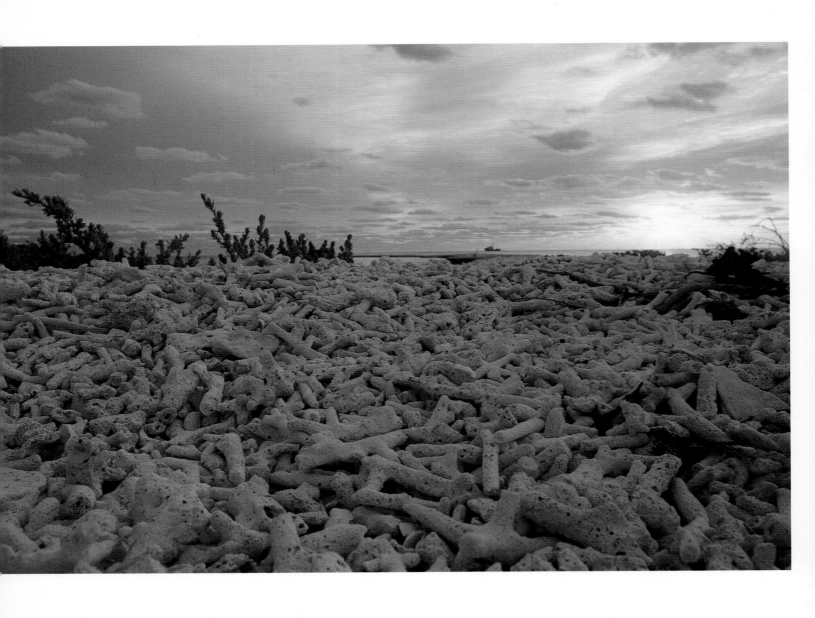

In 1964 a hurricane killed much of the staghorn coral on Alacrán; subsequent storms washed it up on the beach (above). *Lobster fishermen take a break to play volleyball* (above right) *while their dinghies are guarded by sooty terns* (right).

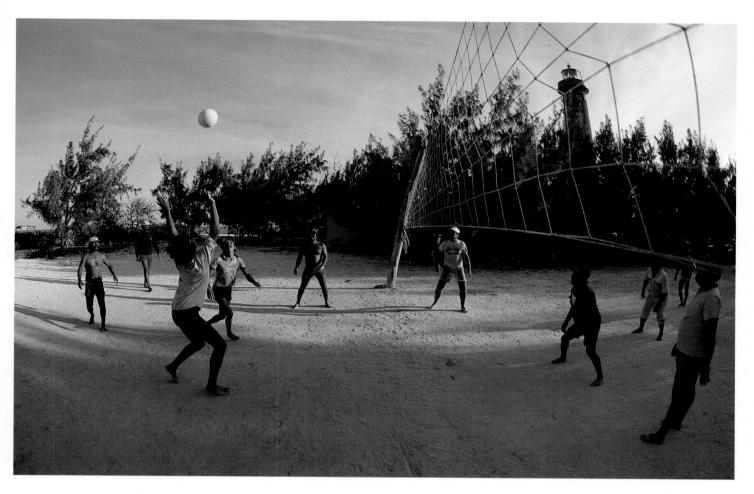

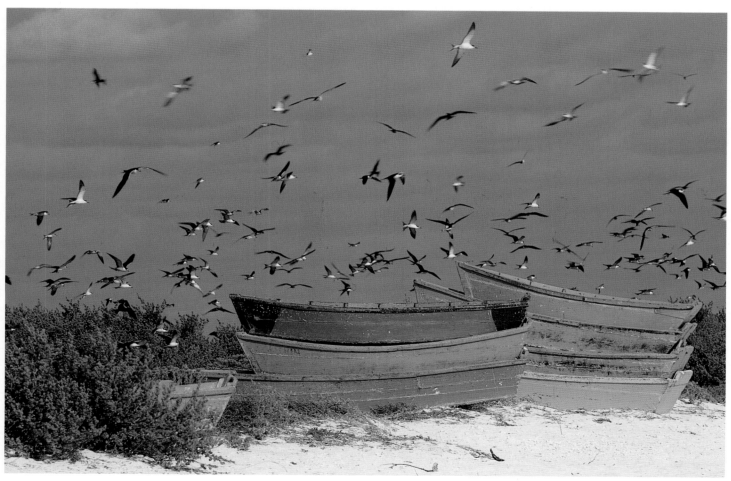

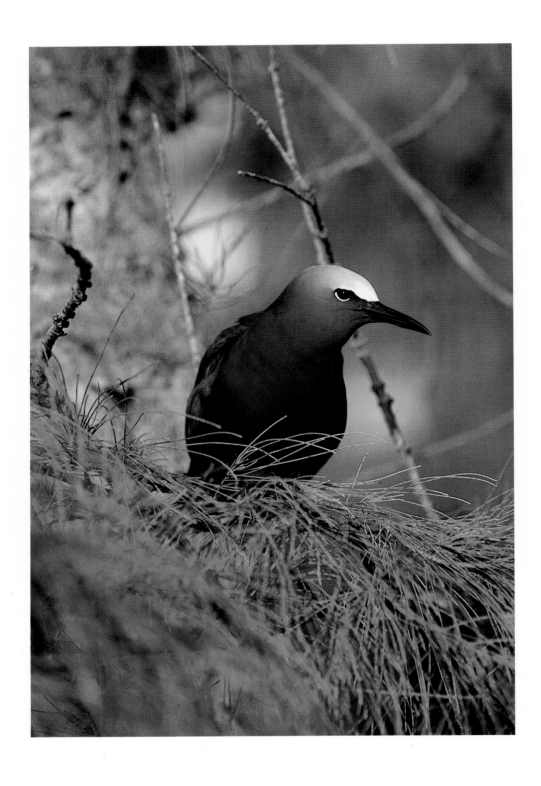

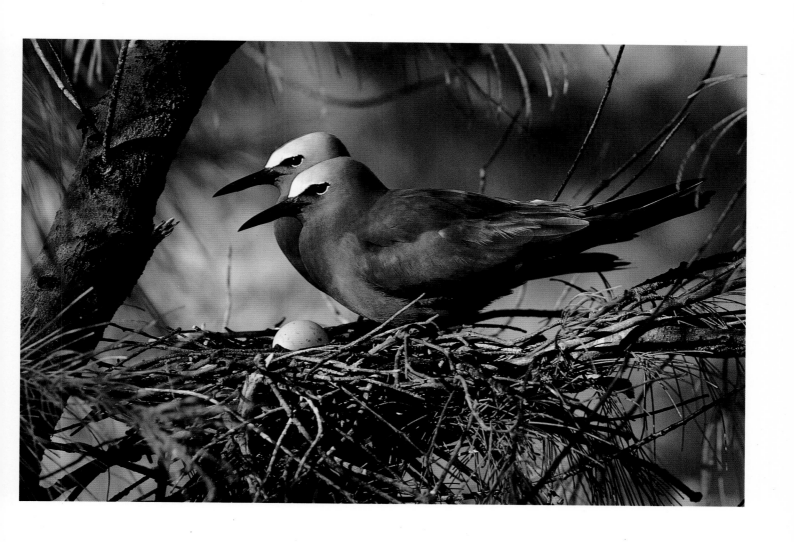

Another of the colonial birds on Isla Pérez is the brown noddy (left). Its fragile nest reminded me of a mourning dove's. Here the male and female are changing guard (above).

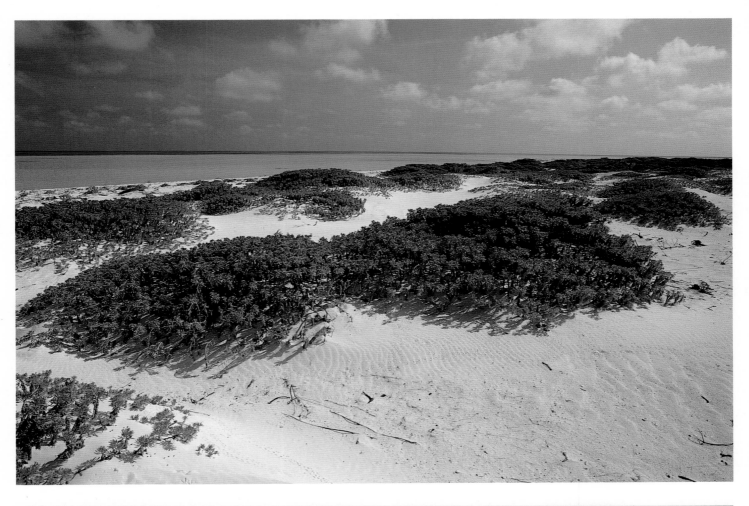

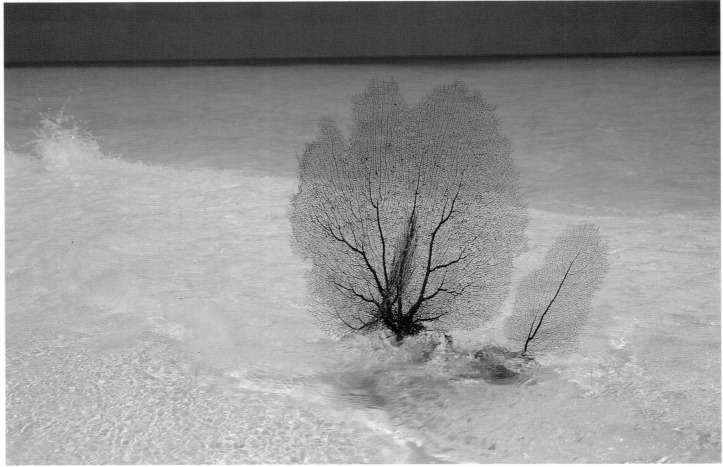

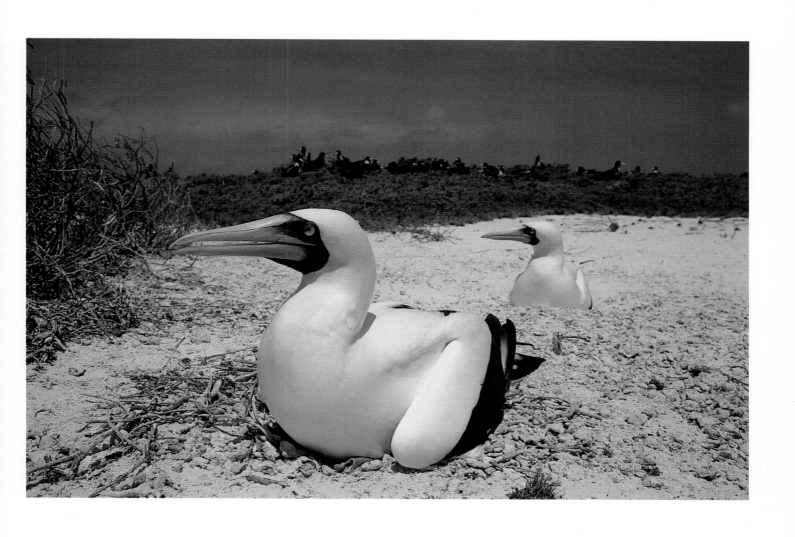

Masked boobies, having evolved over thousands of years in a predator-free environment, are totally unafraid of humans (above). Isla Desterrada has the largest dunes of the five permanent islands at Alacrán Reef (above left), and Isla Desaparecida completely submerges during the summer each year as the southeasterly winds spread its sands out (left).

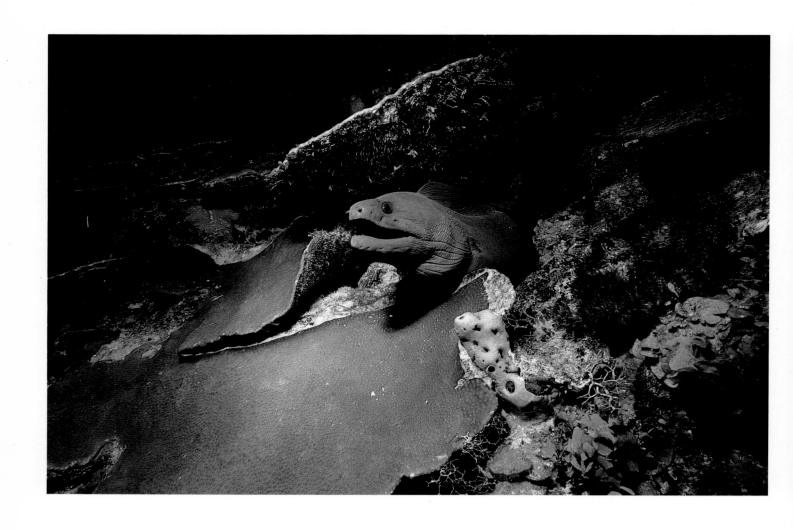

The green moray eel is one of the most exciting creatures to be seen underwater, and despite its ferocious reputation it poses no danger to humans unless they try to grab it.

BANCO CHINCHORRO

My trip to Banco Chinchorro was less organized, or, more accurately, not organized at all. In fact, it was dangerous and could even have been called foolish. But again I would not trade it for anything, because this is indeed the second jewel of the peninsula's wild places.

Like Alacrán, Banco Chinchorro is an atoll-type reef with very little land and lots of coral. It has less solid land and much more coral than Alacrán, probably because it lies in warmer Caribbean waters, about twenty miles east of Quintana Roo's coast. It differs from the previously mentioned reef in that it is surrounded by much deeper waters, waters that often approach (or exceed) three thousand feet in depth. This is also one of the reasons for its more diverse coral community.

Like Alacrán, Banco Chinchorro is hard to get to, for there are no regular boats going there. Only a few local fishermen are regulars out there.

Pure desire got us started, and luck combined with a good boat captain got us to Chinchorro. Richard Ribb, a diving instructor at Akumal, and I loosely planned the trip. We tossed diving gear, six tanks, twenty gallons of gasoline and water, hammocks, my cameras, and some food in the back of his truck. The food was special: seven small cans of peanuts, a few limes, tomatoes, and peppers, as well as a case of mixed soft drinks. Joining us were Fernando Romero, a diver from Cancun, and Cuba, one of the boat boys at Excursións Akumal Dive Shop. Cuba was well trained in following bubbles; and Richard, after hearing about my swim to shore at Punta Allen (an adventure I'll discuss when I get to my Sian Ka'an excursion), wanted to make sure we had a good bubble man. Little did we know that Cuba, who does not weigh more than one hundred pounds, was also a professional soda pop drinker. He downed the case on the first day, leaving us with only water for the rest of the voyage.

We selected the fishing village of Xcalac to embark from, because it offered the best chance to obtain a good boat. Richard had heard there was an American there who had a Boston whaler with two 110-horsepower motors on it. We found the Boston whaler. It had only one 90-horsepower, and its owner had gone back to the states. We were determined not to give up after our six-hour drive from Akumal, the last few hours having been on a quaint beach road that runs down to a point southeast of Chetumal Bay and only five miles north of Belize. There we found a man named Eloy who had a compressor, six more tanks, and some gasoline. Eloy arranged for Luciano, a local fisherman, to take us out early the next morning in a 26-foot *lancha* with a 48-horsepower Yamaha motor and a 25-horsepower spare.

Anticipation ran high among the four of us as we stopped at the only open restaurant in town for a snack and some discussion of the next day's adventure. The owner's son came to our table and asked if we wanted to eat; we said yes. He came back twenty minutes later with four plates of conch steak, cooked in tomato gravy, and some tortillas. Menus are not necessary when there is only one thing to eat.

Since the only hotel was closed, we drove up the beach looking for a place to hang our hammocks. The beach road was covered with blue and red land crabs. We passed thousands, virtually herds of crabs. We found a *palapa*, a structure with no walls, but at least a roof to keep the rain off. It too was full of crabs. Just before dusk I got to meet one closely. A large red one confidently ambled up to my sandal-laden toe and took a taste . . . of the toe, not the sandal. Actually he just pinched me with his claw. I am still wondering why.

Rain showers all night made sleeping a little wet, but not wet enough to dampen our spirits. At 7:10 A.M. we were back in Xcalac with Captain Luciano and a fully loaded *lancha* ready to shove off into some nasty looking squalls. In our excitement, all of us ignored the squalls and refrained from even mentioning them to each other.

The boat was loaded to the hilt, with little room left for us to sit. But the powerful 48 horses pushed us out into the protected waters of the bay. Once we crossed the reef and the rain hit, the waves swelled as we headed into gray clouds so dense they were almost black. Second thoughts? No way! I wanted to get to Banco Chinchorro, but I grabbed my wetsuit and quietly slipped it on. My amigos did the same, for they too knew how much more comfortable they would be in a warm and bouyant wetsuit when lost at sea. My repaired Buoyancy Compensator, or B. C., was also close at hand.

Thirty minutes out into what is normally a two-hour trip we met the first squall. The white-capping seas quickly built to seven feet, with an occasional ten footer. The rain was coming down so hard I could scarcely see forward with my mask on. Soon everyone's teeth were chattering. Amazing to be sweating and hot a few minutes ago and now freezing cold.

Luckily for the boat and for all of us, the seas were coming straight at us. It was uncomfortable, but it was the safest way for a small over-loaded boat. Captain Luciano was earning his pay, for the rain was stinging his face and filling up the boat. He bailed while the compass, a softball size portable model, floated around between his feet. Because no fear showed on his face, I assumed he had done this many times. When I asked him, though, Luciano said, "No, we wait for good weather before we go fishing. You men looked so anxious to go I did not suggest postponing." Pounding onward into the raging squall, we bailed, we shivered, and we never thought of turning back.

Three hours later we found smoother seas as we crossed the western edge of the atoll and saw the sun peeking out. After crossing over three thousand feet of water we could finally see the coral fifteen feet below. There was a mad dash to snorkel, for it was a relief to get in the warmer waters and off the rocking boat.

We found a pretty flat bottom with an occasional coral head. This was not a spectacular reef, but something was different. Was it the fish? Yes, they came closer. Was it the coral? Yes, it was in perfect condition, none broken from thousands of scuba divers. Was it the other creatures? Yes, the lobster and conch were abundant. I let out a whoop. It all now seemed well worth the boat ride.

I grabbed five big conch while Cuba and Fernando speared a couple of fish. Rested from the ride and with the makings of *ceviche* we motored another twenty minutes to Cayo Centro where we set up camp in a small hut on stilts. Having had no breakfast, I was ready for our meal of *ceviche* and peanuts, the same meal we ate for breakfast, lunch, and dinner on each of the next three days.

Cayo Centro is the biggest of the three cays at Banco Chinchorro. Almost a mile long but with no real land, it is solid mangroves and full of mosquitoes. Fishermen had built this group of shacks on stilts fifty yards away from the mangroves so that they could sleep in bug-free peace.

Our hut was about 8 by 10 feet inside, with some erotic art work sketched on the walls. There must be some multi-talented fishermen in these waters. Once we hung up five hammocks, our home looked like a spider web—and felt even more so when we all jumped in for sleep. Everyone was bumped by someone else all night long. Luckily we had a little deck on which to store the compressor, tanks, and diving gear.

After *ceviche* we headed through a gap in the eastern reef to dive the outside of the atoll. Without knowing where a good site would be, we just found water about seventy feet deep and jumped in. Drifting slowly down while clearing my ears, I saw a brain coral head that looked unusual. Upon deeper descent I realized that what had appeared strange to me was large lobster an-

tennae sticking out from every side of this round coral hunk. The eight lobsters with their sixteen antennae looked like spokes on a wagon wheel.

We grabbed one to sweeten up the next *ceviche*, then swam off to find a yellow ray and a gold-spotted moray eel. Moray eels are usually concealed in the coral, with only their heads sticking out. This one was free swimming. Let's feed it, I thought. I got a lobster leg from Fernando, who was holding the grocery bag, and offered it to the moray. He snapped it out of my hand and was soon deep throating two-thirds of the twelve-inch lobster leg. Contorting around every which way, he was not about to turn that leg loose until he got some meat out of it. This lasted for about ten minutes. Finally he gave up and spit it out. I followed the small eel about fifty yards before it went into a hole in the reef.

Forty-two minutes and thirty-six shots of exposed film later I started my ascent. But I was halted immediately by Richard clanging on his tank. Tank-clanging is how one speaks to another underwater. Richard was trying frantically to get my attention, for he and a six-foot nurse shark were on a collision course. Sharks are my favorite, and even without film I eagerly swam toward Richard and the shark.

I noticed it lacked a couple of inches being just as long as Richard. As I swam closer I instinctively put my view-finder to my eye. Wow! As usual, no film for a perfect photo opportunity. We made a shark sandwich. There was Richard . . . two feet . . . shark . . . two feet . . . C.C. What a photo Richard could have had of himself and our friend the shark. Thing is, he thought he did, and on surfacing he was jubilant until he learned I had been out of film. It took Richard a long time to forget that one; maybe he never will. Nice first dive at Banco Chinchorro.

We dove all four sides and the middle of Banco Chinchorro. Although each site was different, they were alike in the same respect as our first snorkel. Untouched. Perfect coral. Lots of friendly fish, conch and lobster.

Back in the hut I was thinking of lobsters as I rubbed my sunburned nose. If I had had a mirror I know I would have seen that it was as red as a flamingo's back—in spite of our being in a rainstorm for half of the day and putting on full-block sunscreen three times. Tomorrow, I thought, I will either stay underwater all day or wear a T-shirt over my face.

I tried to arrange my body in my hammock so as to bump or be bumped by the others as little as possible while I fell asleep listening for the lobster parade. Fernando had told us on the way down that his dad came out here a few years ago and said you could hear the lobsters clicking and bumping into the pilings of these huts.

Wamp! This sound and then the vibration of our temporary home awoke me suddenly. Was that the sound of a big lobster? No, most likely it was a shark after the

conch innards we had dumped under the hut.

The next morning, after more *ceviche* and a boat ride to Cayo Norte, we submerged ourselves over a big sand flat. I saw conch everywhere, but two big southern stingrays caught my fancy first. Two sets of eyes were barely protruding from the sand. As I approached, the stingrays arose with massive wings, causing a miniature snowstorm of sand. A gentle flap, then a glide, another flap, and they were effortlessly out-distancing me, even though I kicked as hard and moved as fast as my rocket fins would propel me.

I followed them across the sand flat over a coral hill, then another flat and another hill. One of the rays finally settled on the third sand flat as the other swam on. When I finally came within ten feet of him, the big ray gave a shimmy and a slight wiggle and was 50 percent covered with sand. I approached slowly, taking a few photos. When I was only one foot away, I realized the ray was almost as long as I. I lay on the sand bottom, taking photos with my super wide underwater lens and admiring this beautiful creature of the deep. After I finished my work I rose quietly, without causing a sandstorm, and saw that the other ray had sneaked up behind me and settled into the sand to watch me photograph his kindred.

I backtracked to the conch area. Without the stingrays to distract me, I stood on the bottom and started counting. I was standing erect on a sand bottom about thirty feet below the surface. Moving slowly and counting carefully, I made a 360-degree turn. There were 186 queen conch in my limited underwater vision. What was even more exciting was that every one of them had both eyes and mouth out moving and feeding. Heading for the surface I was struck by the multitude of tracks behind each shell; they reminded me of dune buggy tracks across the southern California dunes.

Other highlights of diving here were a gorgeous garden of yellow tube sponges with schools of mangrove snappers weaving in and out of them. There were also some of the biggest barrel sponges I have ever seen. One was so wide that Refrigerator Perry of the Chicago Bears could have gotten in it for a bath, and another was so tall it topped my six-feet-plus-flipper length by another six inches.

Back at the hut Cuba, who was getting paid not only to watch bubbles but also to fill tanks, was setting up the rusty compressor Eloy had loaned us. Let me tell you, of all the jobs the boat boys back at the dive shop do, filling tanks is the least liked, even with a decent compressor. With this noisy hunk of junk, it took one hour and twenty minutes to put 2,400 psi into each tank.

It did not surprise me when I heard the compressor shut off. Cuba came running in, jumped into his hammock, and said, "*Chubasco!* Ricardo," and quickly faked sleep. Through the cracks in our hut I could see one small cloud pass over in the silvery moonlight and would be willing to bet my cameras that not more than seven drops of rain hit our hut. But hey, we hadn't wanted to listen to that compressor all night anyway.

The next day we nicknamed Cuba "Chuba." That's short for *chubasco*, the Spanish word for a squall or rain shower. We headed south to dive near Cayo Lobos. Here the water was clearer than it had been for any previous dive, perhaps because we were near the deepest drop off. We went in on the outside reef near a tanker that had wrecked against the reef.

Underwater the massive wreck harbored big grouper and snapper in the bent and barnacle-encrusted steel hideouts of its bilge. Above that swam a school of ten thousand large sardines. They were so near the water's surface they were almost transparent in the beams of sunlight. Soon I swam down the reef, stopping briefly to tickle a big lobster out of a crack in the coral so I could watch him walk along the reef to find another suitable hole to back into.

As I swam along I noticed a difference between this and the other windward reefs I have explored in Belize and Honduras. This one had perpendicular ridges coming off the breaking reef, with canyons between each. From a bottom of forty feet, these thirty-foot-wide ridges come out like fingers from the mother reef. I swam up to the top of one and decided I was viewing the prettiest little hunk of coral I had ever seen.

I have heard people say, "Your aquarium is as pretty as a coral reef." But I would reverse that, because my first thought as I viewed this miniature ecosystem was, "This is as pretty as an aquarium." It was so perfect, like someone had glued every little creature into its ideal position. I was only four feet from the surface of the water as the sun shone through to light up the delicate leaves of lettuce coral and the encompassing fire coral that surrounded a centerpiece of elkhorn with its golden yellows gleaming in the sparkling blue water. Dancing around this marvelous scene was a rainbow of tropical fish, mostly juveniles.

Soon sad times were upon us, for we had very little gas and water left, no air, no peanuts, and no *ceviche* fixings. We had to head home. And how different a ride home can be. The sea was smooth enough to read a book, and it was so hot that we had to stop halfway home and take a swim. With my mask on, I looked down into three thousand feet of blue water, musing that nothing defines the color better than gazing down in the deep waters of an open ocean.

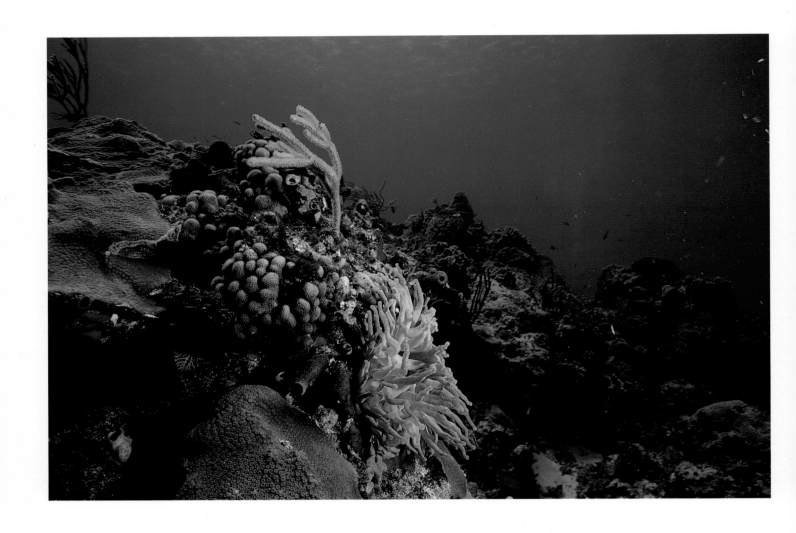

For scuba-diving the clearest water on the peninsula is at Cozumel and Banco Chinchorro. Palencar Reef (above), with its colorful corals and other marine life, is a famous dive site. Near a shipwreck on Banco Chinchorro part of a school of ten thousand small fish swim by (right).

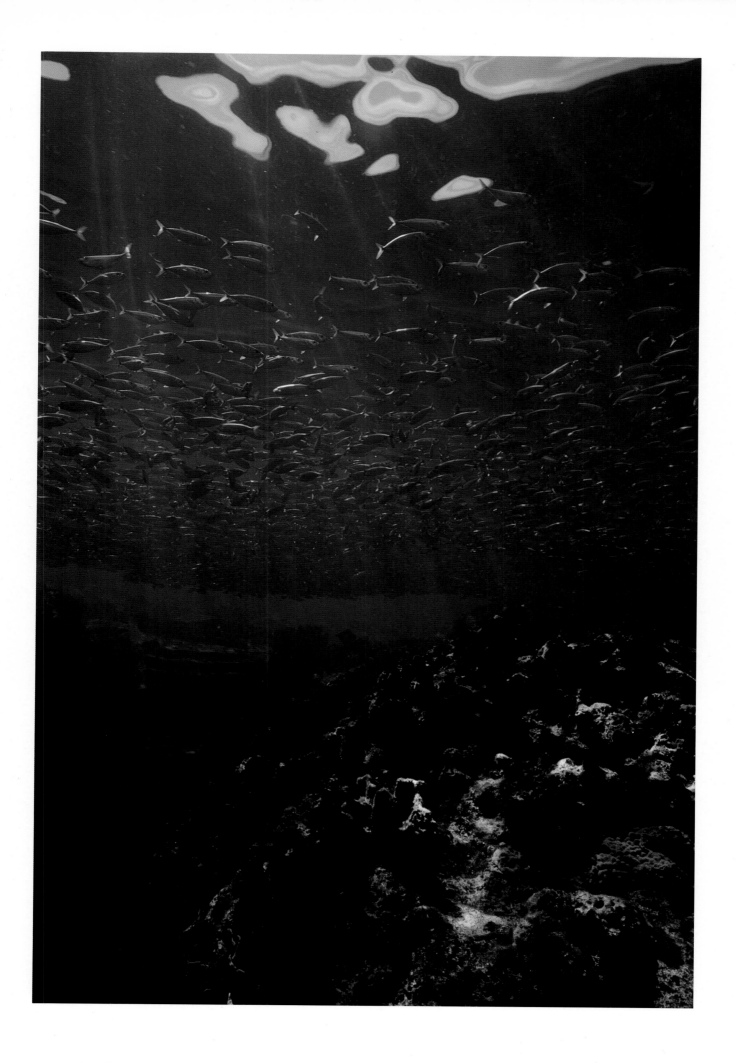

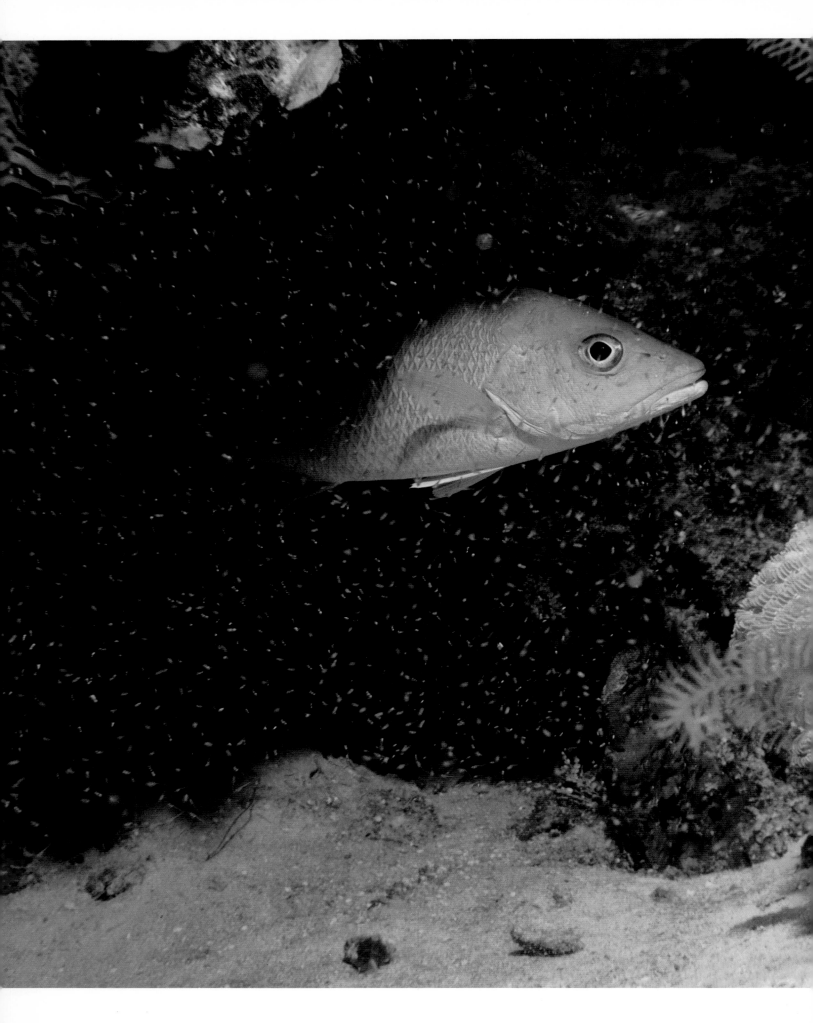

A school of small fry hover around a grey snapper resting under a reef ledge.

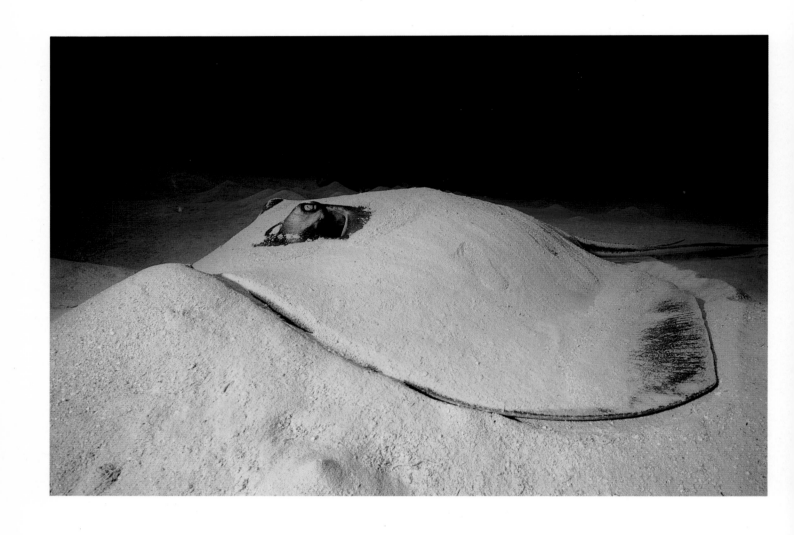

A southern stingray is partially camouflaged after shuffling into the sand. Another shuffle or two, and only his eyes will show.

One of the large basket sponges in Banco Chinchorro.

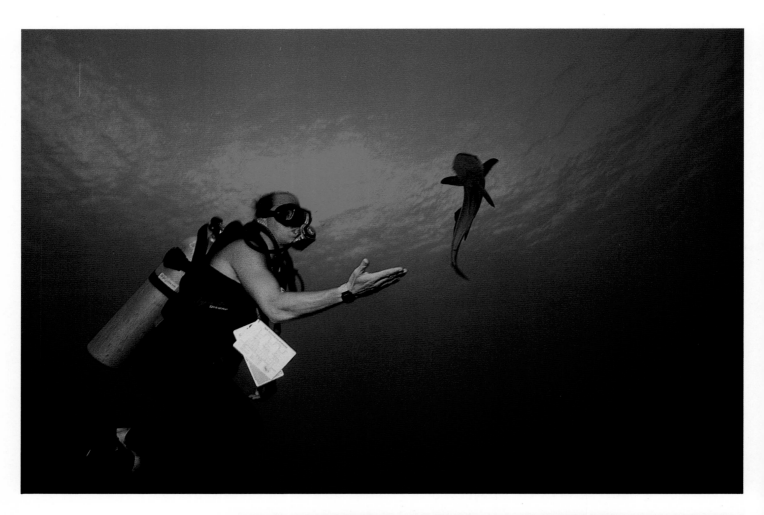

Richard Ribb plays with a shark sucker which twice tried to attach itself to his head (above left). *Long-spine squirrelfish* (left). *Mangrove roots at sunset* (above).

The bromeliad Tillandsia brachycaulos *is a drab brownish green most of the year, but like Cinderella it becomes a brilliant beauty when it flowers.*

SIAN KA'AN

Blue also evokes sky, and I left Banco Chinchorro to visit "the beginning of the sky," which translates into Mayan as Sian Ka'an. The biosphere reserve Sian Ka'an begins only fifty miles north of Xcalac and goes northward until Tulum. This 1.2-million-acre refuge contains such diverse habitats as tropical forests, wetlands, marshes, estuarial bays, beaches, and coral reefs.

Unlike Alacrán and Banco Chinchorro, whose only protection is their distance from the mainland, Sian Ka'an was set aside by presidential decree on January 20, 1986. It is not only Mexico's largest refuge, but also one of the most important, for its varied habitats harbor a multitude of wildlife and other natural resources.

Sian Ka'an is trying a new concept in management plans to help protect the three hundred plus bird species, one thousand plus plants, and such rare animals as the jaguar, crocodile, tapir, and manatee. This plan divides the refuge into three zones: first, an isolated core zone for complete wilderness protection; second, a gathering zone where natives can continue the Maya traditions of using the plants and animals in their daily lives; and finally, a buffer zone. This was most interesting to me, for the plan allows uses such as agriculture, fishing, cattle-raising, and tourism; but the government and Amigos de Sian Ka'an are taking an active role in working with the eight hundred local inhabitants to make sure these activities blend in with the environment rather than overtaking it.

The staff of Amigos gave me my first look at the reserve. Amigos de Sian Ka'an was formed five months after the president's decree to assist this productive area in getting off to a good start. We began our journey at Chunyaxché and toured the ruin Muyil. The ancient jungle trails were nice here. Vines, bromeliads, and flowers blocked out most of the sun. On the forest floor, red-throated ant tanagers were acting true to their name. I photographed them hopping about eating ants.

At the end of the trail we boarded a boat to cross two lagoons and then enter a canal that had been carved out of the marsh by the ancient Maya. The water was clear, about five feet deep, and overgrown with red mangroves on each bank. Fish darted in and out of their tangled roots as we passed. These were stunted mangroves, only two feet high—so different from the forty-foot trees at Celestún, Isla Contoy, and Laguna Nichupte. We passed a single small ruin halfway across the mangrove marsh, perhaps a vacation home or a way-house for a Maya enroute to the sea.

The canal ended in Laguna Boca Paila, a very good bonefishing area with an outlet to the Caribbean Sea. A van was waiting for us there on a hook-shaped sandy spit that divides the clear green waters of the bay from the blue of the sea.

A rattling ride in the Volkswagen van brought us to Punta Allen and the town of Colonel Tavier Rojo Gomez. After finding that the cinder-block building where we would stay the night was locked, we walked around the corner to the house of Victor Barrera, a lobster fisherman, to see a place set for all eight of us at his table. We opened a few beers and sat down; immediately a plate of steaming hot lobster, beans, and rice was put before us. I can only guess that a parrot down the road flew ahead to announce our arrival.

The next morning we took a boat tour of the barrier reef. I snorkeled, seeing quite a few lobster and some nice reef, then we boated in to the bay. The islands we passed were full of brown pelicans and magnificent frigate birds in the early stages of nest-building. We were told wood storks, roseate spoonbills, and various herons would join them later.

After going back to Victor's house for breakfast—lobster omelets, of course—we took a boat over to the interior road to meet another van. Here I saw stacks of logs and 8-by-8-foot concrete pads. Lobster traps. Now I began to realize why we were eating so well. Colonel Gomez is part of a lobster cooperative.

The two bays just south of here, I learned, are the largest lobster staging and growing grounds on Mexico's east coast. These bays, with all their mangrove roots and sea grasses, are a perfect place for little lobster to grow up in. I decided right then and there to come back for July 15, the opening of lobster season. That's prime time because even though the season is open eight months a year, the majority of the ninety tons of tails are caught during the first few weeks of the season.

Six months later Joann Andrews' son David and I were slapping a few mosquitoes as Don Dolo put the outboard on his *lancha*. David, an eighteen-year-old Tulane University student, had recently learned to dive at Akumal, so he could help me with my underwater cameras. A native Yucatecan with an interest in photography and wildlife, he was great to have along. We

spent the last night in one of Dolo's *palapas* at Rancho Retiro listening to his description of lobster-fishing. Rancho Retiro is a laid-back place to stay and eat that is located about ten miles north of Punta Allen. A great place to go if you really want to get away from the big resorts for a few days. You have got to like fish and lobster, though, because that is all that's served.

The traps were the same as those I saw six months ago. Eight logs, log-cabin style, are attached to both sides of the 8-by-8-foot concrete pad. Some fishermen still use a pad of solid logs. These are then put in the bay a couple of hundred yards apart. Each fisherman in the cooperative has his own area of the bay. The interesting thing about it is that there is no trap; it's only a shelter area that the lobsters can go to and from as they please.

Dolo said, "The motor is ready; let's go see if any lobster are under my traps." We motored down to the cooperative and picked up Guadalupe and Arquedo, two fishing companions. At the first trap I jumped in, excited to see a few lobsters gathered under the trap. The water was five feet deep and a chalky green color, with visibility extending about fifteen feet. I took a breath, surface-dived to the bottom, and peered under the trap. Wow! One, two, five, ten. . . . I lost count at thirty. This was not just a small gathering; this was a lobster sock hop. Guadalupe swam over with a milk crate and propped the trap up about two feet. All the lobsters backed up to the low edge, some sticking their tails out.

In the next seven minutes I saw two professionals at work. They used a three-foot stick that was sharpened on one end and had a large fish hook on the other. They would hook a lobster, grasp it in a gloved hand, kill it with the pointed end of the stick, and then drop it. After seven minutes they carried thirty-three lobsters back to the boat.

I watched a couple sneak off into the sea grass and counted six small ones the fishermen had left under the trap; that made a total of forty-one under that 8-by-8 piece of concrete. This pattern ran the same for the next three days.

At the next trap I peered under, a bull red snapper with a fat belly charged out. Later in the day I saw a small nurse shark sleeping under a trap. David and I took pictures of each other petting its head. Dolo told me dolphins sometimes turn the traps over with their noses and eat the lobster. That's why the traps have legs on the top and the bottom. The dolphin may get a few lobster, but at least he will reset the trap.

On most of the dives near the lobster traps, I came up with little leech-like blood-sucking bugs on me. At first I thought the sea grass was brushing me and making me itch. Then I started noticing the bugs stuck to my arms, legs, stomach. Good God, crazy underwater mosquitoes; there is no relief anywhere. Once I knew

what they were I would brush them off as soon as they bit, but some of these guys were persistent. I would pull one off underwater and in less than a second he would make a U-turn and bite me again. I smashed the little devils after that.

At the end of three days we had averaged forty-five kilos of tails, or just about three hundred lobsters a day. Each day I went with Dolo to weigh and sell the catch at the cooperative. At about three in the afternoon the majority of the one hundred plus lobster men would be in line with a similar size catch.

You have never seen so many lobsters in your life. Officials checked size and quality. Lobsters with tails less than five inches are illegal to take. Biologists doing the baywide study checked the lobsters for parasites and took weights and the number caught. Then the tails were soaked and iced down in a truck that zoomed off to Cancun as soon as it was full.

At the end of the third day Dolo motored back to Rancho Retiro on the outside reef. David and I had brought along a few tanks. Not needing them in the bay, we decided we wanted to see the deep reef and burn up a little air. We chose to dive the reef in front of Retiro. After an hour and a half boat ride we arrived there about dusk. My Spanish was nonexistent at this time, so David had to translate our needs. We wanted a good reef, about sixty feet deep, on the edge of a drop off. Dolo was to follow our bubbles and look for us to surface in forty minutes.

Dolo is about sixty years old and very experienced in this area. He knew the island, bays, and shallow reefs perfectly. But since he was not a diver it was hard to get across to him exactly what we wanted. I was frustrated by my inability to communicate. I peered over the side of the boat to try to see a good reef but four-foot waves and a lack of light made it impossible to see the bottom.

Dolo said it was twenty meters deep here, so we rolled overboard and checked our gear. I told David to follow me. My ears hurt, the visibility was bad, and I was disappointed, especially after a flat, uninteresting bottom came into view.

I swam hard, looking for anything of interest, and luckily the bottom started developing a little hilly terrain. A fifteen-pound grouper brightened my outlook, then three more. Now we were in ridges that were ten feet tall. I crossed another and saw a nurse shark come out of a cave next to a sand flat. As I got closer I saw a five-foot green moray eel lying on the sand in the cave. He was a fat one. I stuck my head in the cave for a photograph, but my snorkel knocked some silt off the ceiling. Since I do not usually wear my snorkel on my mask, this would not have happened ordinarily. I ripped my snorkel off and threw it out of the cave, then waited for the silt to clear. It cleared somewhat, but not enough for a good picture. Backing out of the

cave I noticed lobster in three cracks, then another two in small holes above the cave. Swimming on down the ridge we spotted two large lobster out in the open, antenna to antenna. What they were doing I do not know. But they looked good enough for supper, so I swam toward them. They sensed my presence and retired quickly into the same hole.

David's eyes got awfully wide as I reached into the hole, all the way up to my shoulder, to bring both of the beauties out. Their tails were four times the size of the ones we had caught in the bay. David stuffed one in his B. C. pocket, then had to take the tail off the other to fit it in.

Forty minutes flew by, because this turned out to be a good dive after all. We swam back to our starting place and surfaced. No Dolo. The sun was just dropping beyond the palm trees. We fully inflated our B. C.'s and bounced with a kick to the top of the waves, trying to get a better view. Ten minutes later we finally saw Dolo far out to sea. We waved, whistled, and yelled. No response. Only four times could we see the boat, because either it or the two of us would be in the trough of the waves.

I quickly realized why we were in this predicament. Dolo does not have any experience following bubbles. Being an older man with poor eyesight, he wasn't helped much by the approaching darkness and the big waves hiding us. We were basically adrift at sea. I remembered my strobe, and got David to hold it as high as he could. When he was at the pinnacle of a wave I flashed it. I flashed till the battery ran down. Still no Dolo.

Now I realized that our worst problem might be panic. We were not in real bad trouble, not yet anyway. Shore was one mile away across the current and maybe two

miles with it, if we swam to the other side of the bay. It was getting dark and there were no lights on shore here. I realized that if David panicked we were in big trouble, because I had just used my last bit of air to fill my B. C., which had a leak, for the tenth time.

I looked at David and told him there was no more time to wait for Dolo. We would have to swim to shore. The eyes of this young man on his eighth dive showed no signs of panic. Still, I elected to keep the eight-foot shark that was circling us a secret as we swam off.

We had a camera, big strobe, two lobsters, and one pair of gloves. We had no air, a leaky B. C., and a long way to swim across the current to an iron shore in the surf. There was the option of dropping weight belts and cameras, but I was not about to do that until it was absolutely necessary. It took us an hour, but we made it. By sharing the gloves and walking backwards in the surf we escaped any major coral cuts. We were tired and had a few nicks from coral, but those big lobsters at dinner, cooked up by a relieved Dolo, rekindled our energy. I was proud of David for going from a novice diver to a seasoned veteran in just one dive.

Back to my tour with the Amigos group. On our way out through the interior of the reserve we stopped at an experimental farm where a Maya family is showing that it's possible to live off a small-plot garden with compost, other fertilizers, and irrigation, thus foregoing the need to practice slash-and-burn-type agriculture.

We also saw a jabiru on its massive nest in the top of a dead tree. This white stork has a red collar and a black head and beak; it stands four feet. It was quite a treat to see one of the rarest birds in the Yucatán. Another rare creature is the jaguar, and I made two expeditions to Calakmul in search of one.

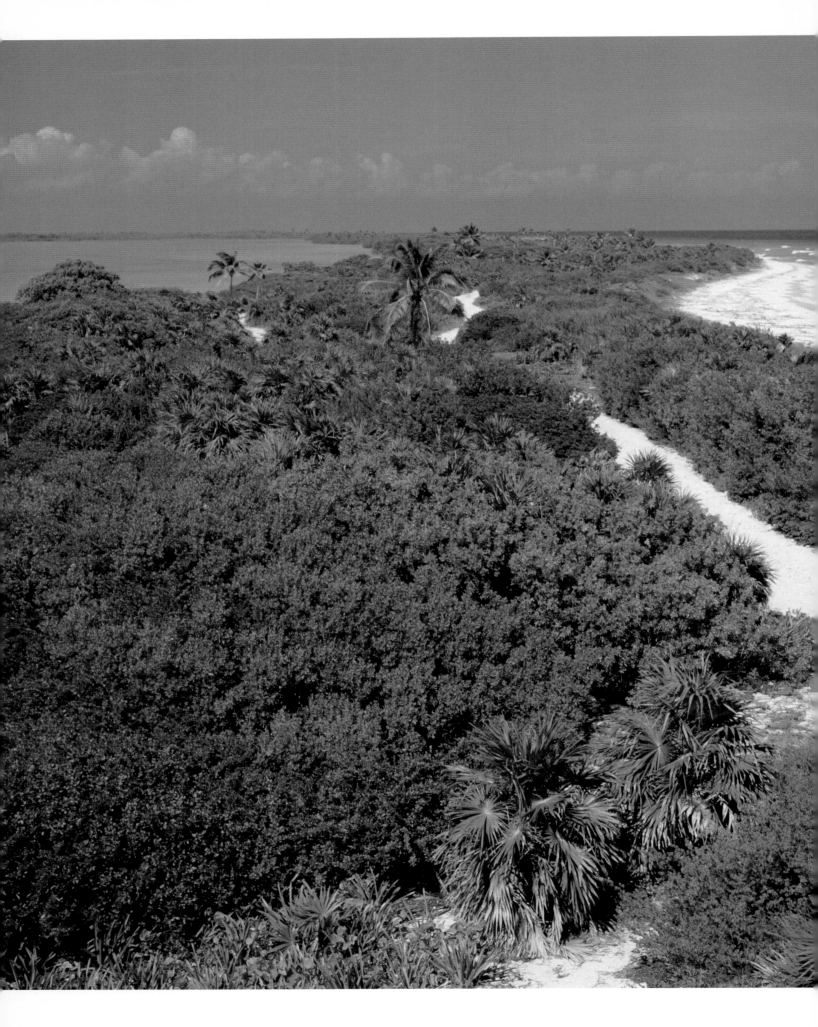

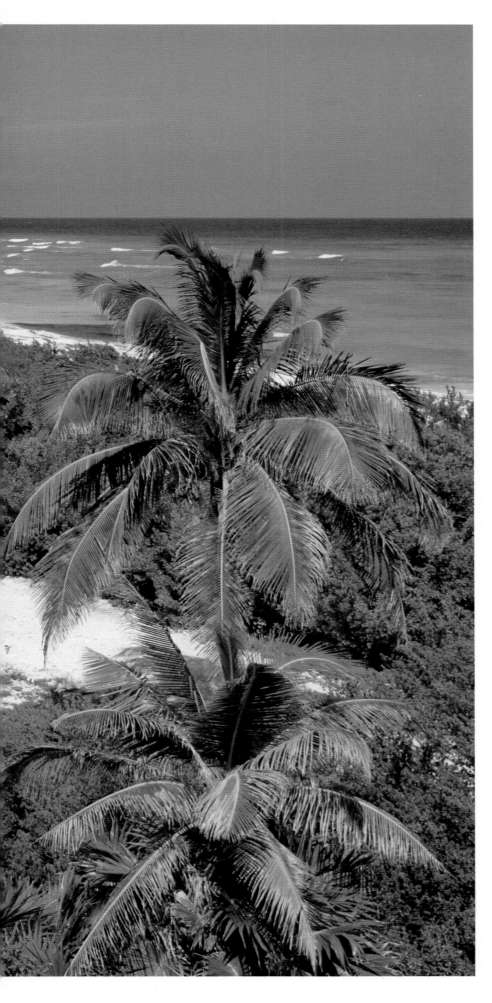

Sian Ka'an has the majority of Quitana Roo's undistributed beaches. This is an island just north of Punta Allen. Note the habitats of a barrier island bay, mangroves, dunes covered with shrubs, beach, surf, and deep blue. An aerial view of the same (overleaf).

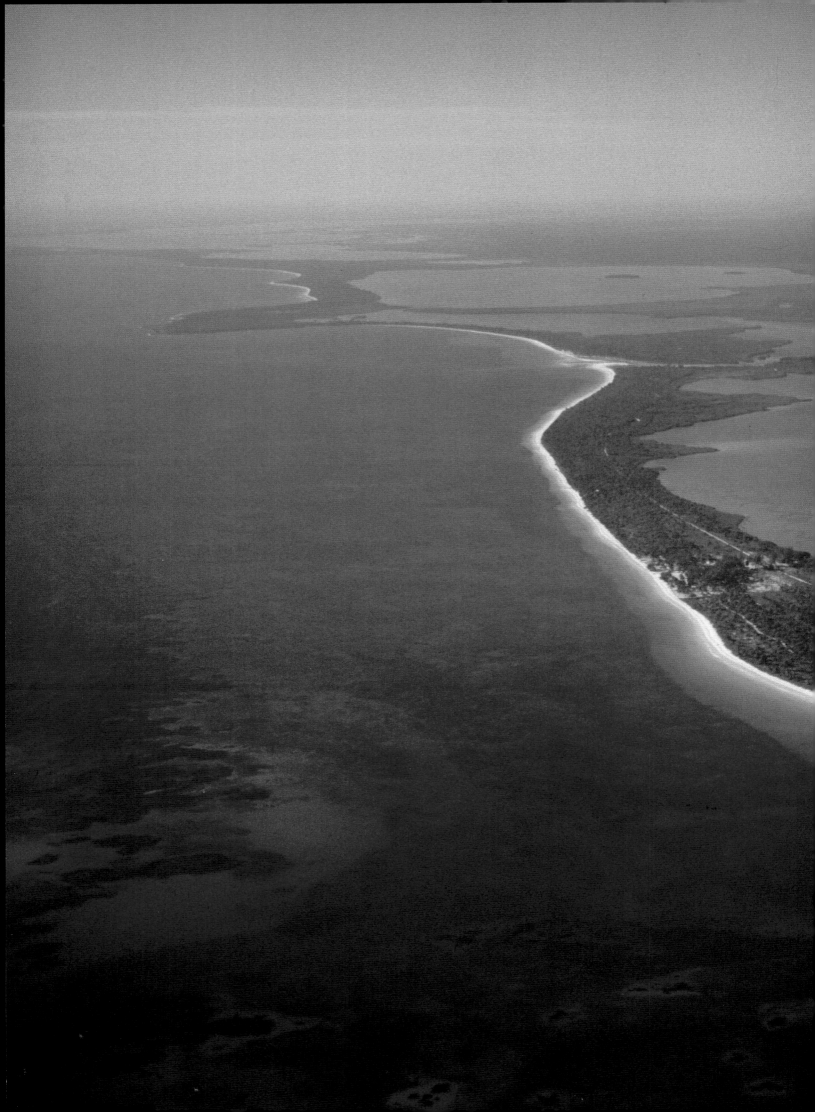

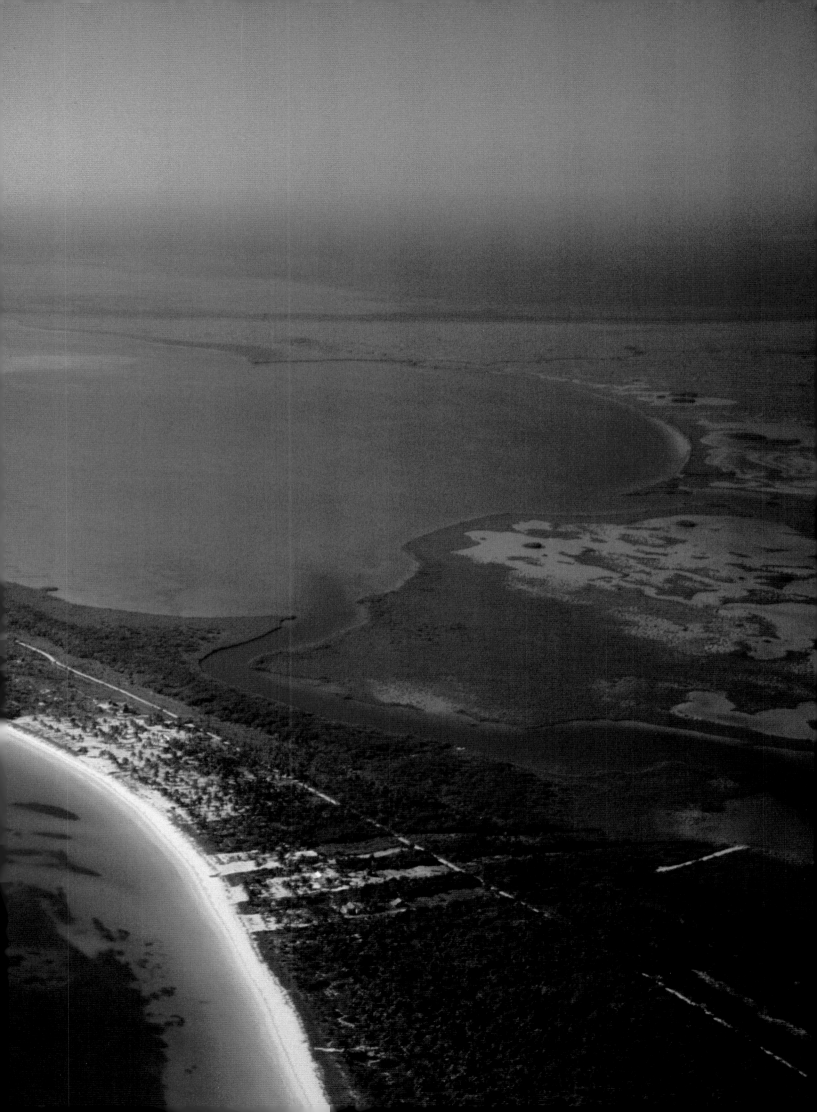

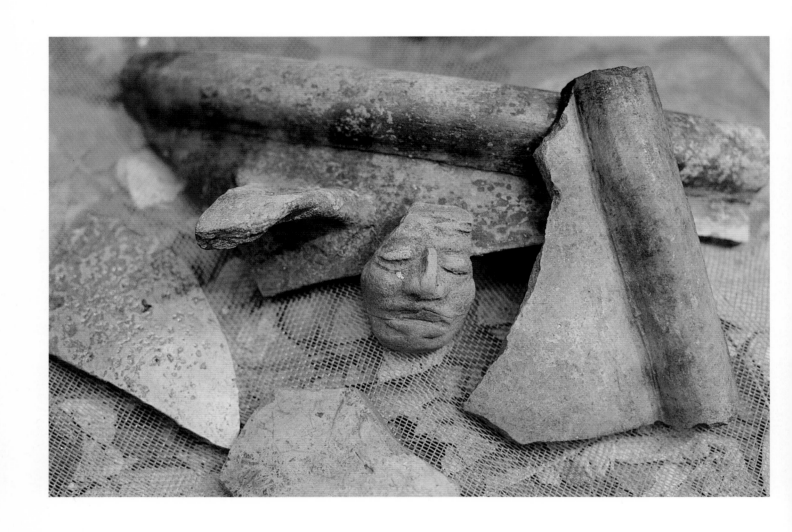

Pot sherds and a decorated face, probably from an incensario (above), were found in a test pit at the ruin Muyil by archeologist Elia del Carmen Trejo (Mexican National Institute of Anthropology and History) and Walter Witschey, head of a Tulane University dig (right). Muyil is one of the many ruins within the boundaries of the Sian Ka'an Biosphere Reserve.

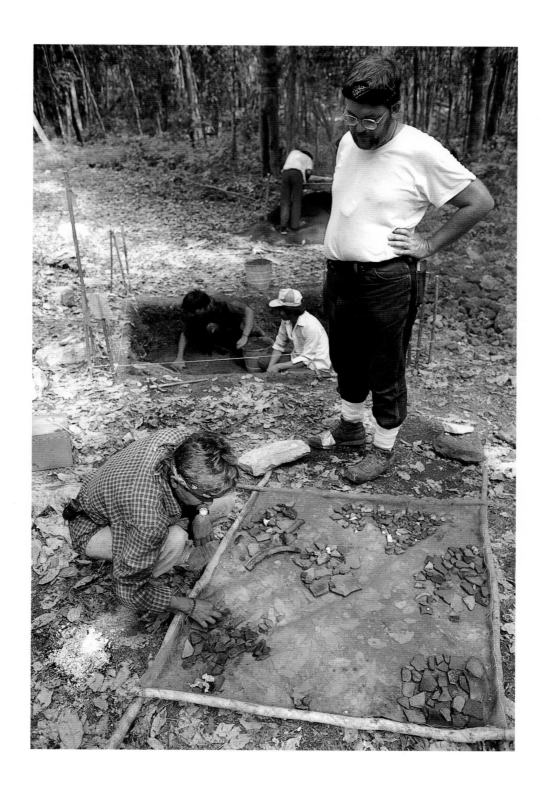

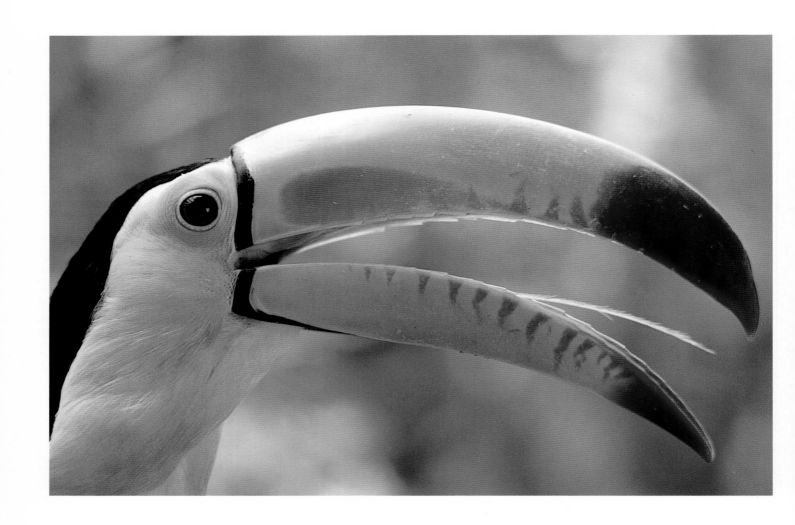

Known as the fruit loop bird to many American children, the keel-billed toucan symbolizes the tropical forest more than any other Yucatecan bird (above). It eats fruit, unlike the red-throated ant tanager that searches the forest floor for ants (right).

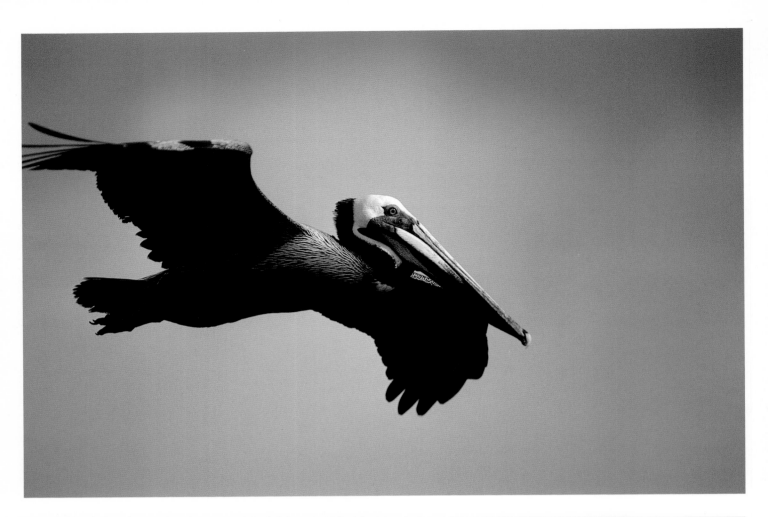

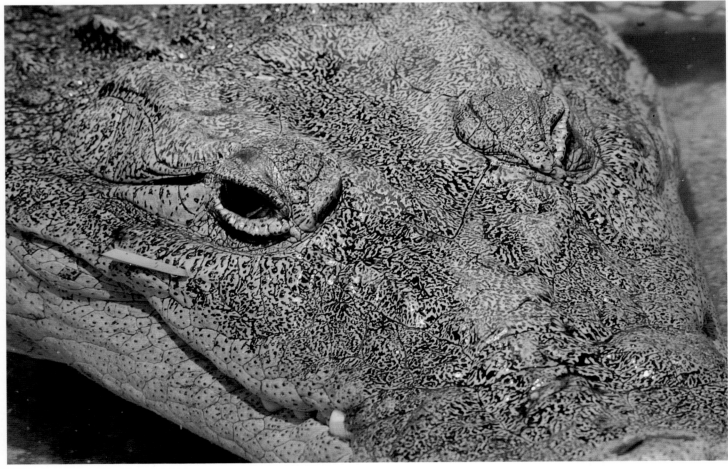

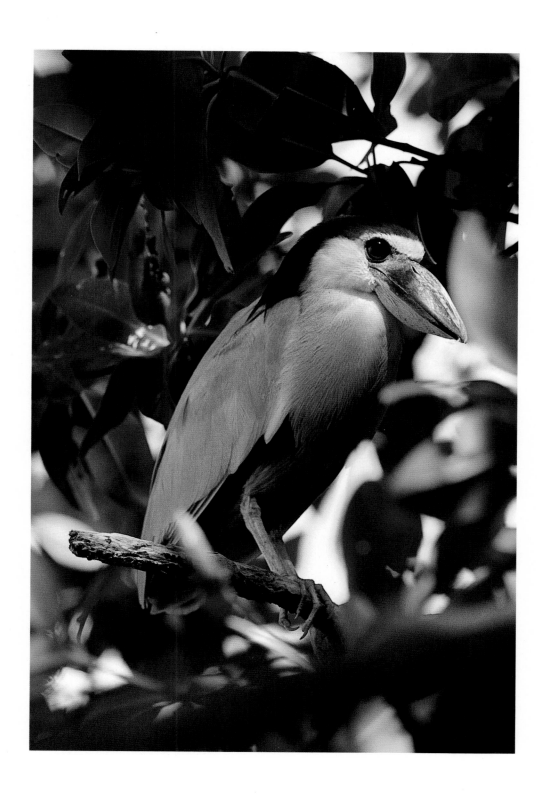

Brown pelicans (top left), *crocodiles* (bottom left), *and boat-billed herons* (above) *are among the residents of the coastal zone of Sian Ka'an as seen on page 44.*

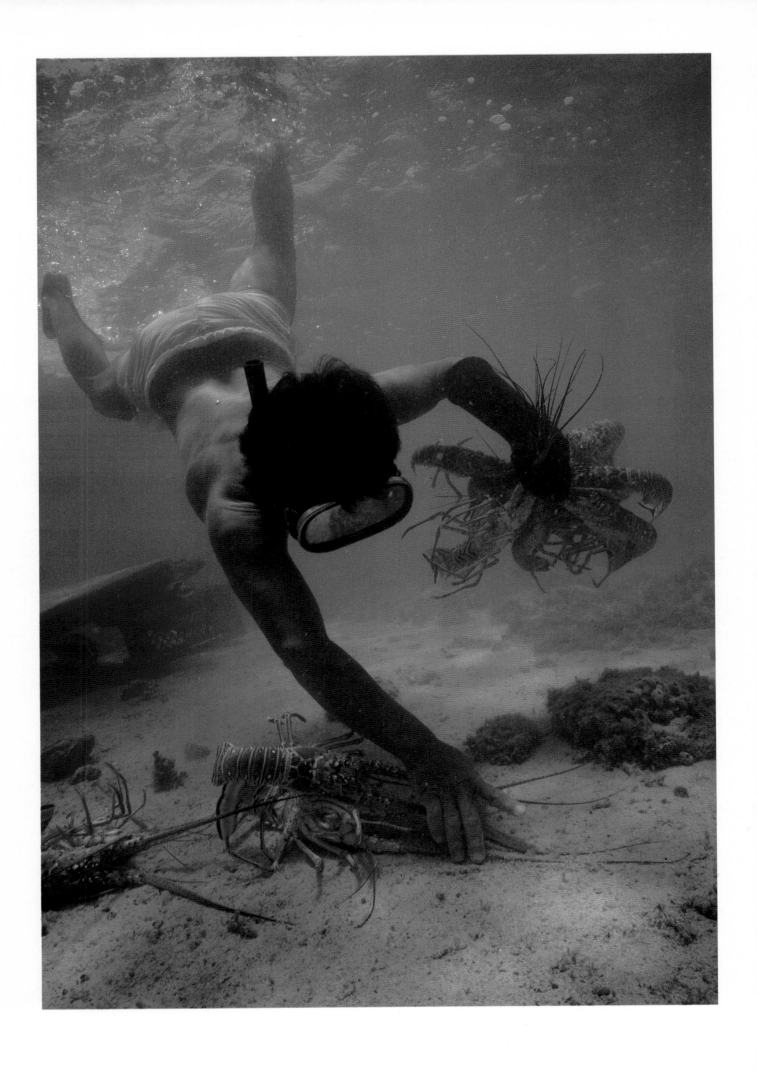

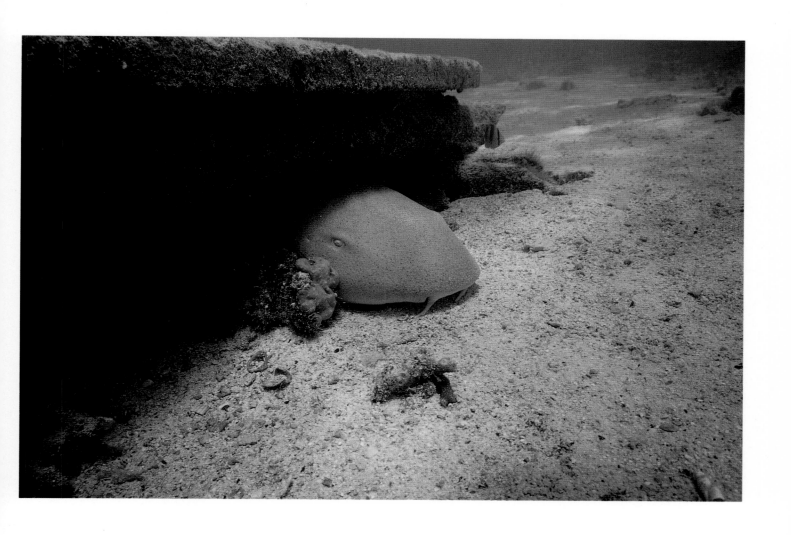

Lobster table traps such as this one (above), *with a resting nurse shark underneath, are used by Punta Allen lobster cooperative fishermen to catch the tasty crustaceans. Guadalupe picks up twelve lobsters he has just snagged under one of his traps* (left).

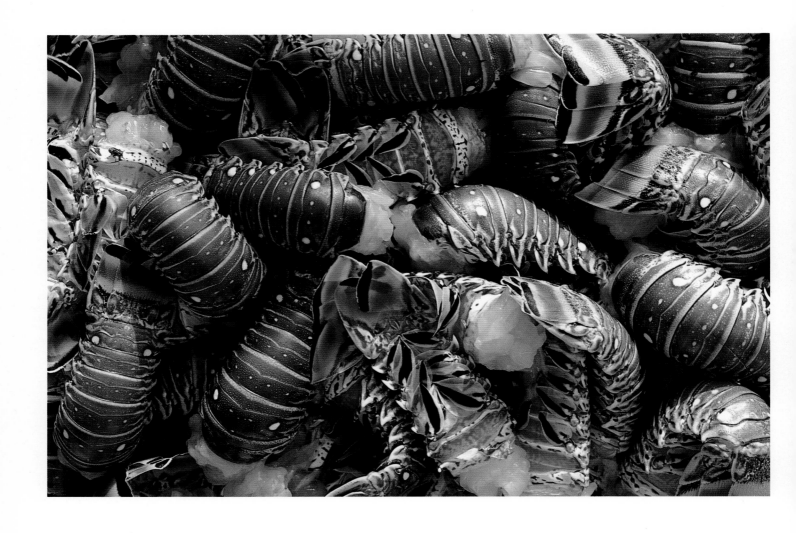

In the first week of the season, a day's haul of lobster easily amounts to forty-five kilos of tail (above). A hard but rewarding day's work for fisherman Arguedo (right).

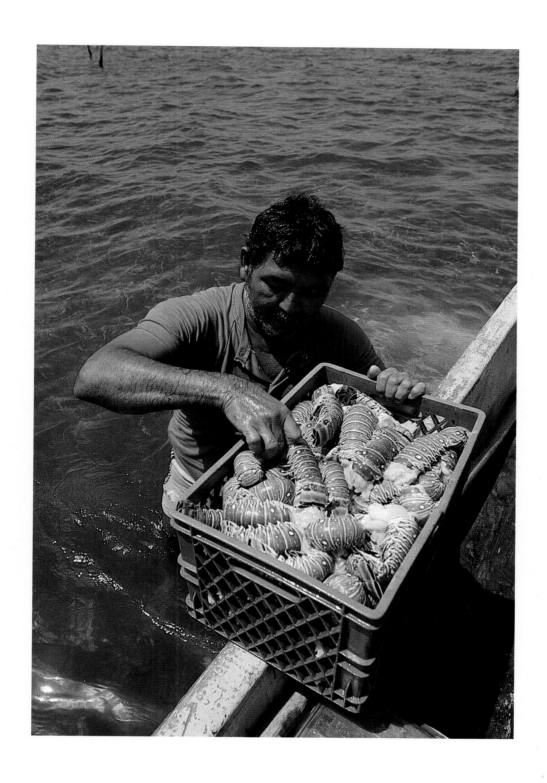

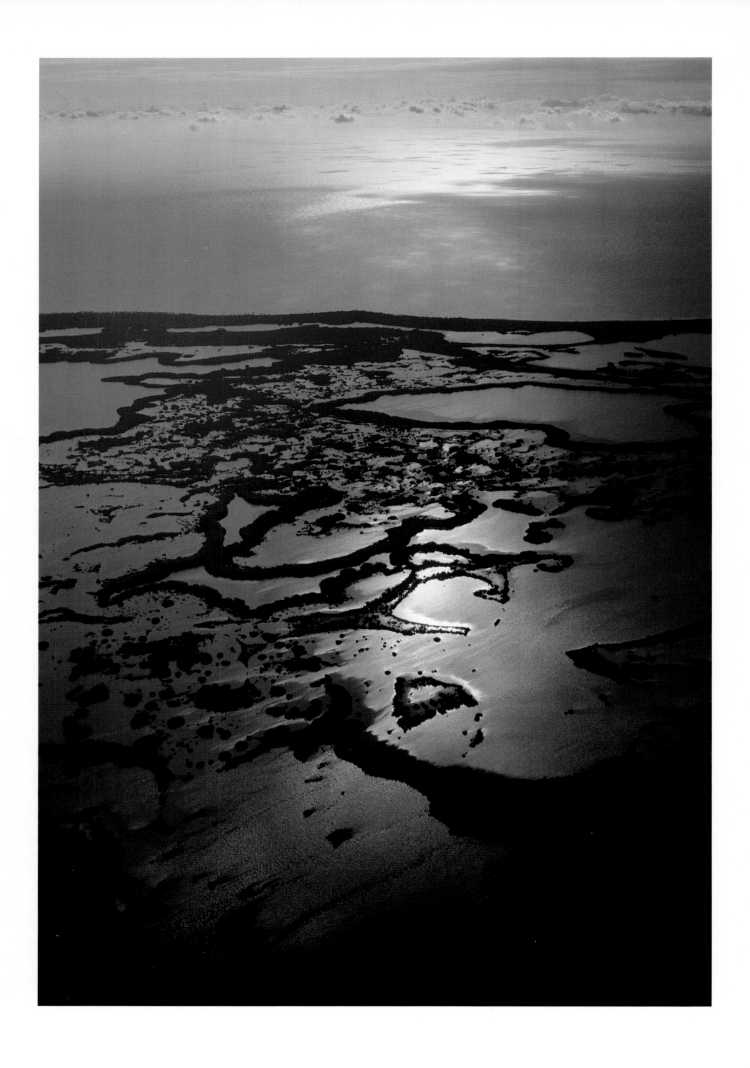

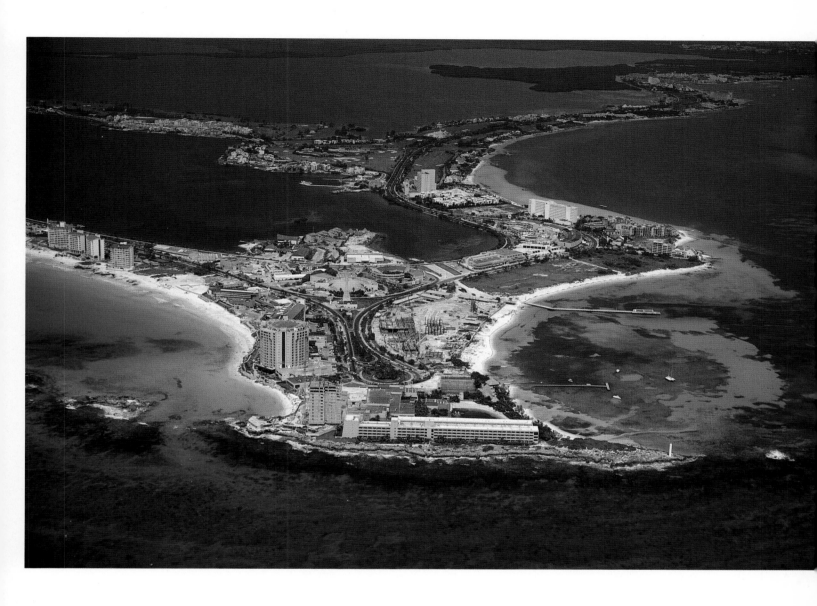

Developmental differences are obvious between Cancun (above) and Ascension Bay (left). Mexico is fortunate to have both a world-class biosphere reserve and a resort. Care should be taken to maintain a balance.

The northern boundary of Sian Ka'an is Tulum, a beautiful Maya city on the Caribbean coast. It is one of the most frequently visited archeological sites in Mexico (overleaf).

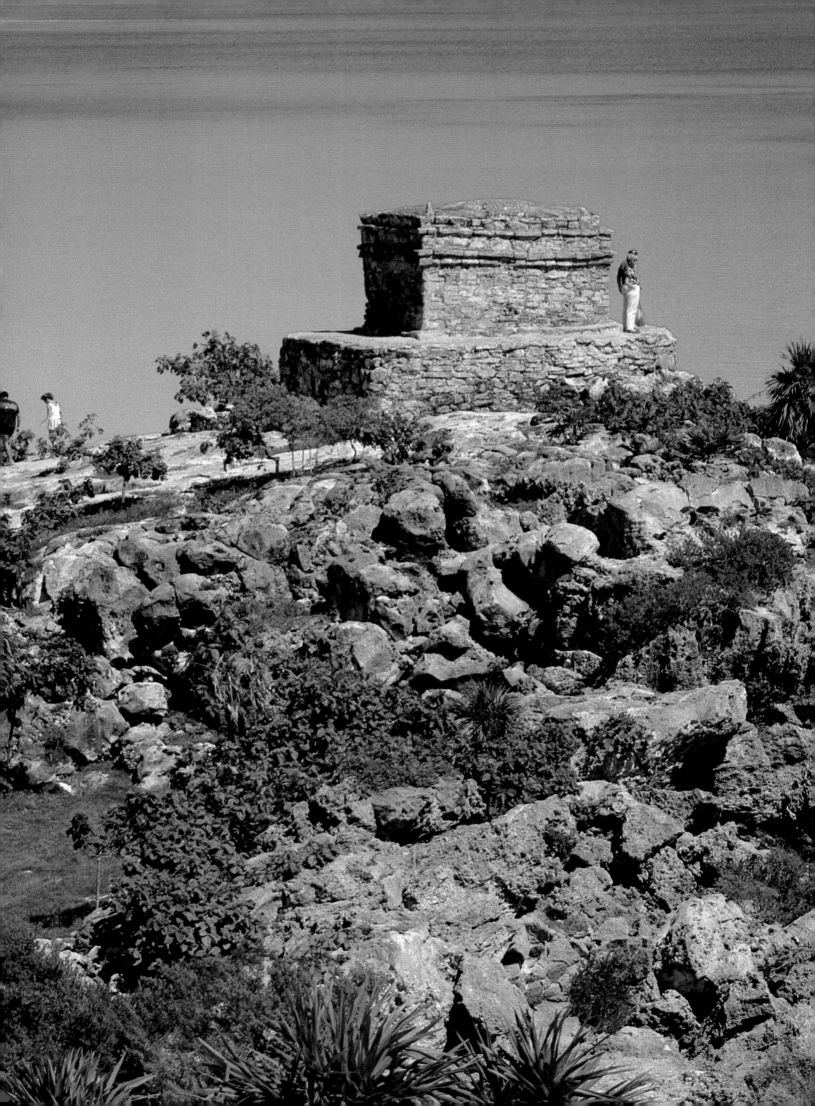

Jungle vegetation has claimed the pyramid at Calakmul, which is tall enough to enable one to see the ruins of Mirador in Guatemala.

CALAKMUL

Calakmul is a large tract of jungle that many Yucatecans want to set aside as a biosphere reserve similar to Sian Ka'an. The area is pretty remote, lying south of highway 186 just about halfway between Chetumal and Escárcega. It is in the state of Campeche and it got its name from the ruin Calakmul.

This vast tract of deciduous rain forest is on the top of the list of areas to be preserved by the Yucatán branch of ProNatura. Joann Andrews is the local representative for the state of Yucatán and knows as much about this area as anybody. I was lucky to get to go in with her twice. I first met Joann in the Mérida airport at 12:45 A.M., just four hours and fifteen minutes before she launched our expedition to Calakmul. It seemed like I already knew her, for everyone else did. I would be talking to someone about jaguars and they would tell me I needed to meet Joann Andrews. It did not matter where I was in the Yucatán, and even a few places in the states, if I mentioned studying the natural history of the Yucatán Peninsula, everyone told me that I needed to meet Joann Andrews.

The purpose of her expedition to Calakmul was to develop a data base in different areas of natural history. Little was known about the plants and animals of Calakmul, and the information was necessary if the president was ever to set this area aside. Besides our group of bird and plant experts who planned to stay for a week, Joann had gotten the director of the Secretary of Urban Development and Ecology (SEDUE) in Campeche and five of his men to come down for a few days. His crew consisted of biologists and archeologists. Ours was B. J. Rose and Robert Singleton, to census the birds, and Joann Andrews, along with her Maya helpers Luciano and Transito Varguez, to collect the plants. Luz and Trans were the first Mayas I really got to know, and I was impressed. Both knew all about the plant and animal life of the Yucatán Peninsula, mainly from practical uses of the flora and fauna in their home village. Joann had added to their knowledge by teaching them the scientific names of the orchids native to the peninsula. I was particularly charmed by their positive attitudes and their ability to have fun with the smallest things or ideas.

By 1 P.M. the next day we had turned off the paved road and started our venture into the forest. Even though this was March, very much the dry season, the road was supposed to be hellish. For the first seven kilometers it was a good gravel road. Just as I was beginning to think they had been teasing me about the rough trip, the road closed up. The gravel ended and vegetation completely covered the road, or, more accurately put, jeep trail. No, I would not even say it was a jeep trail, since it took us seven hours and ten minutes to go sixty-two kilometers. This was absolutely the hottest, most bone-rattling experience I have had.

It was a relief to arrive at the archeology camp near the ruins where several *palapas* and a cooking hut would serve as our base. No archeologists were in camp at this time. Only the four guards who stay in for forty-five-day shifts to guard the ruins were here. Not being used to a hammock yet, I slept nude on an ancient cot and accepted the wrath of the mosquitoes as it was too hot to set up my tent or use a sheet.

Hot and ravaged by mosquitoes, I joined the crew the next morning to climb up the tallest pyramid. We wanted an overview of the jungle. On the way up the overgrown structure, we flushed a group of spider monkeys. On top, what a view! Thirty-six kilometers south we could see the pyramid at Mirador protruding out of the jungle. It is the largest structure of the entire Maya realm. A vast expanse of jungle reached out in all four directions—much farther than we could see. I was excited to see more of the vast forest. Four Yucatán parrots squawked as they flew by, bright red patches flashing from the tops of their green wings. These and the chachalaca are among the noisiest birds in the jungle.

We took a quick tour of the ruins before starting our natural history work. Calakmul is quite impressive. There are two very tall pyramids and a fairly large third one. The palace was a beautiful building and here I got to see my first Maya bathroom, complete with sloping floors and drains that led to the outside.

Calakmul was discovered December 29, 1931, by Cyrus Lundell. It is thought to be one of four regional centers in the Maya realm. Joann showed me a toppled-over stelae and told me that more of these carved monuments have been found here than in any other ruin site.

B. J. and Robert were already chalking up the birds. They tabulated almost a hundred species, and we know there are a lot more out there. Most interesting to me was the common potoo which Luz and I laughed about for the entire week. (That story cannot be told in public.) The keel-billed toucan was fairly abundant. It is the epitome of a tropical bird, with its exotic colors and

large down-curved bill that is almost as big as its body. I also liked the lineated woodpecker. Its red crest and white bill made me think of the extinct ivory-billed woodpecker back home.

We heard singing quail and mottled wood owls and saw the ocellated turkey. This was one of the many birds important to the Maya people. The red BB-shaped skin atop his iridescent blue head is quite a sight.

We saw chachalacas and grey-necked woodrails near the dried-up *aguada* by the campsite. An *aguada* is a shallow depression that holds water and is one of the few places wildlife can drink in the dry season. This one was dry, but another we found a couple of miles away had about a foot of water left in the middle and was surrounded with mud.

Here we saw three white-tailed deer, as we quietly entered from the east side. The mud provided an excellent area for viewing the tracks of jaguar, tapir, and collared peccary among many unidentified bird tracks. Later that evening I got to hear a jaguar roar.

After two days the SEDUE folks left. Joann then got back to her plant collecting. A tireless worker from dawn to dark she bounces up and down trails like a twenty-one-year-old. Orchids are her favorite, and among the hundreds of plants she has collected and identified here, over thirty are orchids. She found a couple of species in bloom for me to photograph.

Each evening after dark we gathered in the cooking hut to eat Trans's vegetable soup and tortillas and drink our hot water. Our water was hot not by our choice but because of the excessive heat, even though we stored our eighty-liter containers in the shade.

You might think we were in a jungle paradise since I haven't mentioned any hardships except the spine-torturing ride in, but you'd be wrong. It was immensely satisfying to see this wonderful tropical forest, but my cameras and I were both suffering. It was hot. I started perspiring Monday when we turned off the main highway and did not stop until Wednesday evening. My T-shirt was soaking wet for the entire time. Once I reached the pyramid's top sweat was pouring down my forehead faster than I could wipe it off, even though this was before sunrise. Salt stung my eyes, coated my viewfinder, and corroded my camera. And I am a person who rarely perspires. To replace these body fluids, I had only the hot water from my canteen.

After dinner Wednesday night I finally found some relief. I walked the two kilometers to the palace to get a better view of the stars. The wind began to stir and I heard the jaguar call. Hoping I might enjoy a breeze on top of the ruin, I hurried for fear a jaguar might also be out there.

At the top of the palace I found paradise in a dry breeze; it took a little humidity out of the air and I was comfortable for the first time. Monday night the mosquitoes had eaten me and Tuesday I roasted in my tent.

On Wednesday, and for the rest of the week, I forced myself to sleep in a hammock with a mosquito net. This provided some slight relief from the heat.

On Thursday I noticed a tick on me. After a closer inspection I counted nine. B. J., who was not using any sulphur either, also had a bunch. So Luz went to work on us. A little sulphur powder dusted on your socks will keep most ticks off. Luz's tools were a straightened-out paper clip and B. J.'s adjustable butane lighter. He would heat up the paper clip, then start poking the tick until it backed out. Of course Luz missed and hit our skin a few times. Our yelps were greeted by laughter from Luz. He adjusted the flame too high once and quickly learned the English words *blow torch* from B. J. This episode left Luz in full giggles. He called B. J. "Blow Torch" for the rest of the trip.

On the way out we found an ornate hawk-eagle's nest. The adult is a regal looking bird of prey, its black crest contrasting with its cinnamon neck. There was a pair of down-covered chicks on the nest. I shinnied up a tree to a branch about thirty feet high. The nest was about forty feet away, and the birds did not seem worried about me. I lowered a rope and dragged up my 600 mm lens and tripod. By perfectly balancing the tripod on three skinny limbs I was able to use the long lens. But that day's rotten luck had a branch cutting the adult bird in two. I stood up there for one hour, hoping the bird would move to the edge of the nest. In the meantime the black lens had soaked up so much heat that I could only hold it by the strap. The bird did not move and my friends below were ready to go, so I left with only a poor shot.

We drove out, stopped at the first store, and tanked up on anything and everything cold. We all agreed it had been a productive trip. Joann wanted to return with a jaguar expert, and I wanted to join her.

It was December, much closer to the end of the rainy season, when she planned the next trip. Marcella Aranda, a jaguar expert with the Instituto Nacional de Investigaciones Sobre Recursos Bioticos (INIREB), Chuck Carr of the New York Zoological Society, Facundo Contreins, a biologist with SEDUE, and Edilberto Ek, a plant collector with INIREB, joined Joann, Trans, Luz, and me. We were expecting wet roads and full *aguadas*. When we got there we found out that it had hardly rained at all in the June-to-October rainy season. The *aguadas* were totally dry.

Before going to Calakmul Joann wanted to visit Villahermosa, a *chiclero* camp on the eastern edge of the proposed biosphere reserve. At Conhuas we picked up a local mechanic and lumber truck driver named Jose del Carmen Pech Gomez. Roughly translated to English his name was Joe the Tick. Not only was he enjoyable to have along, but his skills were really vital.

The road to Villahermosa was sixty miles to the east and paralleled the road to Calakmul both in direction

and in brain-rattling torture. This road was used a little more by lumber trucks and local farmers. About 50 percent of the first day's trip took us through land cleared for *milpas*. It is usually made by slash-and-burn-style agriculture. A plot is hand cut by machete, then burned and planted just before the rainy season. After one or two years, it is left to fallow. Numerous species of legumes grow quickly and put nitrogen back in the soil. After fifteen or twenty years the area can be slashed and burned again.

Around eight o'clock we stopped at a small group of thatched homes to see if we were on the right road. Pablo Gonzales Hernandez welcomed us to his town, Veintedos de Abril, by offering the barn for us to tie our hammocks to. It was late and we were tired, so we stayed. I hung my hammock between two poles on the porch of the chicken hut and noticed that the heat of the day was gone.

I must admit that when Joann told me to bring a sleeping bag I just kind of laughed to myself. No way would I need a sleeping bag in early December when my blood boiled all night long in early March. So I brought my thin, cheap, discount-store camping blanket. The weave was big enough to drop marbles through. Needless to say, I froze that night and each of the next six.

It was damp, cold, and foggy at daybreak when I began to explore Don Pablo's farm. It was one of the cleanest I had seen. His kitchen building had a china cabinet; in it were dishes his wife was very proud of. How they got the cabinet or the dishes down that rough road I will never know. More interesting to me, though, were his animals. Some tame, some domestic, and some in cages. He had a spider monkey, four Yucatán parrots, one dove, two pigeons, five dogs, an agouti, two dozen turkeys, numerous chickens, along with horses, cows, pigs, and goats. His place should have been called the Campeche Zoo.

He offered to kill one of his turkeys for our breakfast, but we declined so that we could get on with our destination. Another long hard drive was slightly broken up by viewing laughing falcons and black hawks. We passed a dead anteater in the road, the first and only one I saw in my journeys, and Marcella Aranda took a mold of some jaguar tracks. Perhaps with his expertise I would get to see one. We did, but not quite the way I had in mind.

Later at Villahermosa we heard of a recent sighting and subsequent shooting of a jaguar twenty kilometers toward Calakmul. Joann and Marcella wanted to go see the skin. While they got directions I surveyed the *chiclero* camp. This village has been here for two hundred years for the sole purpose of gathering *chicle.*

If you have ever heard of Chicklets chewing gum you might have guessed what they use *chicle* for. It is the base for chewing gum, although most today is made artificially. *Chicle* is the sap of the zapota tree. The za-

pota has a tasty fruit good for both wildlife and man, as well as a hard, long-lasting wood used in construction.

The two hundred *chicleros* who work here come and stay from July to January; they spread out to huts for miles around to collect the sap from the zapota tree. They do this by cutting v-shaped slashes in the bark and catching the *chicle* in bags at the bottom of each tree. A tree only gives sap three times in its lifetime. You must wait five years after slashing one before it is ready again. Each time the tree yields five to ten kilos of *chicle*.

Only twenty men and four women were in Villahermosa when we arrived. Most of them were support personnel. The *chicleros* were out in the bush. Three of the ladies had come from the city of Campeche to cook for the men during the six-month season. I went into the *cocina* (*kitchen*) and watched them make bread.

They were making bread in nine different shapes. By varying the amounts of sugar and oil they made bread with different tastes. A crested guan feather was used to baste the tops of the rolls. When the ladies had finished, there was a huge bin of pieces of hot homemade bread. I eagerly ate one, but as the men came in for supper, most asked for corn tortillas and passed on the bread. I guess what you grow up on is what you like.

We camped at an *aguada* about four kilometers away. It was muddy and shallow, with green, algae-covered water. This was the only water for miles. The mule wrangler from Villahermosa made three trips a day here with four mules to carry back water for drinking. The *aguada* near town had been dry for four years. Our group ran out of water two days later and had to drink this green stuff for the rest of the trip.

Lots of birds and frogs were near the water, as well as three pacas that came up to feed on the fallen fruit of a zapota tree near my tent. In Mexico this large rodent is called a *tepescuintle* and is considered good eating. I noticed it on the menu in several places across the peninsula.

The second morning we were awakened by the raucous sounds of a flock of chachalacas. I watched them through binoculars as they flew amongst the understory toward a clearing full of morning glories in bloom. It was quite a sight, watching this chicken-like bird delicately pluck a flower and then seemingly suck it in as I might swallow a strand of spaghetti.

I spent the day at the dry *aguada* looking at North American warblers in their winter plumage and following an army of leaf-cutting ants. There were seven different trails coming out of the center of the dry pond to a massive nest under a tree trunk on the edge. Each trail had been worn down a half-inch from the surrounding terrain by the continuous flow of ants carrying cutup pieces of leaf. What diligent workers they are!

The next day we went looking for the lumber/*chiclero* camp called Los Hornos. After a three-hour ride we

found this one-family town, but it was not quite up to the standards of Veintedos de Abril. The main *palapa* had no sides and used corrugated tar paper instead of palm thatch for its roof. It was decorated with a deer-skin still dripping blood from the morning hunt. The venison had been hung over a rafter to dry near the stove. Upon seeing company arrive the señora immediately started cooking some of the meat.

Three stringy hammocks were dropped from the rafters. A beat-up single-barrel shotgun hung from the nail, and a brocket deer fawn played with a little boy. Crested guan feathers were littered about among pieces of bone and skin from other animals.

We asked about the jaguar and the lumberjack proudly brought it out, saying he had sold the skin of one he shot last year for eighty dollars. He had shot this one at twelve noon—a week ago. The jaguar was walking across the jeep trail, three hundred yards from his house. Marcello and I would have given anything to see one alive.

It was a sad scene for me. For a mere eighty dollars some "collector" might buy this skin. Without a demand for these skins, the lumberjack probably would not have shot the jaguar. There is still plenty of habitat for the jaguar in the peninsula. If senseless killing can be stopped and a reasonable management plan be put in place for the forest, then the king of the American jungle will continue to prowl. Setting Calakmul aside as a biosphere reserve makes good ecologic sense.

Back at Villahermosa Trans was putting out the black beans and tortillas when Luz pulled out some peppers. I asked him if they were hot. Luz responded, "No, no. . . . Es dulce." That means *sweet* in Spanish. So I picked one up, wrapped a tortilla around it, and scooped up some beans. About one second after my first bite, my mouth began to explode like a volcano.

Luz and Joe the Tick went into a knee-slapping, thirty-minute spasm of laughter. For the rest of the week, at every meal, they would offer me another pepper. I would take it, fake a bite, and entertain them again and again and again. So much fun with such little things!

After the pepper episode we began a marathon drive-out. With Joe the Tick leading, we made pretty good time. I was driving the second jeep, and I tell you such rides are much more comfortable when you have the steering wheel to hold on to.

At nine o'clock we had problems with the bearings on the front left wheel of the lead jeep. In the tall grass of the grown-up road, with the aid of two dim flash-lights, Joe took the wheel apart, repaired the bearings, and put it back together in ten minutes. All this with a tire tool and a pair of pliers.

Other exploits by this southern Campeche woods-man involved his chainsaw with a three-foot blade. He first cut down a huge tree that blocked the road, but tangled vines overhead prevented the tree from falling. Not to be stopped Joe the Tick then wielded his chain-saw over his head. Standing on his tiptoes, he managed to cut the tree in two so that we could drive under it. Later a massive tree, two-and-a-half-feet thick, lay completely across our trail. He cut it into three pieces and was getting rid of two while Luz and Edilberto were trying to roll away the third. Joe just picked it up and tossed it to the side of the road. He was also a good tracker with a thorough knowledge of edible plants—not to mention the fact that he was just a pleasure to have along. I teased Joann about pondering a way to marry him off to her daughter so that she could have him on all her expeditions.

We made it to Joe's house at two o'clock, dead tired. He told us we could sleep in the kitchen, on the porch, or in the yard; he ventured into the sleeping quarters with his family. I settled in the kitchen, as far away from a pool of blood as I could get. Joe's dad had cleaned a pig earlier. Chicken and ducks were in the kitchen, and turkeys and pigs roamed the yard. Still cold, I lay down, covered up with every article of clothing I had, and drifted off for three hours of sound sleep. I woke to see a flash of feathers leave. Upon closer inspection I saw the egg this chicken had just laid six inches from my right ear. Breakfast!

After stocking up on water and gasoline, we headed back into the ruin site of Calakmul. It was so nice to be there in cooler weather. We saw deer, an ocelot, a jaguarundi, and all the birds again. The *aguada* was dry as we had heard. There were probably others we did not locate, since the animals were surely drinking somewhere.

While the scientific crew did its job of surveying the area, I wandered alone seeing butterflies and humming-birds, as well as lizards and tarantulas. I listened to the jungle sounds, smelled the clean air, and thought about all the wildlife I had seen in this harsh but special place called Calakmul—certainly the fourth jewel of the Yuca-tán Peninsula and a perfect place for a reserve.

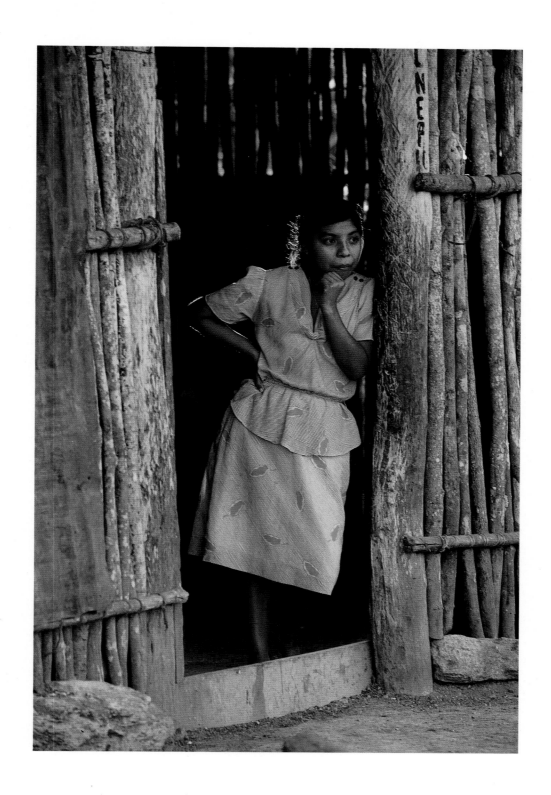

One of the cooks at the chiclero camp of Villahermosa takes a break from baking bread and frying tortillas.

Most of the central and southern part of the Yucatán Peninsula is an endless sea of green, technically called second-growth deciduous tropical forest—deciduous because a lot of plants lose their leaves during the October through May dry season (overleaf).

The palace at Calakmul was living quarters for the Maya royalty. The interior had many sleeping and storage rooms, as well as a bathroom.

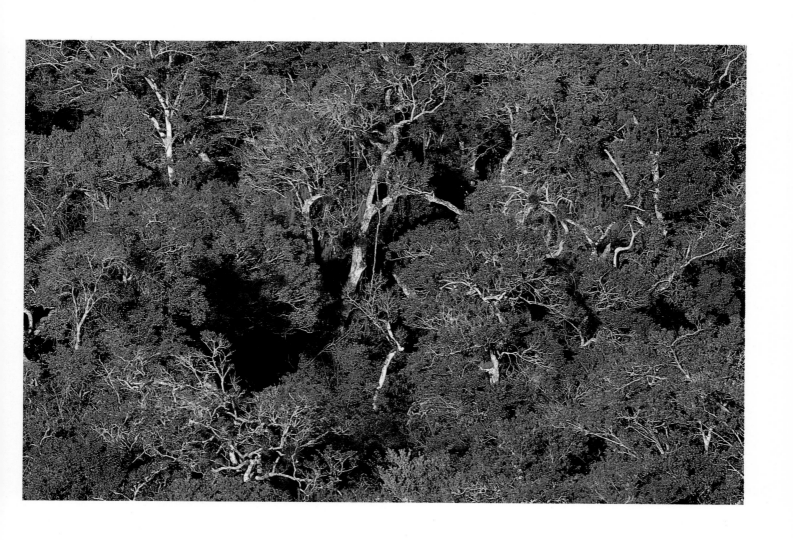

Looking down at the jungle from the top of the pyramid you can see many brown patches of bromeliads. They will glow red later in the year.

The groove-billed ani (above) and the keel-billed toucan (right) are two of the birds seen in the forest around Calakmul.

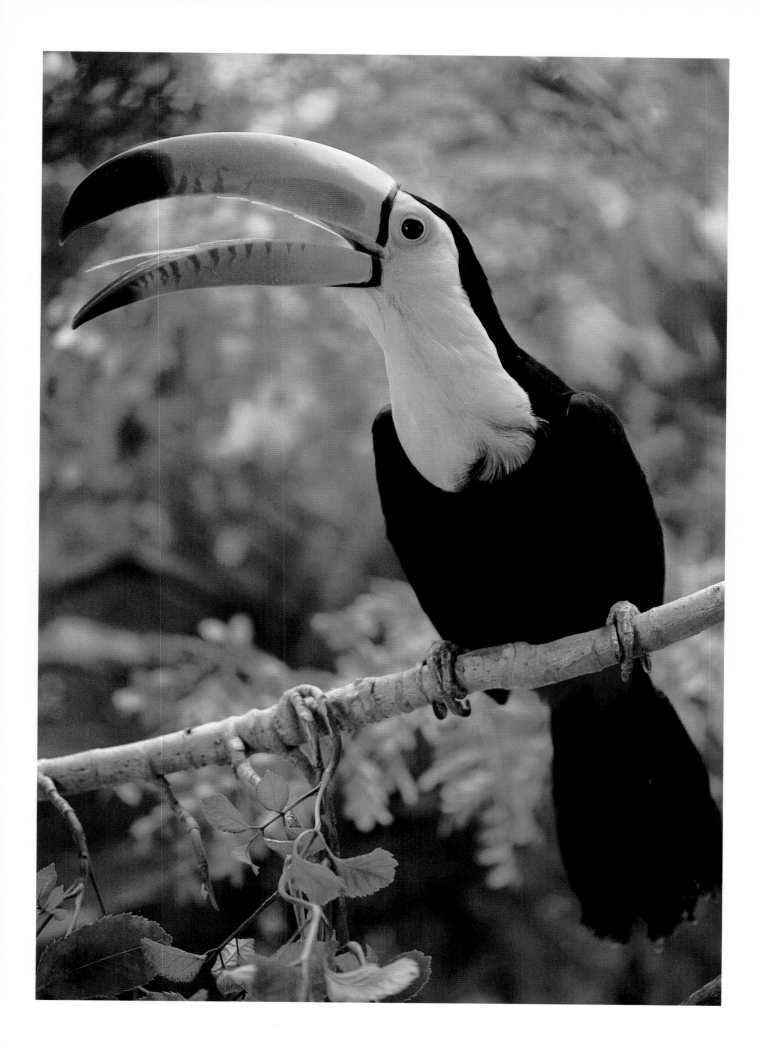

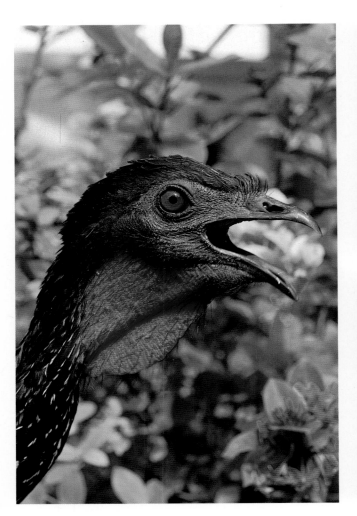

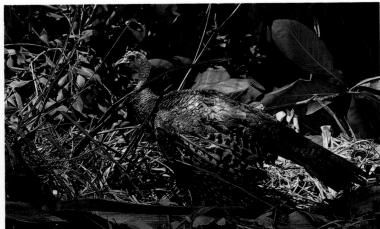

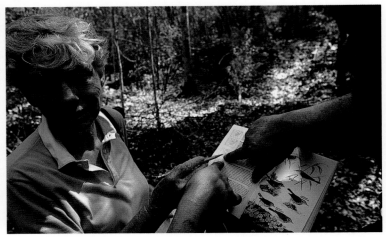

Joann Andrews, Yucatecan naturalist, goes over some of the birds our expedition recorded in Calakmul (lower right). The ocellated turkey (top) and the crested guan (left) are two birds that were important for food and ceremony among the ancient Maya.

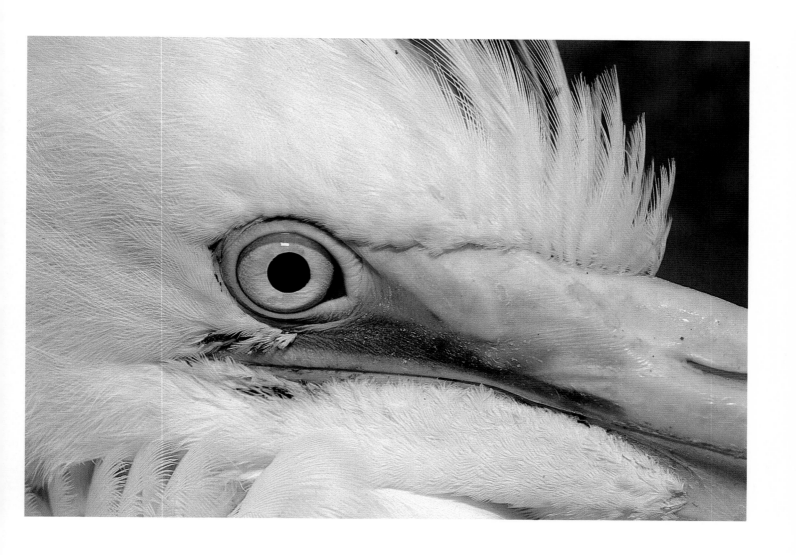

Herons and egrets like this great egret were seen around the aquada on our first expedition into Calakmul.

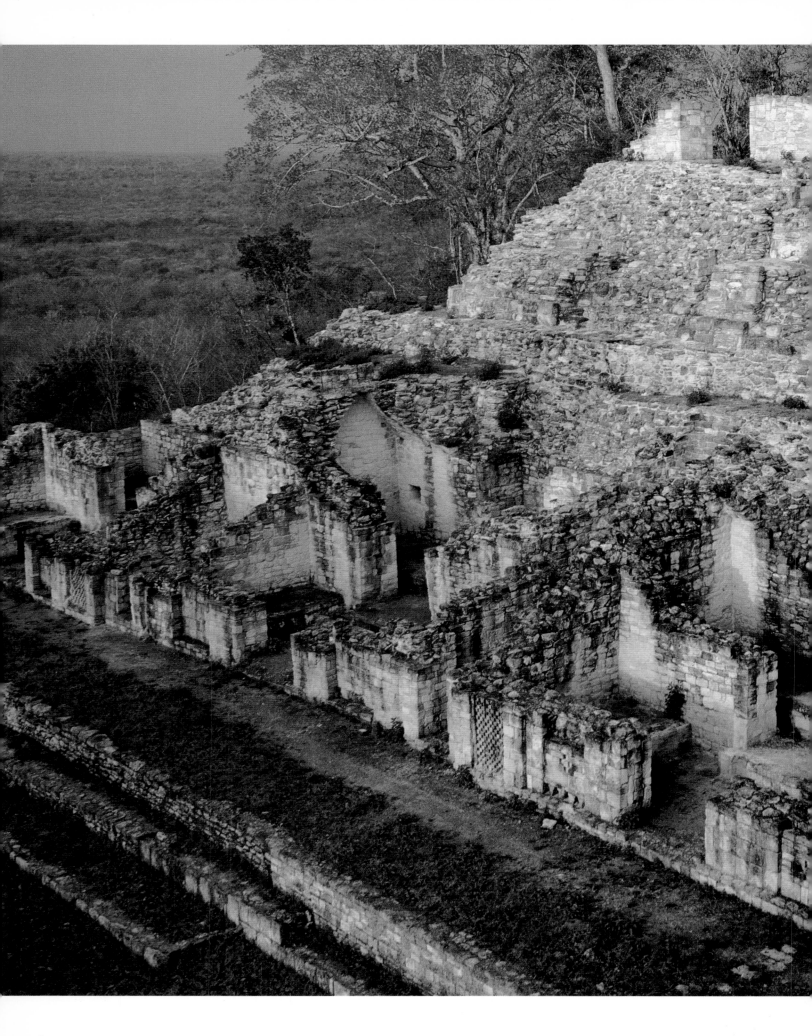

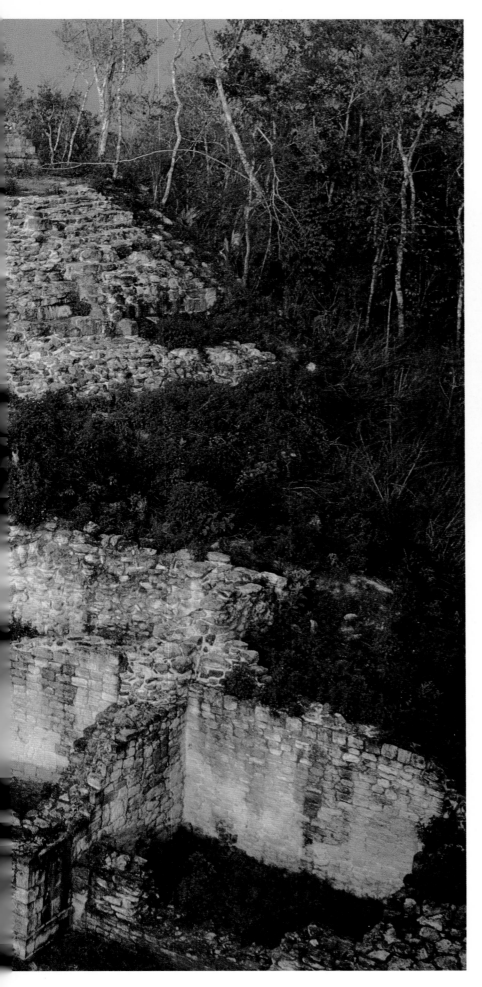

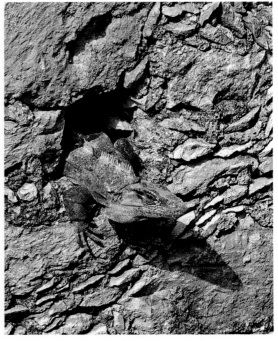

Animals such as the iguana (above) have adapted to life around the ruins at Becan (left). Many birds and other animals nest in both the restored ruins and those still covered with jungle growth.

The ivory-billed woodcreeper.

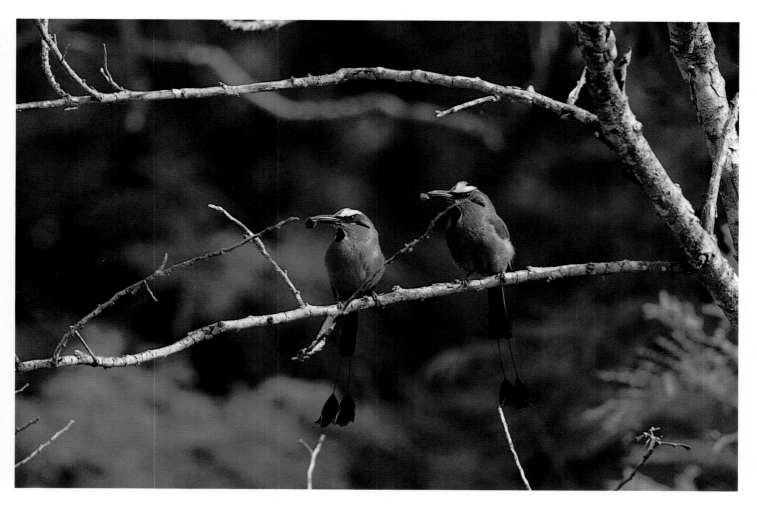

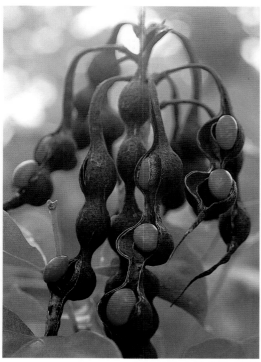

Turquoise-browed mots mots, with spiders to bring to their nestlings. These birds (top) were nesting inside the ruins. Colorful seeds of Erythrina americana *(left).*

Joann Andrews has identified over thirty orchids in the proposed Calakmul park. Here we have three, the showy Rhyncholaelia diobyana (top left), *the delicate* Encyclia alala (above), *and my favorite* Brassavola cucullata (right). *The Moon flower* (left) *blooms at night.*

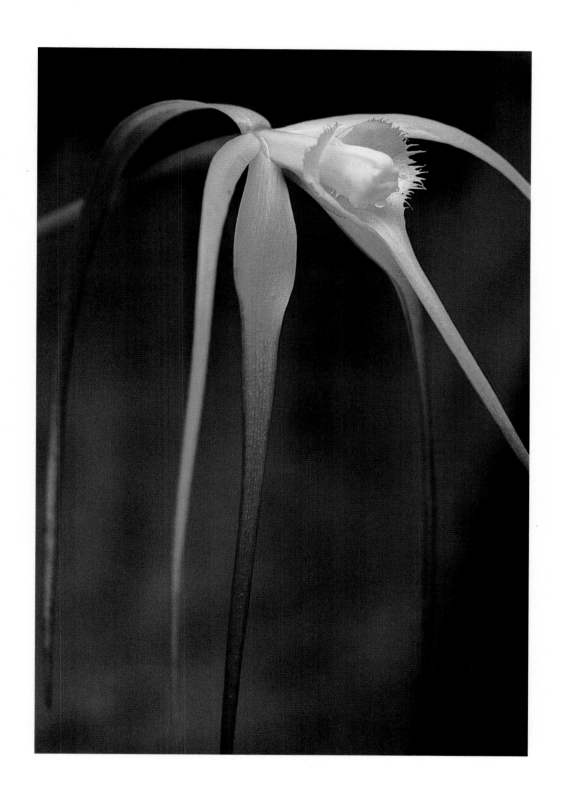

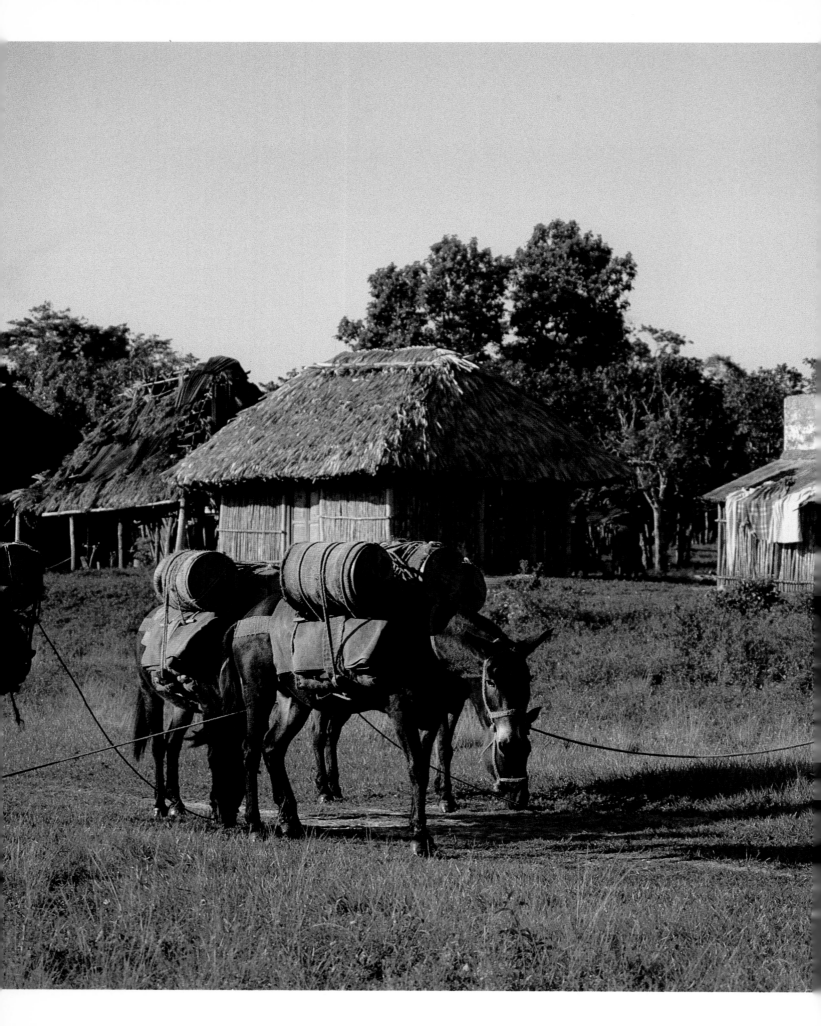

With their aquada dry for the past four years, Villahermosa had to send mules out to fetch water three times a day (left). The gear of the head mule man at the chiclero *camp (above).*

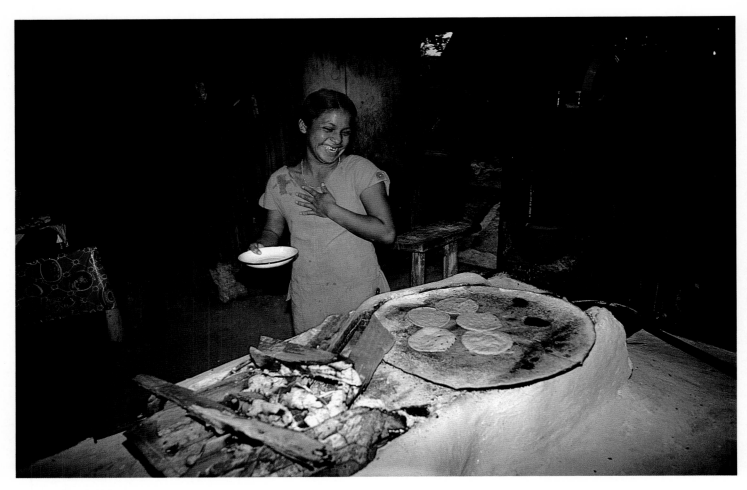

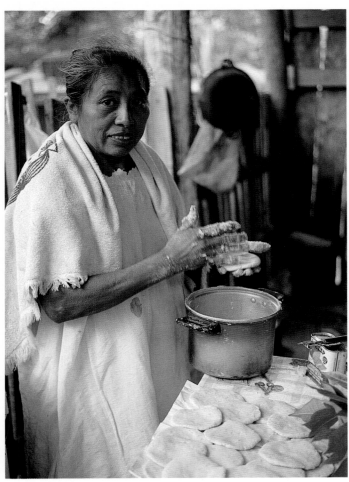

One of the Yucatecan cooks at the chiclero camp fries a batch of tortilla (above). Transita does the same for our expedition at Joe the Tick's house just before she cooks the egg laid beside my head (left).

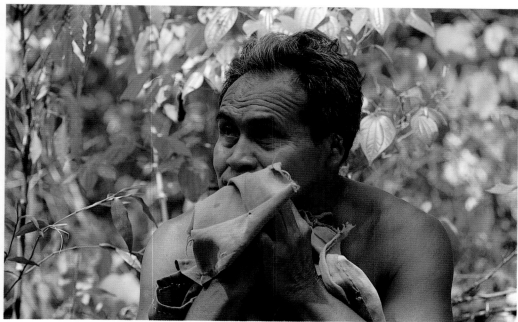

A load of chicle, the raw material for chewing gum, Villahermosa (top). The guard at Calakmul was bitten on the ear by a fly while working as a chiclero years ago. Being in the jungle for six months at a time, with no doctors to heal the infection, caused this man and many others to lose parts of their ears. Thus the affliction came to be called chiclero's ear (bottom).

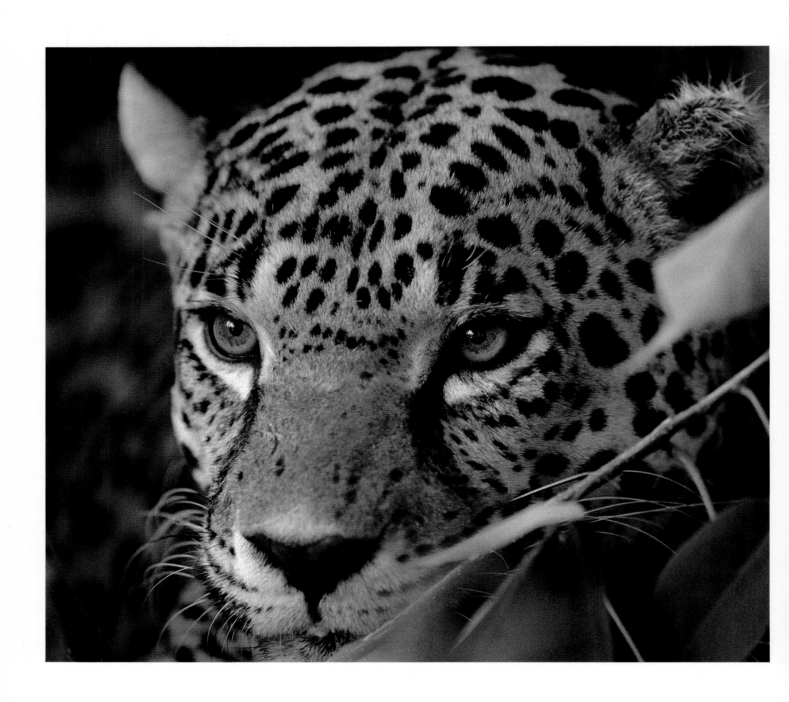

Part of the reason Joann Andrews and others are working to set aside Calakmul as a reserve is to protect some habitat for the jaguar (above). It is hoped that this may stop such senseless killing as that depicted here (right). The standing lumberjack wearing the blue hat killed the animal to sell its skin for $80, a very small token of its real value in the wild.

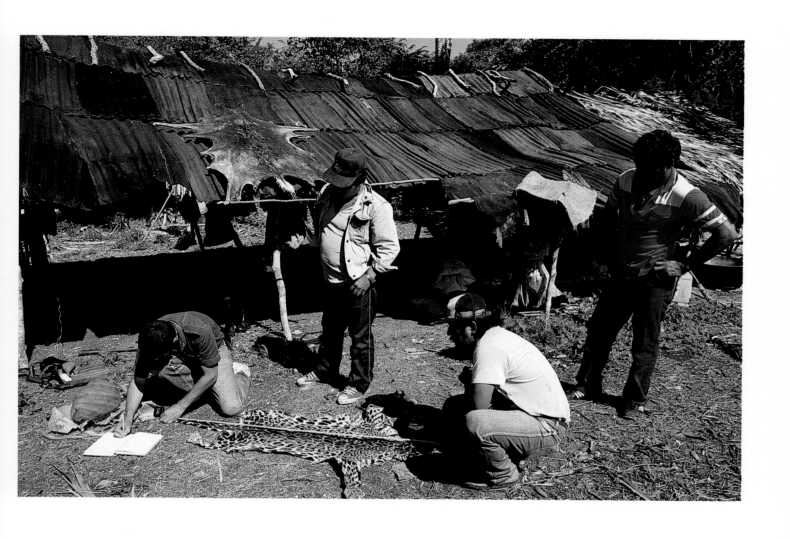

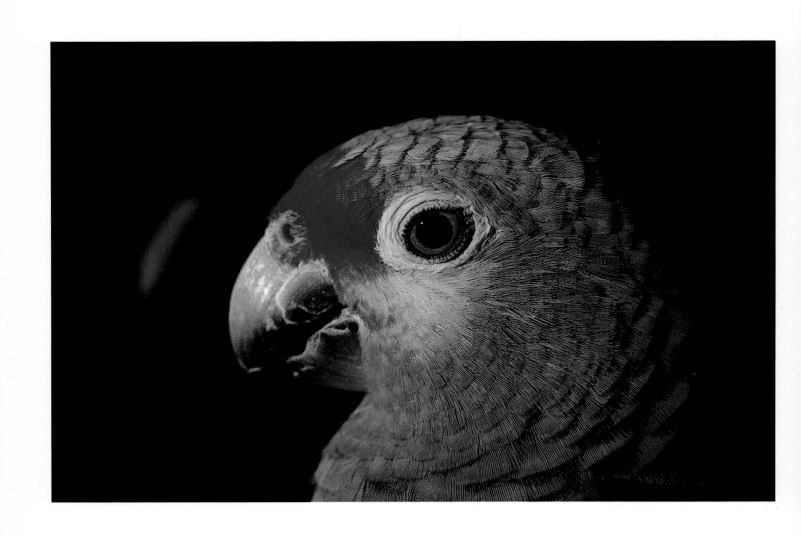

The red-lored parrot.

WILDLIFE

The reserves and reefs are a great place to see wildlife, but they are not the only good habitats in the Yucatán Peninsula. Wild animals can be seen almost anywhere if you take the time to look. Northern Quintana Roo has many good spots, for it is still mostly covered in forest. The woods are pretty tough going, so it is easier to look around ruins. Cobá is great for bird-watching and Punta Laguna is a sure bet for seeing monkeys.

Punta Laguna is the name of a village, a ruin, and a lake about halfway between Cobá and Nuevo Xcan. The highway to this small pueblo is new and in good condition. It is straight and so narrow that you feel as if the jungle could close in on you any minute. With a few field guides you can take a self-led tour and see almost as much wildlife as you would in a small zoo. Among the many species of birds I have seen on this drive was my first sighting of a keel-billed toucan. Better yet were all the mammals, for most of these are secretive, nocturnal creatures that are rarely seen anywhere. On different trips I saw raccoons, coatimundi, tayra, weasel, and grey fox. In June the road is aflutter with butterflies, and in October it is crawling with tarantulas. A friend of mine saw a jaguar crossing the road here, so one is well warned to stay alert when traveling this route.

To see monkeys it is best to get out and do some walking near Punta Laguna. Village chief Don Serapio can find some monkeys for you just about anytime. The monkey you see here is called the spider monkey. It gets its name because of its long skinny legs and tail. According to Don Serapio, about eighty monkeys inhabit this area. The other monkey native to the peninsula is called the howler, simply because of its loud howling voice.

The ruin here is small compared to the better-known sites and is completely overgrown. There are many big trees, because the area has not been cut for a long time. An older, more diverse forest is better for most wildlife. I saw monkeys on three separate visits. On the first we walked around the lake on a steep hillside trail. After about one hour we found three adult monkeys high in a tree. They spotted us and flew through the trees. I never got a picture that day; each time we caught up with them, their arms, legs, and tails would work in perfect coordination to swing them away.

On our last trip, everything was perfect. We found a troupe of eleven after about one hour of walking. It was mid-morning on a sunny day and the group was feeding. They were in a large tree of the legume family. The tree had a long seed pod that made two spirals, and this was what the monkeys were after. They would reach out for the easy ones and leap out for the pods that were on the tips of branches. After biting them open, they would chew out the pulp and/or the seeds. Some ate while hanging by their tails and one arm, while others would settle in a comfortable spot on a large limb.

When they moved a couple of hundred yards to another tree, I noticed a mother swinging from branch to branch with a baby clutching her chest. Later, while focused on a resting adult, I began to get over my initial excitement and notice the rest of my surroundings. The monkeys were in a massive tree. I was thirty feet up a hill from the tree trunk and the monkey was still way above me. The leaves were lime green and almost sparkling. The morning was still cool, and the forest was alive with sounds. A motmot cooed in the distance. On one occasion I had an oriole, trogon, hummingbird, flycatcher, and an owl in sight, at the same time as I had the monkeys. This was an ornithologist's dream.

Birds are abundant here. Mexico is about one-fifth the size of the United States, yet it has substantially more birds. Many of Mexico's 1,018 different species live in the peninsula. It was special for me to see all these tropicals, plus puff birds, tinamous, and flamingos.

The Caribbean flamingo, *Phoenicópterus ruber ruber,* is one of the first wildlife spectacles I got to see in Mexico. It was on our second sailing trip to Isla Mujeres that we heard of the birds near Río Lagartos, and all of us wanted to see them. So four gringo sailors set sail for the north shore of the peninsula. We stopped at Isla Contoy for a few nights and were able to see a small colony of another pink bird, the roseate spoonbill. Contoy was teeming with bird life. There were five thousand frigates and just as many cormorants, to name only a couple. The real treat was sitting on a dune one evening and seeing a manta ray twenty feet wide leap out of the surf and dive back in. Biologists say they do this to rid themselves of parasites. I bet they also have fun doing it.

Late the third evening we left for a night sail to Río Lagartos. On my shift I used the constellation Orion to steer by. I kept it in one position in the rigging. This way I could lie back and be comfortable, only rising

every fifteen minutes or so to look for other ships.

We made the entrance to Río Lagartos at daybreak and accepted the offer of two fishermen, Cris and Manuel, to lead us in after we got briefly stuck in the shallow channel. They showed us a good anchorage, and on hearing our intentions to see the flamingos offered to take us to them. They would come back for us at 1 P.M.

Our anchorage was a photographer's paradise, for birds were everywhere. Sandbars and shallow ponds held godwits, plovers, sandpipers, terns, gulls, pelicans. Fishermen young and old threw cast nets from tiny skiffs for yellow-tail snapper and mojarras, sometimes working within a few feet of our sailboat. After the good morning light was blasted away by a high hot sun we took the dinghy to town.

Having previously only been in Isla Mujeres, I enjoyed seeing a town without any tourists. We were the only nonresidents in town that afternoon. Río Lagartos does do a little tourism for both sport fishermen and bird-watchers coming to see the flamingos. But Celestún, more accessible to Mérida, does the majority of this business. We had breakfast in the restaurant at the Hotel Nefertiti which doubles as the Flamingo disco at night. Its pink motif warmed us up for the real thing.

One of the most interesting things to me in our walk around the village was the *tortilleria*. An ancient machine was punching out round tortillas from a wad of cornmeal, dropping them on a conveyer belt, and sending them through an oven. The locals were lined up twenty deep waiting for their stacks. As I toured other cities and towns I learned to equate any long line I saw with this kind of establishment.

Later that day I photographed a small child by the gate of his house. Then he led me into his backyard to show me an injured white pelican. His mother, sister, and grandmother were sitting around a tub of small murex shells that they called *caracol negro*. They were cleaning them for *ceviche* and offered me a couple raw. They tasted okay, but I would have preferred waiting until they had been soaked in lime juice.

Cris and Manuel picked us up as planned. I was excited about our adventure. Besides seeing twelve birds from a long way off in the Galápagos, I had only seen flamingos in the zoo.

Because of shallow water it was a long boat trip to the feeding grounds. Río Lagartos lagoon is lined with red mangroves. We saw pinnated bitterns, bare-throated tigers, and boat-bill herons—three new birds for me. Once we passed the salt factory at Los Colorados the lagoon opened up into more of a super salty estuary.

Finally we found them. A flock of five hundred! They were wading, feeding, and preening in all their glory. This bird is most impressive—standing four feet tall with flame scarlet plumage, contrasting black flight feathers, pink legs, and a tricolored bill. We beached

the boat nearby, and Terri painted while I photographed from the bushes. We watched subgroups within the flock go through some kind of a mating ritual. They would walk briskly in one direction, seemingly following a leader, all with their necks held the same way. And then, as if a drill sergeant had called "about face," they reversed and marched the other way.

I wanted to know more and to see the nesting colony. I found out courting starts in October and peaks in February. Soon after this the flocks in Celestún and Río Lagartos move east to be near the nesting grounds. By June, eggs would be laid, and that would be a good time to see the birds on their nests.

I was lucky when I came back in June, for both Jesus Garcia and Ricardo Gonzalez were spending a lot of time at the breeding colony. Jesus, nicknamed "Chucho," is a field biologist with SEDUE and has been monitoring the breeding colony for the past ten years. The nesting area at El Cuyo and the wintering area at Celestún are currently national parks administered by SEDUE. When Chucho first started watching the birds the population was down to 8,000 flamingos. One of the main threats then was egg-collecting. SEDUE stopped this by having Chucho up there to monitor the colony and educate the locals. The agency also hired a local warden to watch the colony when the biologist was not there.

Today the population is up to 19,895 birds according to a thesis prepared by Ricardo Gonzalez. From Monterrey, Mexico, Ricardo is a graduate student at Auburn University, who spent most of 1987 watching the flamingos in both their wintering and their breeding areas.

I learned a lot viewing the flamingos with these two men. There are six species and about seven million individual birds in the world. Of the six species, only the Caribbean one is truly reddish. Some twenty-thousand of the eighty-thousand Caribbean birds live in the Yucatán. They get their color from their diet; thus many of the same species in captivity lose their vivid hues and are almost white.

As far as the conservation of the colony, the birds are doing pretty well since the egg thievery was stopped. The two problems now are loss of habitat and harassment by tourists. It is possible that if the birds get too much pressure from the tour boats in Laguna Celestún (which sometimes chase them), they will leave their wintering ground and be crowded into an area that does not have optimum feeding conditions. It is acceptable to view the birds at a distance, but not to chase them from a boat.

Loss of habitat is especially problematic because of expanding salt ponds. The estuary at El Cuyo is very salty; it has been used as a salt-collection area since ancient Maya times. If the salt ponds do not expand any farther the flamingos can probably survive there, but any more would certainly endanger them.

Already roads, bridges, and salt works have modified the water flow in the lagoon. In 1988 the entire nesting colony was flooded by a heavy rain that did not drain out of the lagoon as fast as it should have. Luckily it was early enough for some of the birds to renest. Ricardo thinks the food supply on the north coast of the Yucatán could support forty thousand birds. However, nesting areas are at their capacity because of habitat changes in the lagoon.

I watched the courtship ritual with Ricardo from one of his blinds in Celestún as blue-winged teal and shovelers dabbled nearby. This bay, he tells me, is a very productive feeding ground. He figures that from October to February the flamingos eat 794,000 pounds of crustaceans, mollusks, aquatic insects, and other creepy oozey things. This is definitely a productive bay.

DUMAC (Ducks Unlimited of Mexico) has a research station on the banks of the lagoon for the sole purpose of assisting people studying the ecology of the area. Director Robert Singleton told me DUMAC is always looking for graduate students with viable subjects concerning this area's wildlife. The agency assists with room, board, and laboratory space.

Bob had a particular spot in the lagoon that he wanted me to see. He, I, and Señor Thomas took off in a little skiff. Señor Thomas was an old man who worked for DUMAC. His weathered face and thin, strong arms told of his many years in the lagoon. He poled us into a small creek called Sinitún, which runs into the lagoon.

I was awed by the size of the red mangroves. Some of the prop roots were twenty feet tall. The canopy, much higher, formed a tunnel-like effect, blocking out half the sunlight. It was eerie, almost cathedral like. Up ahead we saw a bird—a pygmy kingfisher balanced on a prop root, surveying the tannic waters for a minnow.

This kingfisher's wings and back were green and his underparts were rusty. He flew ahead each time we approached, just teasing me with his handsome profile. He finally stopped long enough for me to get out and set up my tripod. I sunk in the mud up to my knees before I was stable enough to manage a shot.

It was smelly and slimy, but this ooze determines the basis for the food chain here. Bacteria work on the fallen leaves to form detritus, which is so important to the insects and shrimp, and thus to the beautiful flamingo.

Back near El Cuyo I sat in a blind with Chucho at the nesting colony. There were about three thousand nests. Each one was a castle of mud about one foot tall with a hollowed-out depression on top. The female lays one egg that takes between twenty-four and thirty-two days to hatch. After eight days the chicks can leave the nest to feed themselves. Then two months later they are ready to fly.

This summer SEDUE decided to band the flamingos when they were two to three weeks old. The National Audubon Society ornithologist and flamingo expert Sandy Sprunt came down to help, since SEDUE had not done this before.

The time was just about one month after Chucho and I had first watched the colony. Today's team of fifteen was listening to the plan of attack from Sandy Sprunt. We would begin at 5 A.M. on an overcast morning, which prevented the chicks from getting too hot while we banded them.

The plan was to surround the group of 3,000 chicks and drive them toward two holding pens. One person for each pen would be hiding in the bushes to close up the pens. Since we needed only 200 birds at a time, we could let many in the group get away. The operation was a success; we had banded and released 190 chicks in less than two hours. The next day we returned and banded 200 more. Now Chucho and his associate have a group of birds of known age. This will be invaluable in collecting more data on the flamingos here, most especially when this group enters the breeding populations.

Flamingos were daytime work for Chucho. At night he turned his attention to sea turtles. Of eight species of sea turtles worldwide, three nest regularly on the beaches of the Yucatán Peninsula. Most of these species are considered endangered. Over-fishing, loss of habitat, and egg-poaching are the three primary reasons they are endangered. They need protection. If you had the opportunity to see one swim by underwater, you too would join the movement to save this wonderful creature.

I have swum with sea turtles a number of times, especially while diving at Akumal, Quintana Roo. The symbol for this laid-back resort is the sea turtle, which is appropriate because turtles are viewable here almost anytime. The best viewing time begins in April, while the turtles are breeding, and goes through the end of nesting season in September. I once saw nine turtles in one forty-minute dive here.

The green and loggerhead sea turtles, which are the main species that nest on the Caribbean coast of the peninsula, lay about one hundred eggs at each of their six different nests. They wait about ten days between nestings; and while they wait, they are resting and feeding on the reef. It was during such a time that I had one of my best turtle experiences.

I saw a turtle resting on the bottom as I jumped in one day. She was a big green turtle with a barnacle-encrusted back. On seeing our small group of divers descend, she effortlessly swam off over a ridge. As we checked the reef looking for other critters, my hands were free for the second time in my diving career. My checkout dive seventeen years ago was the only other time I had gone in without a camera or, on a few occasions, a speargun. I wanted to see the reef without concentrating on getting a picture. Without my camera,

I knew I would see something special, and I was kind of glad the turtle left before she got close enough for a picture.

Lorie Conlin, the dive master, swam ahead, stopping occasionally to show our group a lobster or a spotted drum. It was fun not to rush over and try to take everything's picture. I lagged behind to check out a barrel sponge that was playing host to arrowhead crabs, cleaner shrimp, and brittle starfish on the outside, while a stone crab was hiding inside among the broken bits of shell and gorgonia. Realizing that I was probably pretty far behind the group, I kicked hard over two ridges.

I caught up just in time to see the same big green sea turtle swimming directly for Lorie. From fifty feet away, I could see her eyes light up—with excitement, partially, but also with a bit of fear since turtles do not usually come on that strong toward humans. Lorie held her ground and the turtle circled her twice, the second time close enough to tap my friend's head with her flipper.

I moved to a depression in the ridge, about twenty feet from Lorie, just guessing that the turtle would swim down the edge of this reef and give me a clear view. My guess was right. But better still, the big green turned right toward me and slowly swam for my head. At the last second the green turned up slightly, sliding by eight inches above my astonished eyes. That is one negative I will never lose, for that picture is embedded in my mind forever.

During three summers I went out a number of times with Chucho and two other SEDUE biologists, Norma Benitez and Isabel Aguirre. On the first trip Juan, who works with Mexico's Secretariat of Fishing, PESCA, joined us. These biologists on nighttime beach patrols accomplished three goals: first, their presence discouraged poachers; second, they collected and replanted the eggs of the sea turtles in a safer location; and third, they gathered statistics on the nesting behavior of the turtles.

My first night on the beach with them was the most exciting. Their study area was about thirty kilometers of beach, half to the east of El Cuyo and the other half to the west. We traveled by jeep on the hard sand near the surf, flushing a few sleeping shore birds and looking for turtle tracks. To the east we found two sets of tracks that led to no nests. Occasionally a turtle will not like a spot and turn back to sea without laying eggs.

On the west side we had better luck. A hawksbill turtle had just started digging her nest. It would be fifteen to twenty-five minutes before she finished digging and began laying her eggs, so Chucho and Norma drove on down the beach to finish checking their study area. Juan and I watched the powerful rear flippers of the hawksbill alternate as they scooped out the sand.

At this time I spoke no Spanish and Juan spoke no English. Chucho had told him to stay with me, that I

was waiting to photograph the turtle laying. As soon as the headlights of the jeep disappeared, I realized I did not have a flashlight and therefore would not be able to focus well enough to take the pictures. Of course Juan did not know this.

Fifteen minutes later, when the first of 230 eggs came out, Juan excitedly pointed to the turtle's tail (the hawksbill lays many more eggs than the other two species). The longer I went without taking a picture, the more anxious Juan got. He was thinking I did not know the eggs were coming out. Finally, he reached in the hole and pulled out an egg to show me. In the faint moonlight I could see a round egg with a dent in it very similar to a damaged ping-pong ball. When the other two biologists returned thirty minutes later, I was trying to tell Juan in sign language that I could not focus in the dark. He laughed on getting the translation from Chucho.

We collected the eggs and replanted them in a fenced-in area near the army barracks in El Cuyo. Here they would be safe from man, dog, and raccoon. The biologists were very careful to measure the depth of the hole from which they removed the eggs so as to replant them at the same depth the mother had used. Recent studies indicate that soil temperature influences whether the eggs hatch as male or female. Data are recorded on species, size of turtle, depth of nest, number of eggs, and location. When the baby turtles hatch in sixty days, they will be released at the original nest location.

Later in the season, I joined the biologists to release a nest of squirming baby hawksbill turtles. At midnight we drove up the beach to the spot where the eggs had originally been laid. Chucho and Isabel gently took the babies out of the bucket and set them on the beach. All headed toward the jeep's headlights rather than the water. But once the lights were turned off, the troupe turned and headed directly for the sound of the surf.

Baby turtles are programmed genetically to swim hard for two days; then they relax and the currents carry them to convergent zones, like a rip tide or the Sargasso Sea. Here they stay for a few years, hiding and feeding in the mass of weeds. Oil tar and plastic also converge here. Some baby turtles get tarred or wrapped in plastic and die, which adds to their already high mortality rate. Biologists say only five out of every one hundred make it from eggs to breeding adult.

Turtles can expect to have more problems in the future as their nest sites vanish. Beaches, particularly on the Caribbean coast, are being gobbled up by development at an unprecedented rate. The success of Cancun has put pressure on every beach between this booming resort city and the northern edge of the Sian Ka'an biosphere reserve. On a flight down the coast, I saw hotels, condominiums, or at least bulldozer tracks, on virtually every beach there. Developments bring lights,

people walking on the beach, and a loss of the sand to erosion. All these factors are detrimental to the turtle.

In Cancun, where the island is nearly totally developed, almost every turtle nesting habitat has been disturbed and many are lighted by highrise hotels. A few hotels have taken an interest in helping the turtles. The Royal Maya Condominiums is one that wants to help. One June night I went with SEDUE biologist Ignacio Pedroza to look for turtle nests near the Royal Maya. We found one green turtle nest that night and relocated the eggs at a safer spot by the condominiums. This turtle had laid her eggs on the darkest spot in the gap between two big hotels. The dark gap will not be there next summer. A new hotel will, with its new lights shining on the beach. Perhaps this turtle will never return.

Ecotours are the adventures and educational vacations of the future. Perhaps the monies these generate will cause developers to set aside some areas for wildlife. Earthwatch, one of the original ecotour organizations, is helping Mexico with a turtle watch in Quintana Roo. I met Tundi Agardy, their principal investigator for 1988 and a research fellow at Woods Hole Marine Laboratory. On leave from her regular job, she is re-

sponsible for ten beaches south of Playa del Carmen. These beaches are worked all night, every night during nesting season, by volunteers who pay for a ten-day working vacation. Participants can go back home knowing they have done something for the good of the earth. Tundi and her crew try to get local people involved by passing on their knowledge about the ecology of sea turtles. Locally the marines are helping patrol the beaches, and they are pretty enthusiastic about it. Tundi told me that on her first week there, a very excited marine came running up to her while on beach patrol. He was yelling, "I slit his throat." Tundi's first thought was that the marine may have killed an egg poacher, but she shrugged that off and asked him to calm down and tell her what had happened. He had killed a coatimundi that he found digging up the eggs.

Earthwatch will return for five years to get the turtle program going. Then they will turn it over to the Center for Investigation of Quintana Roo, or CIQRO. With CIQRO and SEDUE and Earthwatch helping, perhaps the future of the sea turtle can be secured so that divers in Mexico and the world over may experience that special moment when this graceful reptile glides by.

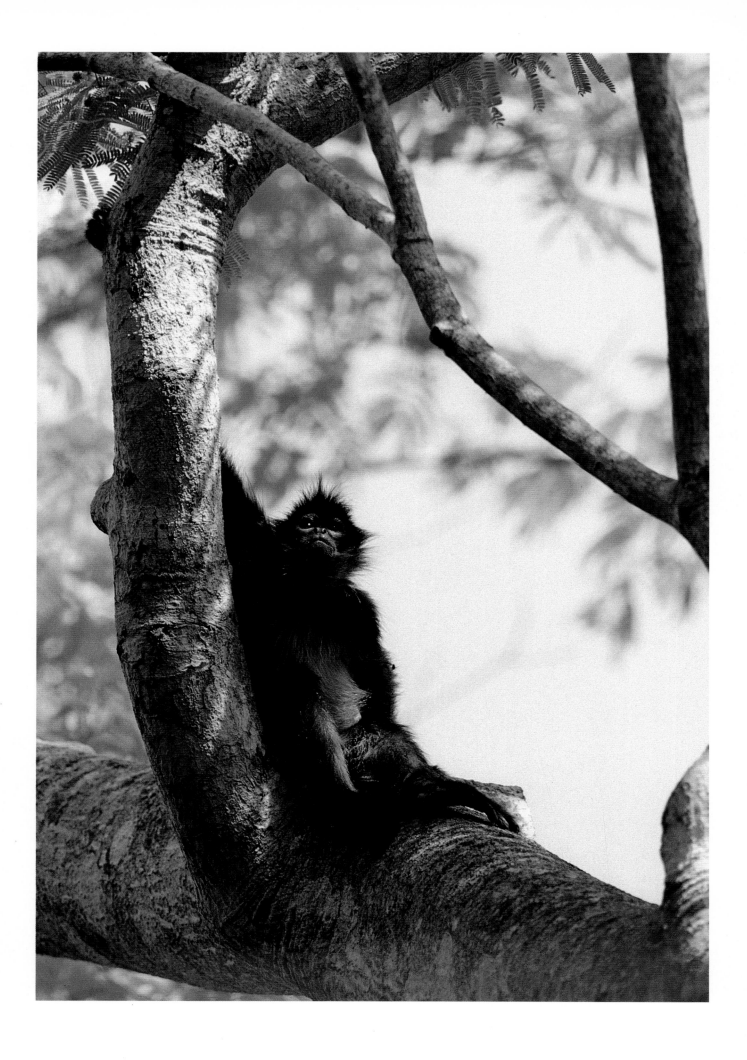

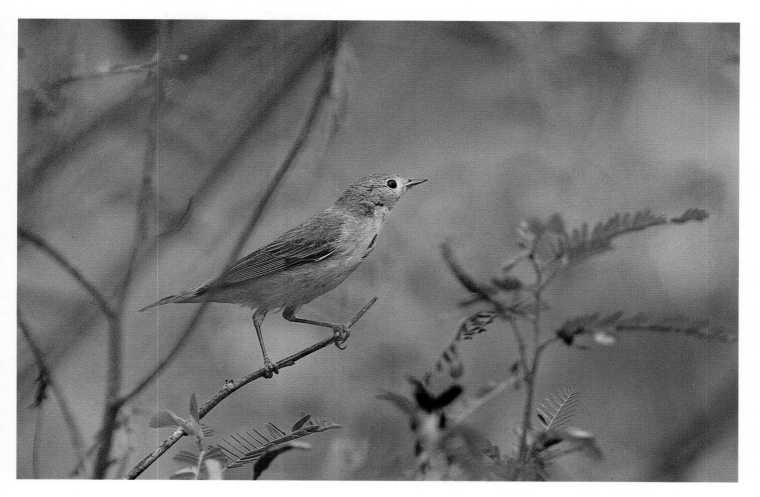

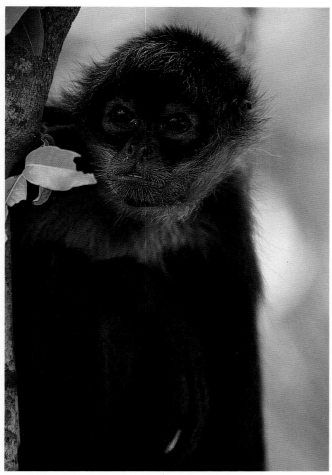

The jungle is habitat for native animals like the spider monkey (left and far left) and for migrants like the yellow warbler (top).

A zebra longwing butterfly feeds on Eupatorium odoratum *(top). The boa is a common snake on the peninsula (left). Almost camouflaged, the pinnated bittern perches on a red mangrove root near Río Lagartos (right).*

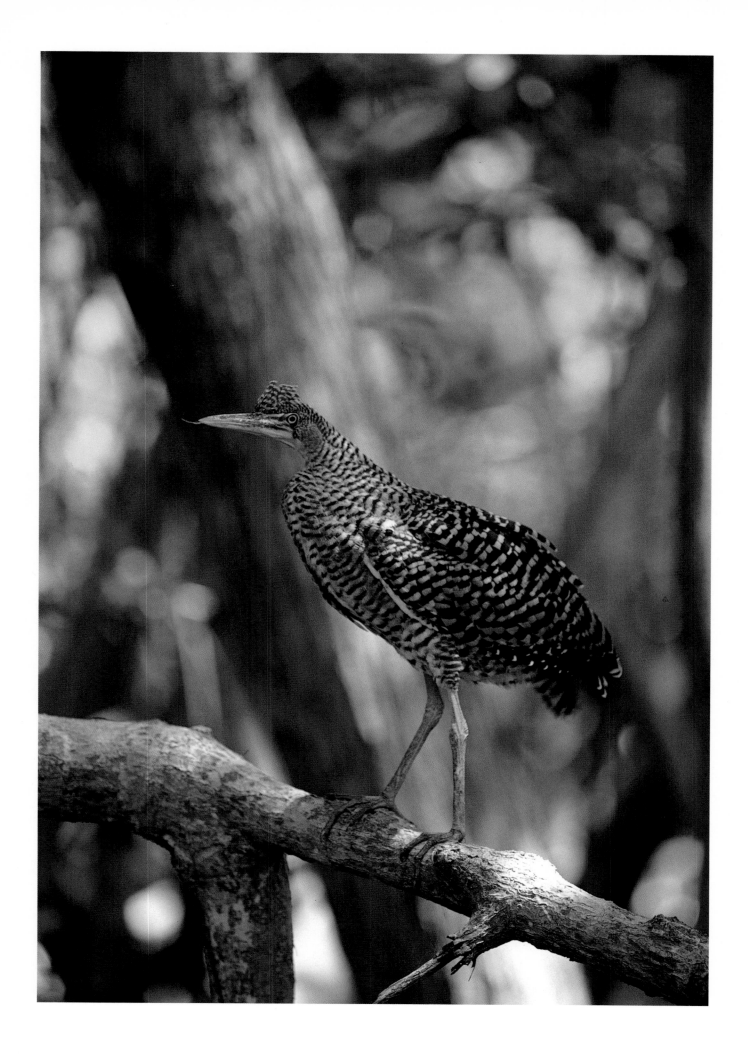

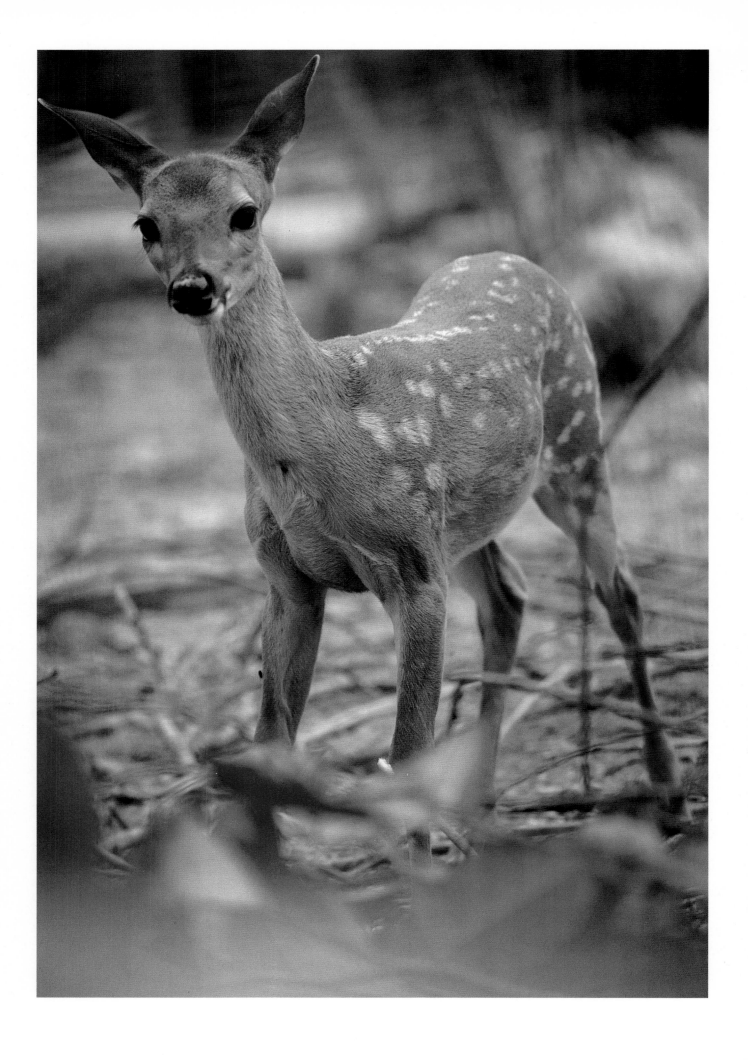

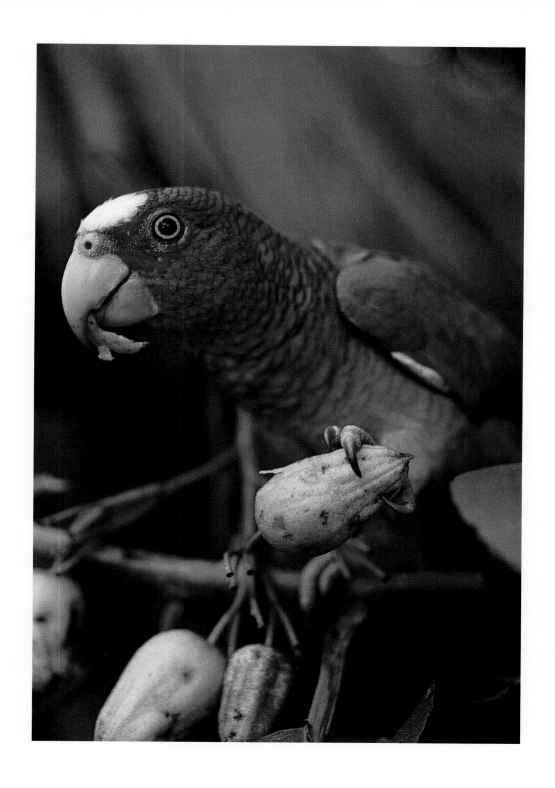

Of the two species of deer native to the Yucatán, the white-tail is the largest. A fawn standing alert (left) is as big as an adult brocket deer. The Yellow-lored or Yucatán parrot was one of my favorite birds. Here one chews on zericote seeds (above).

Predator and prey. A roadside hawk resting in a light rain (right) *would call the male spiney pocket mouse supper any time he had a chance* (above).

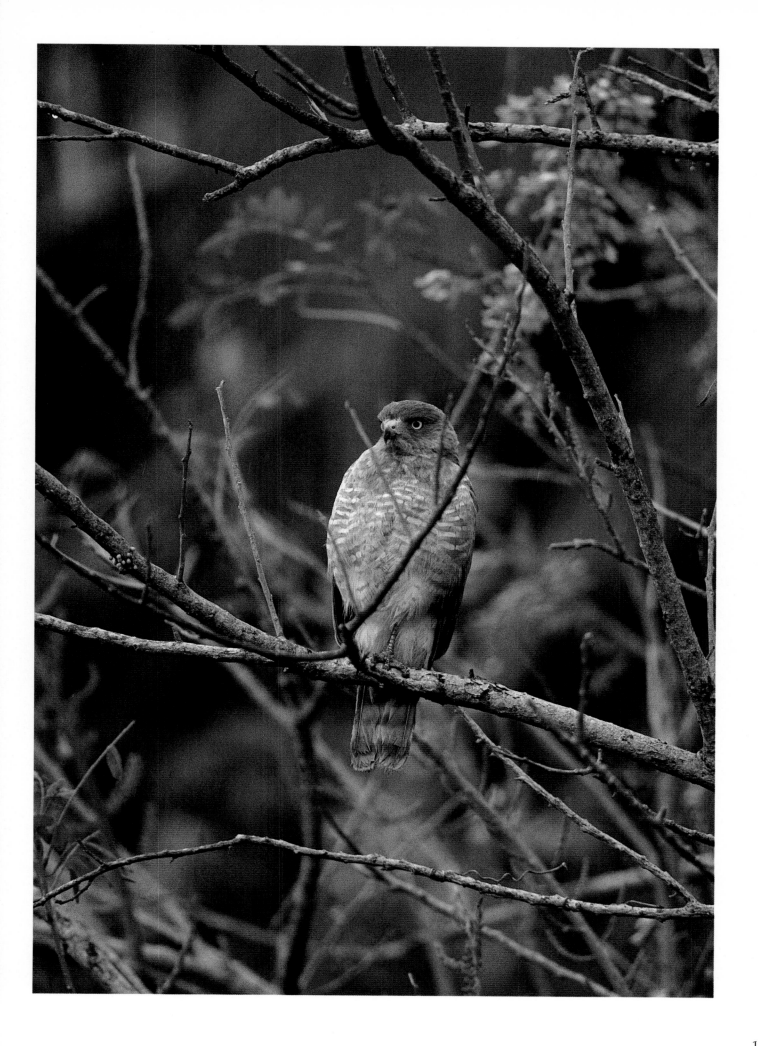

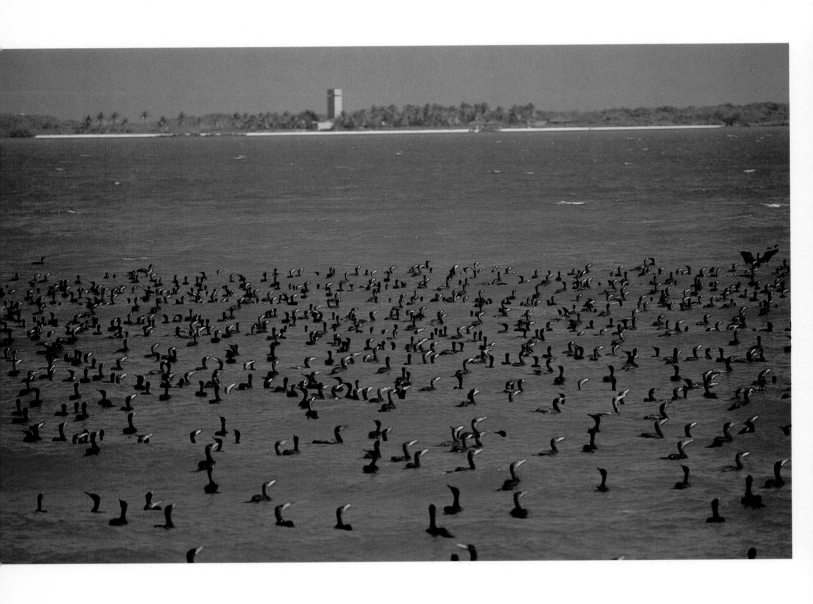

A contrast in colors: black cormorant rest in blue waters in front of Isla Contoy National Park (above), while royal terns watch over their nests with flamingos in the background (right).

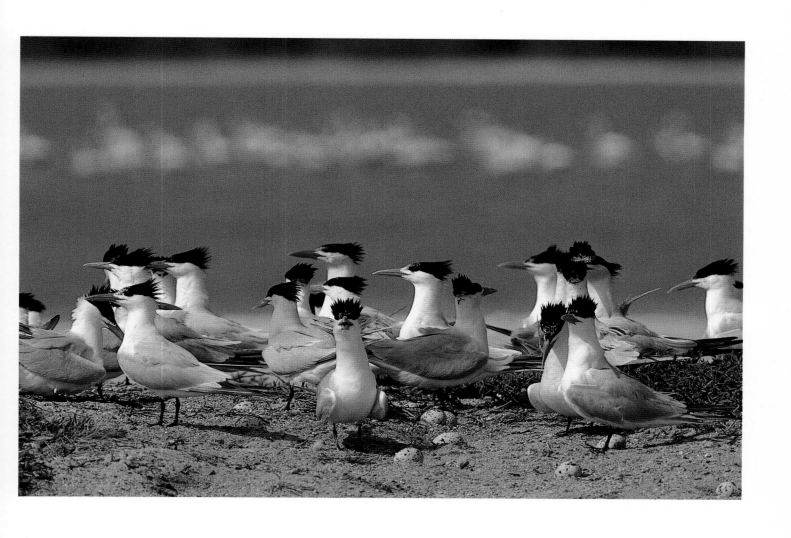

An aerial view of Río Lagartos (overleaf) shows the more natural part of the estuary where the flamingos nest.

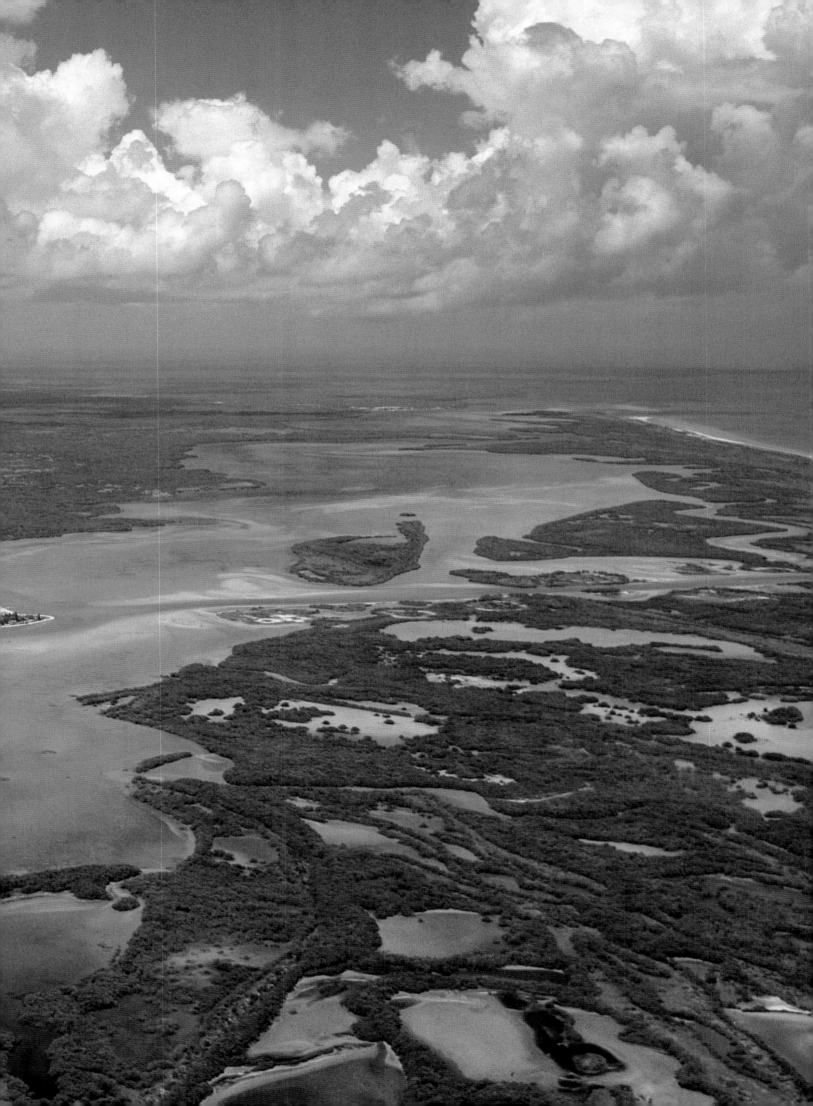

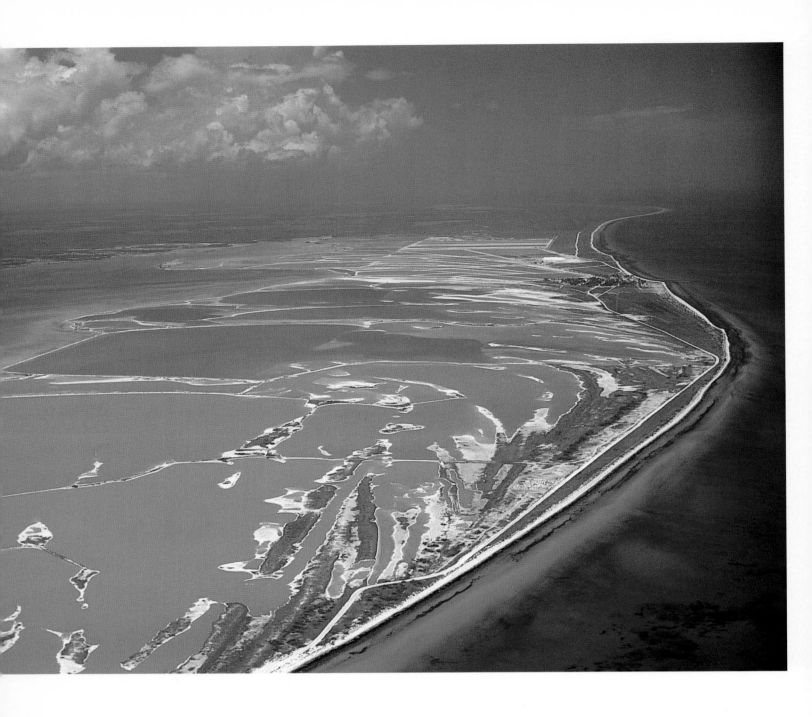

A few miles east is the salt factory at Los Coloradas, with its man-made evaporation ponds (above). As long as the ponds do not encroach any farther, this magnificent flame scarlet bird can survive. A tireless salt worker carries a heavy load to shore to stack in the conical piles seen in the background (right). Aggressiveness by fishermen and tourists can have a detrimental effect on the fragile birds (top right).

Flamingos are here incubating their eggs. There were over five thousand birds on the island when this picture was taken (overleaf).

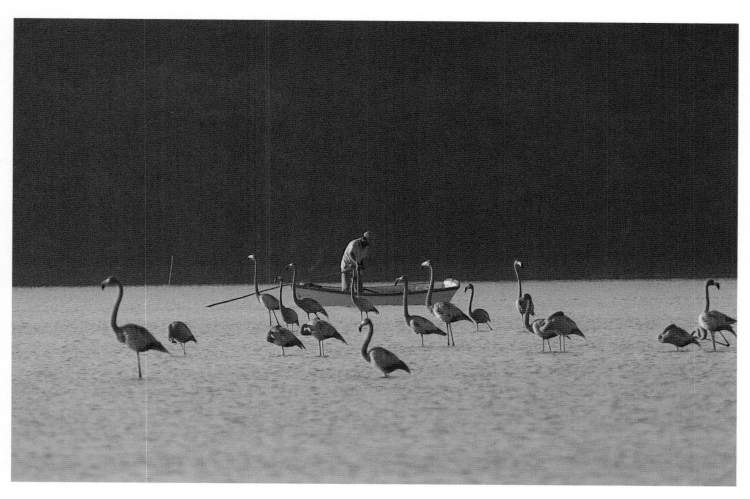

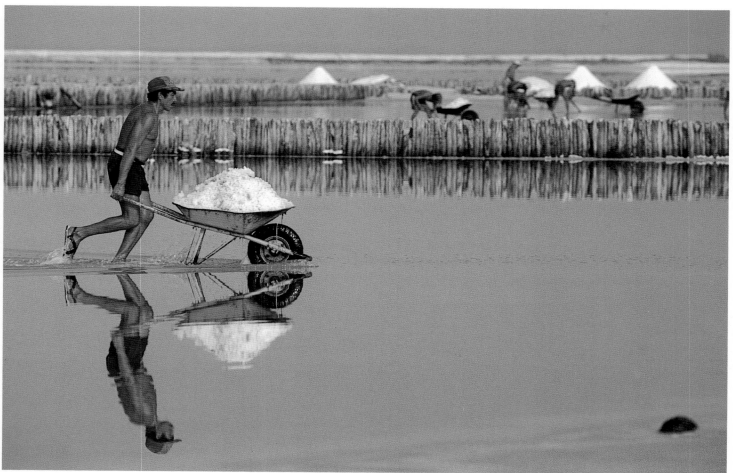

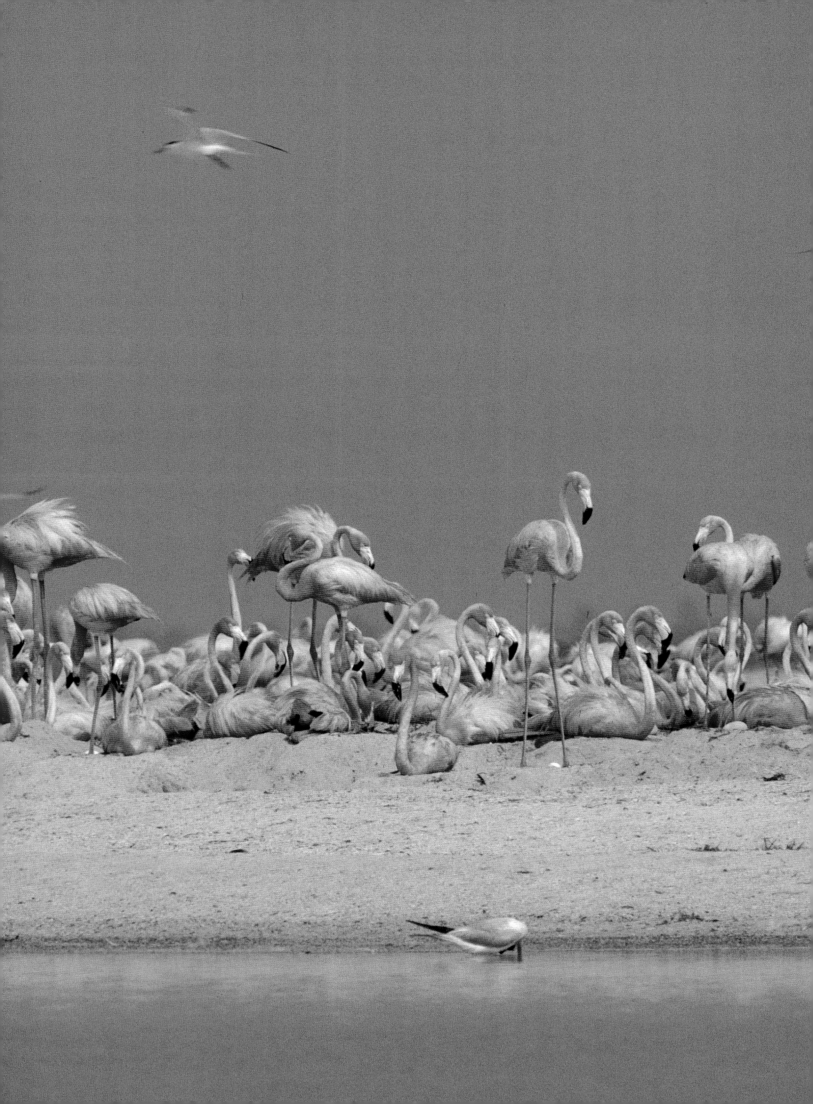

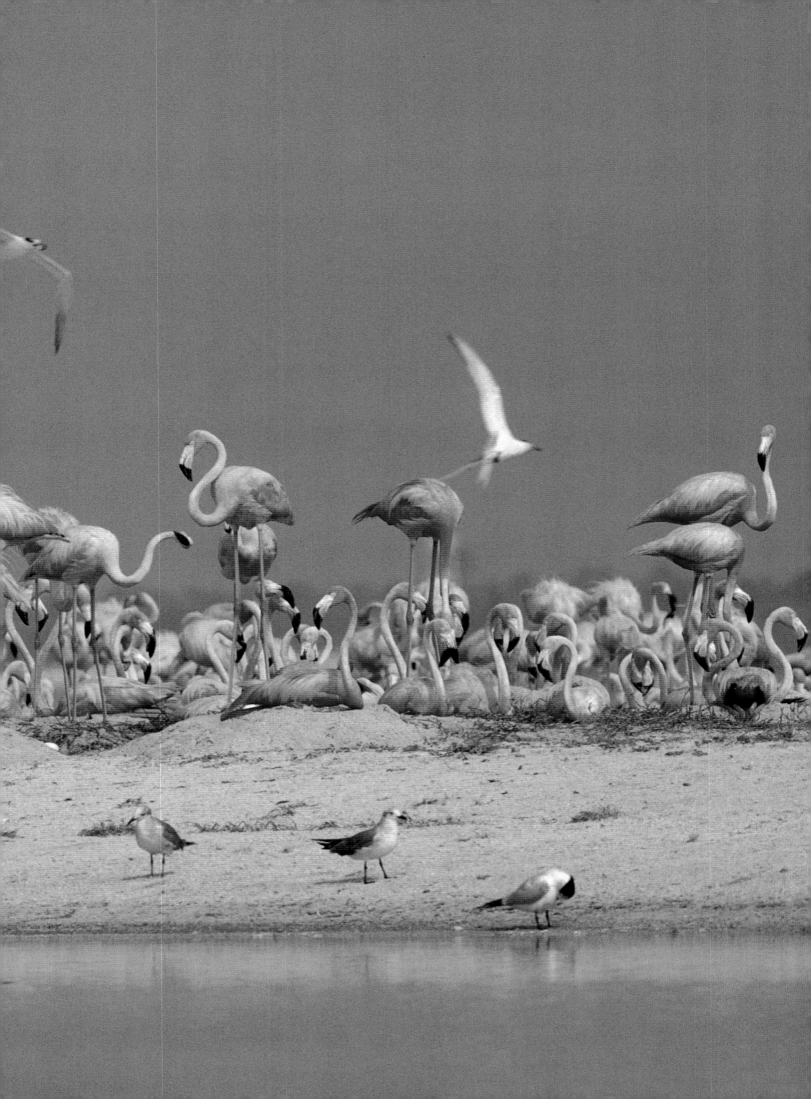

The chain of life for most Yucatecan estuaries starts with the red mangrove (right). Its leaves fall among its tangly prop roots (top) and eventually drift out into the estuary at high tide, finally disintegrating into detritis, a food for the lower organisms (bottom).

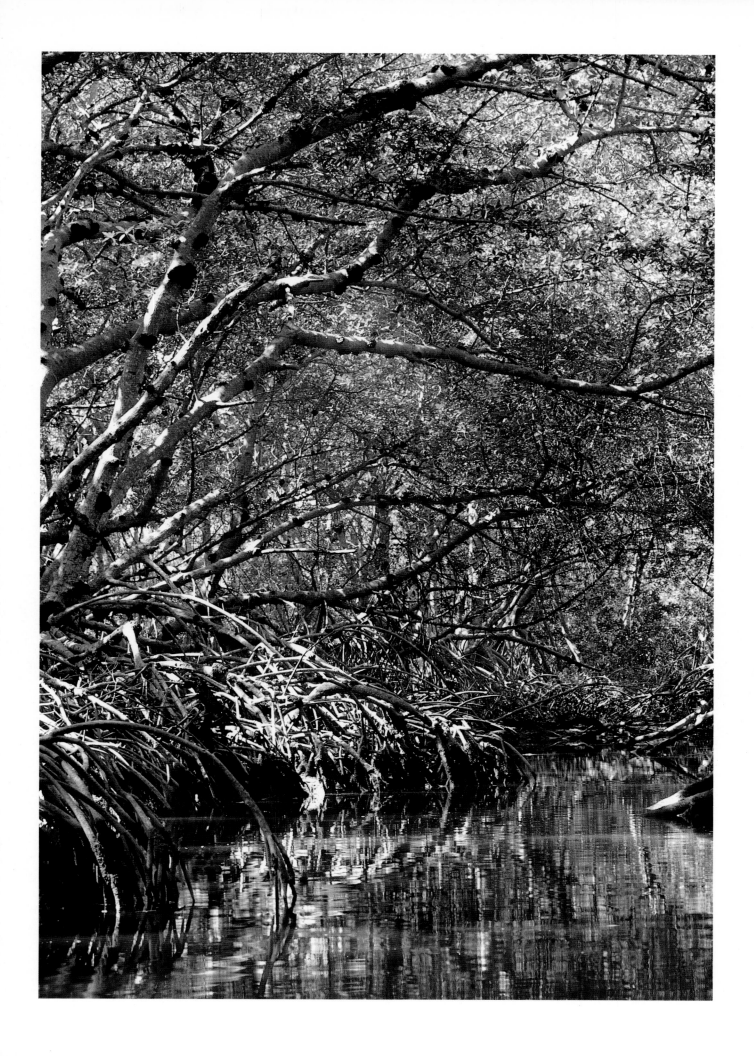

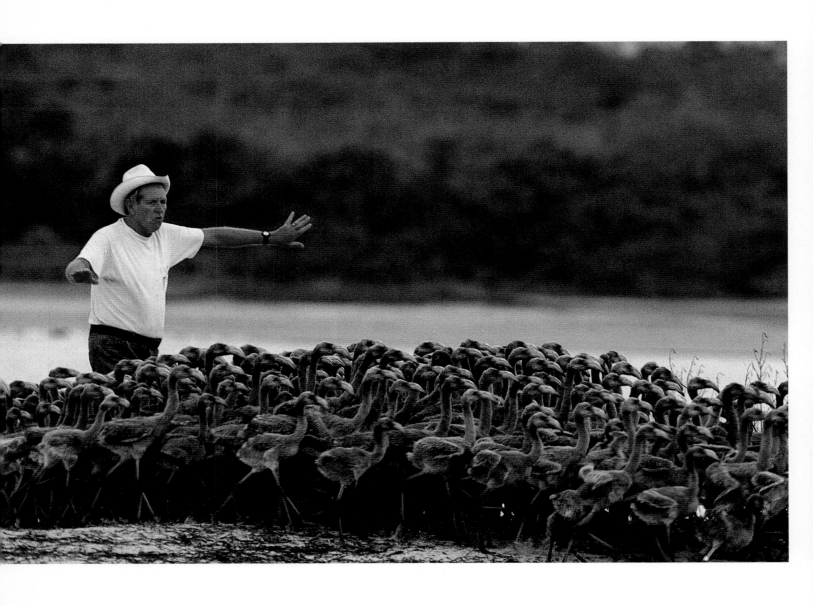

Sandy Sprunt of the National Audubon Society herds flamingo chicks into a trap (above). He and Jorge Correa of SEDUE put bands on a young bird. The blue band, signifying that the bird was born in 1987, will allow biologists to know how old the birds are when they start breeding (right).

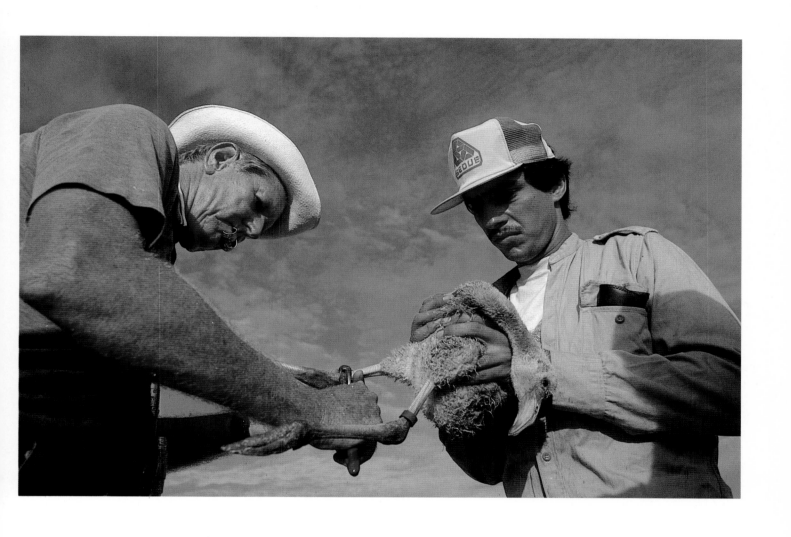

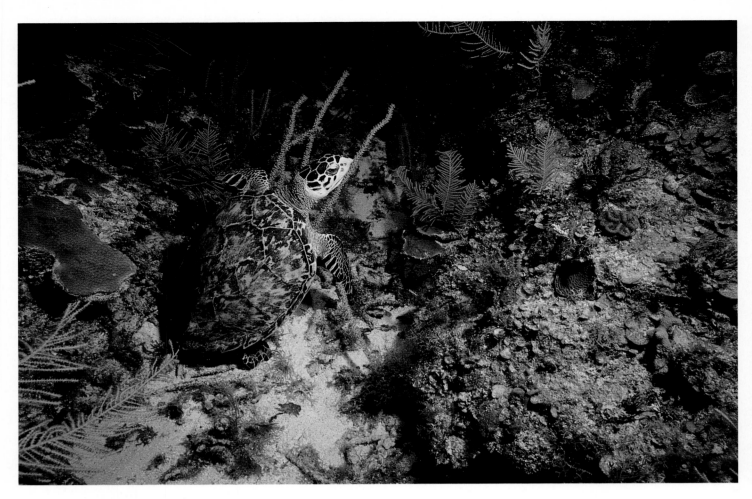

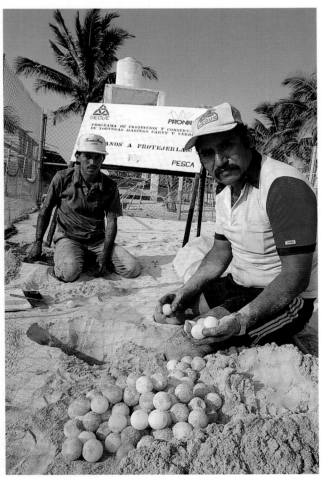

A hawksbill turtle on the reef at Akumal (above). SEDUE biologist Jesus Garcia and his helper Saul Pacheco rebury the hawksbill eggs in a protected area at El Cuyo. Here the eggs are safe from poachers and predators (left).

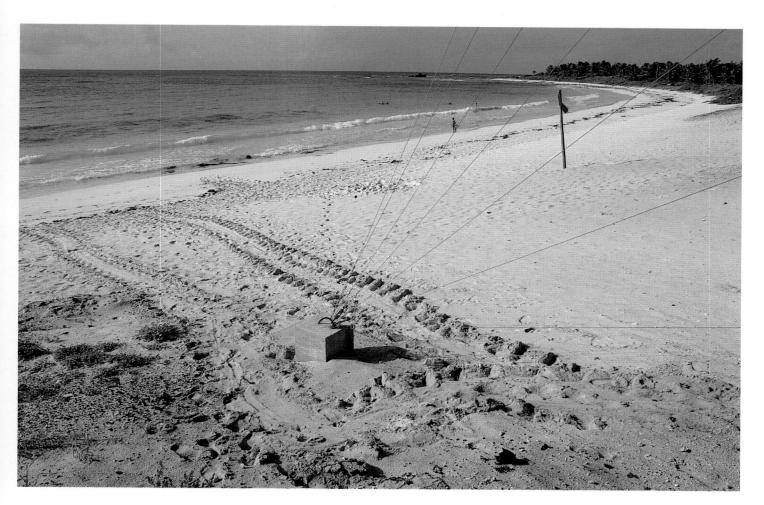

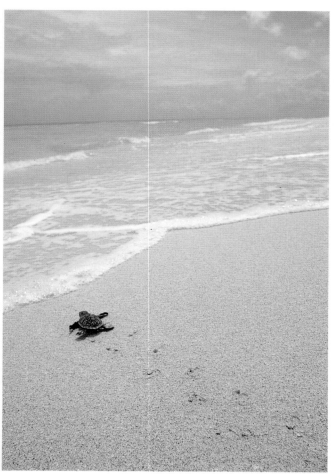

Habitats for green and loggerhead turtles are declining on the Caribbean coast of the peninsula, since almost every beach between Cancun and Tulum has some sort of development on it. At Xcacel a turtle finds an anchor to a new radio tower unattractive and returns to sea without nesting (above). Things are better on the north coast where a recent hatchling from the SEDUE project makes its way to sea (left).

A not-so-shy young Yucatecan poses for the author's camera in Río Lagartos.

PEOPLE

My intentions were clear when I started this project: to photograph as many plants, animals, and fishes as I could find in the peninsula. In my travels, I found much more. The people, their history and their architecture, offered material for another book. It was hard to pass up the smiling faces of children, the vibrant colors of the markets, or the subtle mysteries of the ruins. At first, I just looked at these scenes; then I took a few photographs for my personal scrapbook. But finally I realized these subjects demanded a place in this book. The Maya have been here a long time. I enjoyed being with them, learning from them and from their culture.

A chance to see a citreoline trogon who was feeding regularly in a roble tree brought me my first view of a Maya village. I was at the Andrews' home in Mérida, and Luz told me of the tree because it was attracting the trogon and other birds. The tree was at the ruin Mayapán near his hometown of Telchaquillo.

That evening David Andrews, Luz, and I drove the seventy kilometers south to Telchaquillo, planning to arrive after supper so the family would not raise a fuss over us. We got there just before dark to find one of Luz's brothers up in a ramón tree, cutting leaves to feed their livestock. The leaf of this tree is very nutritious for cattle, mules, and horses. The tree's fruit, called the breadnut, has served as a staple for the Mayas during hard times.

Luz's mother, father, and some of his brothers live in a compound made of two small cinder-block buildings and two thatched *palapas*. The compound is partially enclosed by a rock wall, and the yard is full of animals. There were pigs, goats, chickens, ducks, turkeys, dogs, cats, a horse, and a cow. I received a friendly welcome as the family ushered us to the kitchen fire and immediately started cooking supper for us. Our beg-offs, which included saying that we had already eaten, meant nothing.

Soon we were talking while dipping tortillas in black beans and salsa, then picking up small pieces of pork right off the fire. A few neighbor men joined us and the conversation picked up. I noticed some tension in the air, but as usual missed the actual conversation. When David asked, "Are you ready?" I said, "For bed, sure; we've got to get up early." "No," he said, "for a coon hunt."

The conversation had been about how the raccoons were digging up the recently planted corn seed. We were going to the *milpa* to shoot the coon. Luz, David, and I drove about three kilometers and parked near Mayapán. Luz's brothers and the other men followed on bicycles. They had one shotgun and six dogs.

After walking down a trail through the woods, we came out in the first *milpa*. One of the men showed me how they planted corn. It was simple. All they did was make a hole with a pointed stick and drop four kernels of corn in the hole. We quickly found coon tracks and signs of where they had dug up the seeds.

Soon the lead dog was off on a scent. The other five stayed with us. The men told me that only the lead dog was smart enough to track an animal. The rest would stay with us until he got close and started barking; then the other dogs would join him. Forty-five minutes later we heard the barks. The Mayas and the dogs took off. I followed, running with my cameras jangling around my neck. With two head lamps and one flashlight among the nine of us, it was an exciting run across the *milpa* and into the woods, then *milpa*, then woods again. The barking increased. The coon was treed. I caught up just in time to see the coon drop.

Not only was the corn thievery going to slow down, but the folks had supper for tomorrow night. It was close to midnight as we started back. The lead dog did not know we were finished and soon slipped away toward another scent. The barking started again, and we were off. We caught up quickly because the dogs had turned and were coming toward us. One of the head lamps turned on the noise. It was an armadillo, and the lead dog, holding onto the tail, was being dragged by the armadillo. The dog was on his side, but he wasn't letting go.

Luz jerked the armadillo away from the dog and held it over his head to keep the other dogs from biting at it. The lead dog flopped over whining. We quickly saw the trouble; there were two fang holes in the dog, better than an inch apart. A rattlesnake bite. With David in the lead, some of the Mayas began first aid. They shaved the wound, cut it open, put on a tourniquet, squeezed out the poison, put gun powder and tobacco juice on the bite, as well as a jar of some Maya remedy they were carrying. The still dog looked to be in bad shape.

The rest of the men had back-tracked to find the snake. When we heard a shot ring out through the woods, we knew they had found it.

Back in Telchaquillo, David and Luz decided to drive

the dog to a veterinarian in Mérida. They were back by six A.M., with news that the dog had died that morning. This was a big loss for Luz's family; it would take awhile to train a new lead dog. Not much was said about the dog. The people just went on with their daily lives.

That morning I went to Mayapán. The guard, who happened to have been one of the hunters with us the previous night, showed me the roble tree. I set up my camera and promptly saw eleven species of birds land in that fruit-laden tree.

Later that year, I was passing through a small village just south of El Cuyo called Luis Rosada Vega. There were three young Maya girls pulling buckets of water up from the village well, and I stopped to photograph them. They were shy and did not seem to understand my Spanish. Before I knew it, kids were coming from everywhere. The children were all between five and fourteen years old. Two of the older girls spoke a few words of English, and soon we were talking away in Spanish. (I had finally learned a little.) They told me the younger kids only spoke Mayan. They asked if I knew any Mayan and I said *sac* (*white*) and *dios botic* (*thank you*). When they found out I was single the younger girls began teasing the older ones that I was a potential husband.

I was having a hard time explaining to them what I did for a living and why I was there. So I got out my book, *The Gulf Coast,* and showed it to them. Before long I had thirty-three kids crowded around the hood of my rented car. When we turned to a picture of an animal they recognized, we traded names—like *raccoon* in English, *mapache* in Spanish, and *culu* in Mayan. I was having fun. When we finished the book the kids showed me around the village and some introduced

me to their parents.

When they asked me if I wanted to see their cenote, I told them I was very interested, as I had been diving in them. A cenote is a cavern with a roof that has fallen in. It usually has underground water associated with it. There are thousands of cenotes throughout the peninsula. Almost all villages are located near a cenote, because it's a reliable water supply.

The cenote at Luis Rosada Vega had two openings. One required a jump or dive forty feet down into the water, and the other opening led down a little cliff to a ledge with a more reasonable jump to the water.

I inquired as to whether I could snorkel in the cenote. They said yes and were eager to watch, as very few of them had ever seen a mask and flippers. One of the older fellows who had just joined the group of kids asked if I would look for his watch he dropped in there. I said I would.

The kids got a rope for me to use climbing down into the second opening, and I jumped into the water. It was very clear, but so dark I could not see the bottom. I swam down thirty-five feet and still could not see the bottom, but I did see the possibility of a cave. Wishing I had a scuba tank, I surfaced, disappointing the man who had lost his watch.

A few of the kids tried out my mask and snorkel; then I took them all back to the village well for a group shot. We joked around some more, and I let them take some pictures of me. It was great fun visiting that village and many others in my travels. The friendliness of most all of the people I encountered on the Yucatán Peninsula made my many days there especially pleasant.

Vegetable market in Mérida.

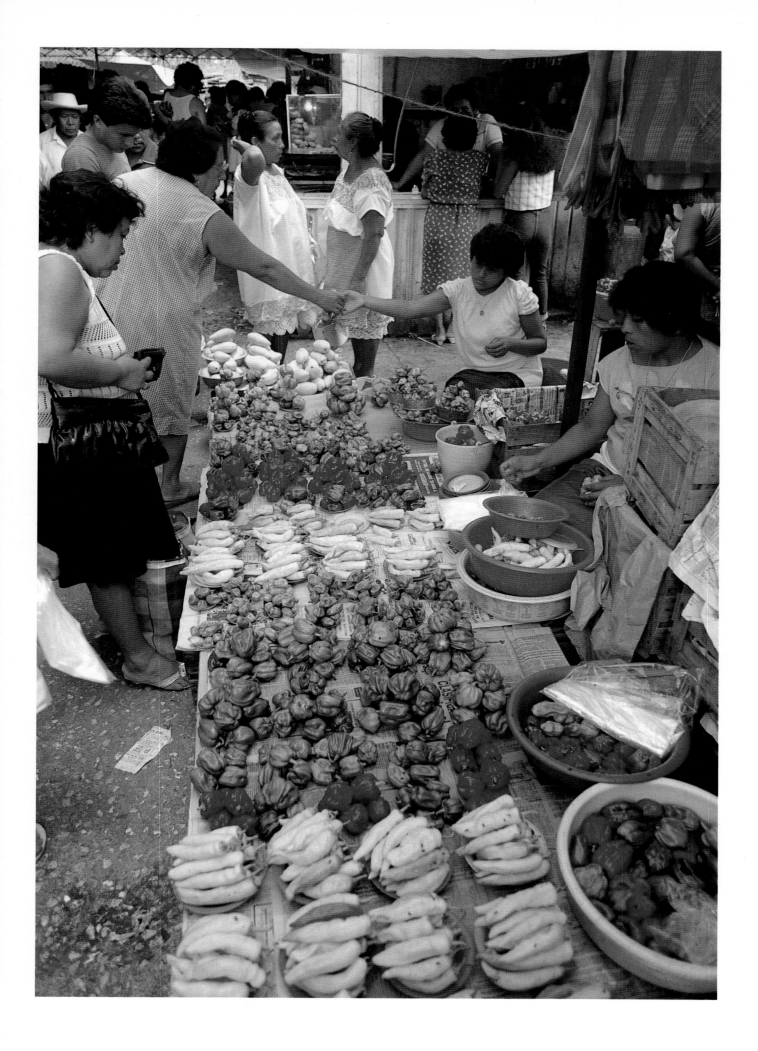

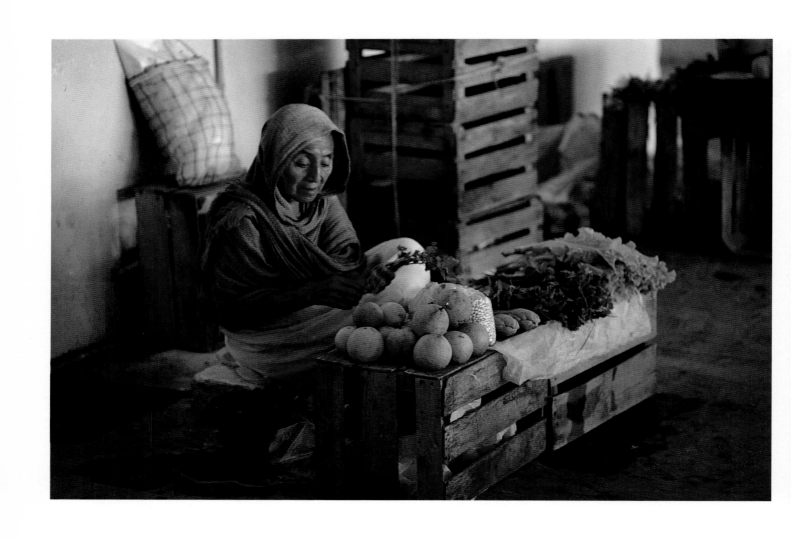

A Maya vendor in the city market in Valladolid.

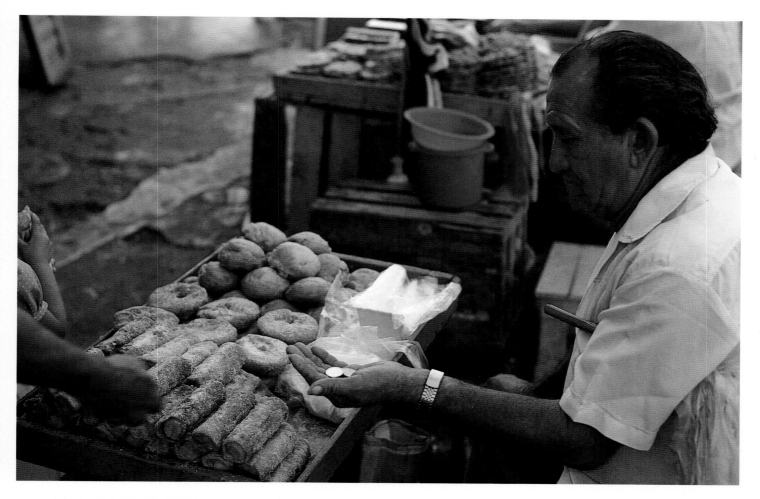

Downtown Mérida houses a major market area where one can buy just about anything, from street foods (above) to animals. Crowded cages of cardinals and at least twelve other species of wild animals were for sale.

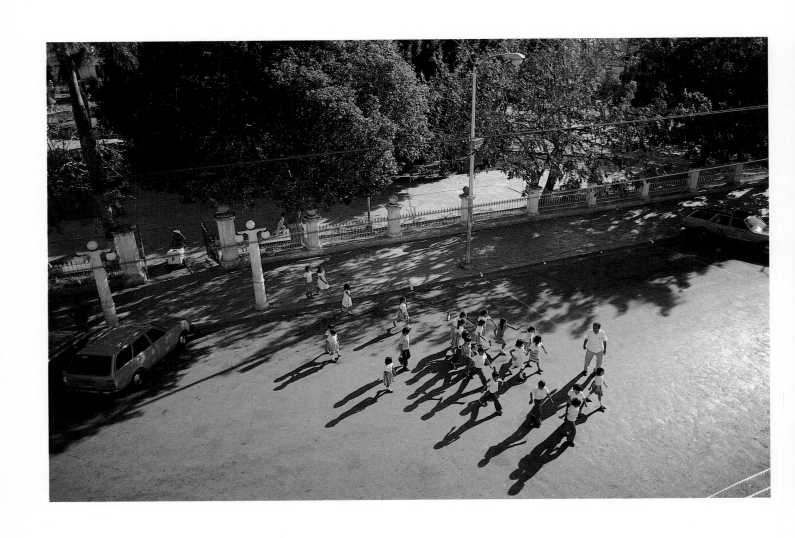

School children return to classes at the town square in Valladolid.

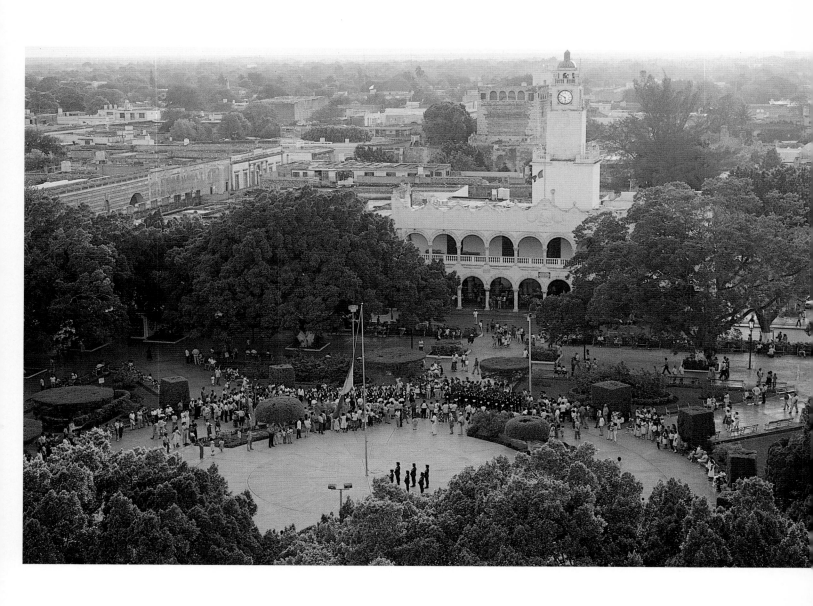

Pomp and circumstance, as well as blocked-off streets, make the Sunday evening flag-lowering ceremony a sight to behold in downtown Mérida.

123

Left behind while his master is out fishing, this Celestún dog finds a comfortable spot in the nets.

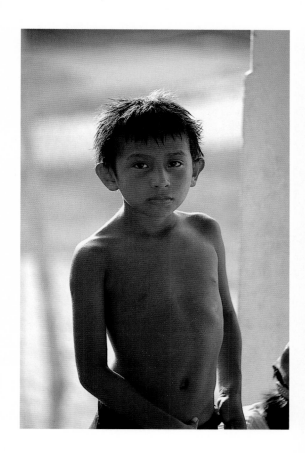

Maya boy (above). The brilliant red of the flamboyant tree shines in the last blast of sun before a thunderstorm. Teapa (right).

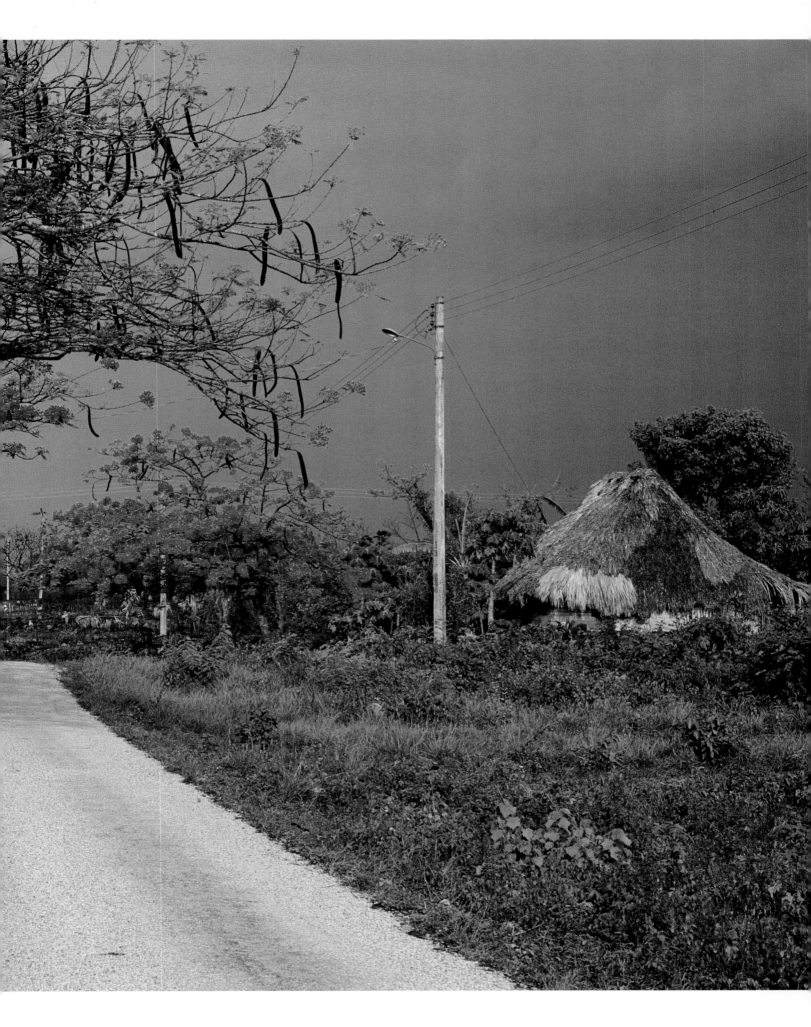

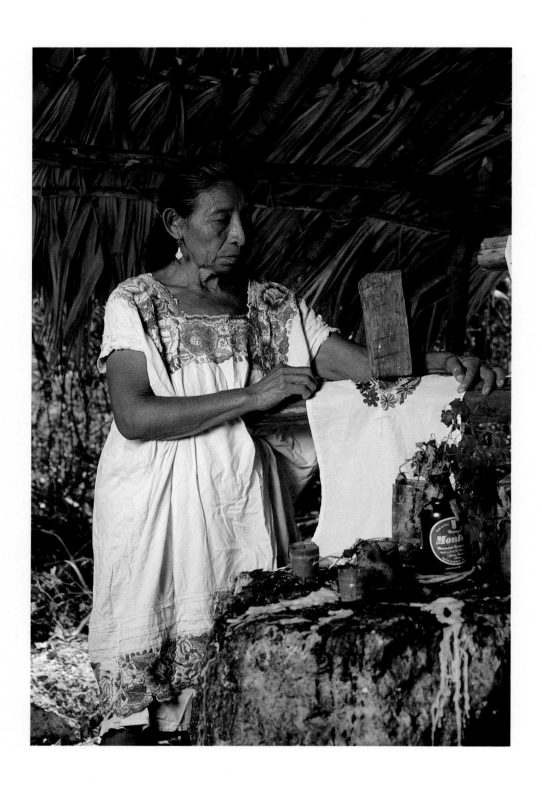

A Maya lady at Punta Laguna adjusts the decoration on a Catholic/Maya shrine (above). A full moon rises over the Temple of Seven Dolls at Dzibilchtun. The ancient Maya were very knowledgeable about astronomy and built many of their structures in relation to the activities of the sun and moon (right).

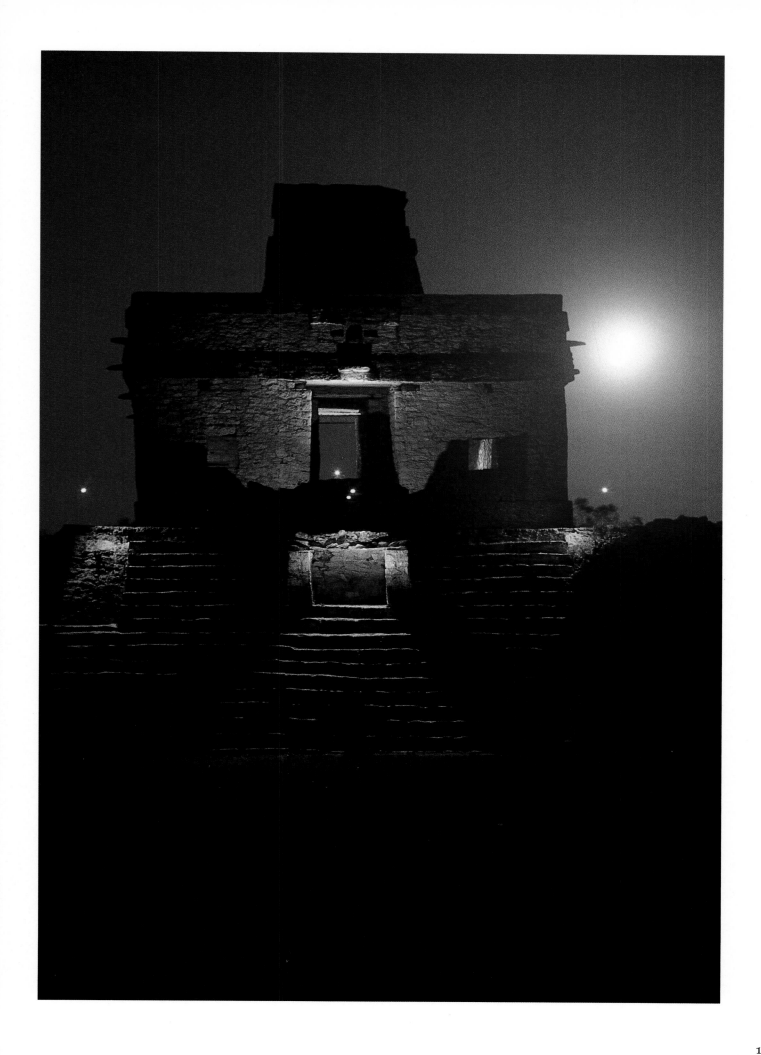

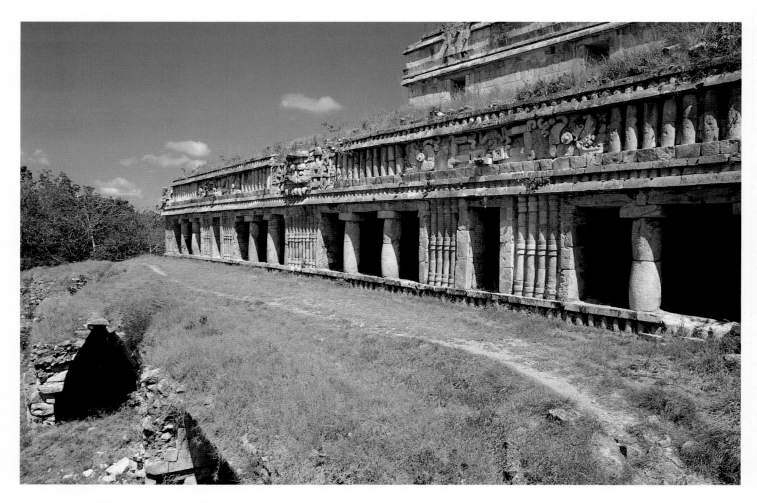

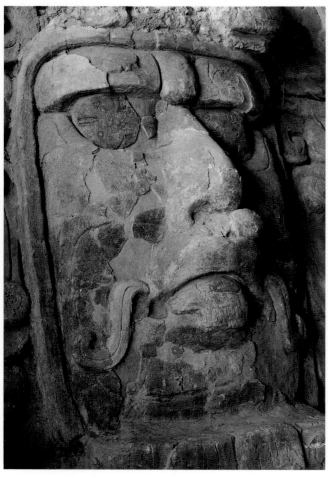

The Maya were excellent builders. The palace at Zayil is particularly beautiful (above), as are the man-sized masks at Kohunlich (left). A modern-day Maya wall-builder (right).

Gill net fishermen clean and fold their nets on a Gulf of Mexico beach south of Celestún. The youngest fisherman tosses aside a starfish, the creature many tourists like to bring home with them (overleaf).

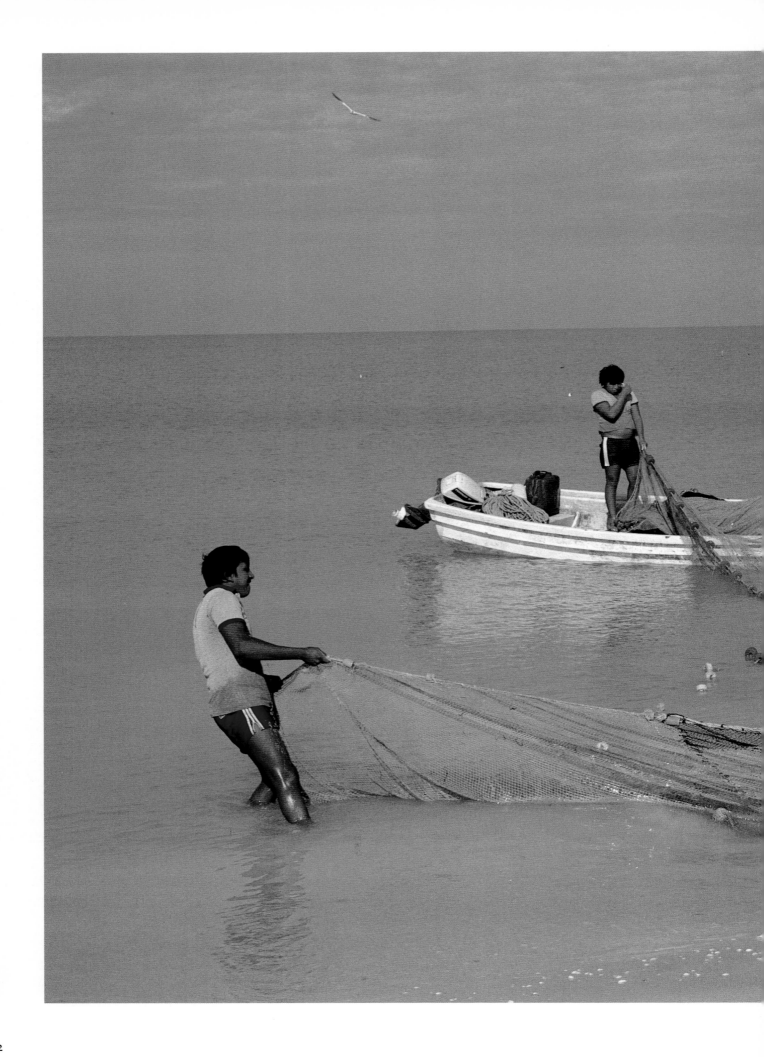

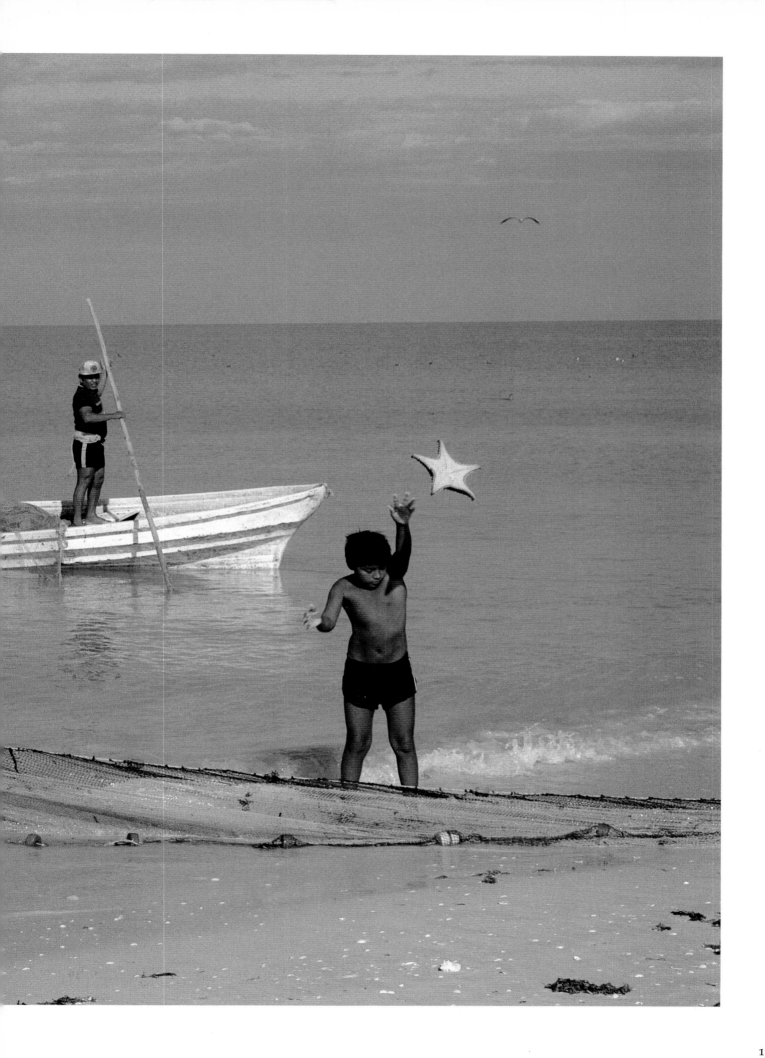

Cave-diving with Jim Coke can be quite an ordeal. After walking for half a mile through the jungle, he and Cy Goulet then climb down 25 feet with 110 pounds of gear to get to the water.

CENOTES

My least-expected discovery in the land of the Maya was cave-diving in the cenotes. Cave-diving had meant nothing to me. I had never had any desire to try it. I had heard stories of divers lost or drowned in Florida spring systems. And other stories of caves lacking in color and diversity of fish life had left me totally uninterested. Reef-diving seemed to offer so much more.

When I was in dive shops along the Caribbean coast asking where the best places for underwater photos were, I listened as people recommended Cozumel for wall-diving, Akumal for turtles, and Banco Chinchorro for wrecks. When they mentioned a cenote dive, I paid no attention. I just was not interested.

It was almost a year later that I changed my mind. On a hot day I jumped in the Carwash Cenote with mask, snorkel, and fins to cool off. It is called the Carwash because it is one of the few cenotes one can drive right up to, and many of the local cab drivers wash their cars there.

The Carwash has an algae bloom each summer during the rainy season. Its waters, usually crystal clear, are a murky greenish brown from the surface down to eight feet. My companion said it was clear below, so I snorkeled down below the murky layer and into the opening of the cavern. Looking back toward the sunlight, the view was awesome. The black silhouette of the cavern ceiling, including stalactites and dangling roots, framed the multicolored scene beyond. The emerald green grasses bending gently in the current were on the bottom. Then a layer of cobalt blue water, topped by the murky brown layer, let only a few shafts of sunlight through. At that moment I decided to be at least a cavern-diver.

A few months later I got Jim Coke, cenote explorer and certified cave-diving instructor, to teach me cave-diving. After the initial lecture he took me back to the Carwash to do a cavern-dive. First we did the exercise of running a line, practicing various flipper kicks designed not to stir up sediment; then we toured the cavern. Even though it is dark, it is a massive room large enough to drive a Greyhound bus in. At the end of the cavern zone, after which one can no longer see light, is a sign. The sign is white, with big red letters saying: "PREVENT YOUR DEATH. Go no further unless trained in cave diving. Many open water divers (even instructors) have died attempting to dive caves. Please heed warning." It makes its point quickly, discouraging untrained

divers from making the mistake of a lifetime.

Luke Boissoneault, a diver from Canada, almost made that mistake on November 21, 1985, just before trained cave-divers came to this area. Luke was observing an open-water diving instructor teach two students an advanced diving course. The morning dive was their deep one, and they had gone to 120 feet for fourteen minutes in salt water. Then the instructor decided to simulate their night-dive requirement in the Carwash Cenote so that the two students could go back to Cancun that evening.

The instructor was not cave trained, and he was not following any of the very important safety rules of double tanks, two regulators, and three flashlights for each diver. It is also essential to have run a continuous line from the surface to your destination. They didn't. The instructor buddied with one of the students and put Luke with the other. They went in, following some frayed ski rope that a previous diver had left. The rope was broken in two places, allowing a panicked diver the opportunity to turn the wrong way.

These haphazardly laid ropes led to a slate where one could sign his name saying he had been there. The instructor was the only one of the group who had ever been in a cave before. He and his buddy signed the slate and turned to exit. When Luke and his buddy had finished, they turned to find that they were alone, and neither knew which way to go. Luke's buddy then panicked, sank to the bottom, and stirred up silt.

Luke calmly waited for the silt to clear, and when it did he was alone. He then began to swim out, but chose the wrong way. As his air started to get low, he looked for air pockets on the ceiling and found a few, copping a breath here and there. He was starting to panic and was breathing faster. Soon he had only a few minutes of air left. Still swimming the wrong way, he saw a mirror-like reflection on the ceiling, a large air pocket he thought. He poked his head through, spit out his regulator, and took a breath of real air. Then he saw light, and a small hole he could crawl out of. He was not ashamed to tell me he had cried and prayed as he pulled himself up into the jungle. Today that entrance is called Luke's Hope.

With proper training, cave-diving can be practiced safely and is well worth it. It is a whole new realm of diving, just as it is a whole new realm of caving. To compare cave-diving with land-caving, you can figure

the latter is much messier. In a land cave one is crawling, or slipping, or stumbling over a wet and muddy environment. It is dark and musty, and it smells of bat droppings. Cave-diving feels like flying, as the water is so clear it seems nonexistent. The white formations are the clouds, and your flippers are your wings as you glide past the stalactites. You can view them at any angle. I enjoyed my lessons.

Upon completion of the course, Jim and I began photographing. I learned quickly that it was necessary to have another diver in cave photographs, for when I got my first two rolls of film back, the water was so clear that the photos did not appear to have been taken underwater. Jim is the perfect underwater model. He has complete buoyancy control and a good knowledge of photography. That stands to reason, since Jim has explored about fifty cenotes and made seven hundred cave-dives in the last three years. He has explored, surveyed, and mapped cenote systems with names like Maya Blue, Naharon, Sac Actun, and the Temple of Doom.

The Temple is one of my favorite dives, with its circular route through white-walled rooms decorated with delicate crystalline formations. The entrance is how it got its name. First, there is a half-kilometer walk from the road, over trails that were not made for transporting gear. The loose rock and uneven ground make it extra tough for carrying the 110 pounds of tanks, lights, cameras, and safety equipment needed for the dive. When one finally reaches the edge of the cenote, there is a fifteen-foot drop into the water.

We usually lowered our tanks on block and tackle, then dove in and geared up in the water. This commotion awoke the bats that sleep in the air cave part. Having these winged mammals flying around adds to the aura of the Temple of Doom. Diving to thirty feet, one can look up and see people forty-five feet above, standing on the rim of the round shaft of sunlight that beams down into the cave. Getting out is tougher yet, for one has to climb up a tree root to get out, then haul tanks and cameras up. Two of these dives a day leaves a person one tired puppy.

The newest cenote Jim is exploring now is one called Sac Actun, which means *white cave* in Mayan. Jim began exploring this system in December of 1987 and quickly realized it was one of the nicer cenotes found to date. I followed Jim and fellow cave-divers Tom Young and Cy Goulet when they went to punch out some new line in a recently discovered entrance. One either takes a temporary line in and then reels it back up on the way out, or ties down a permanent line to use on subsequent dives to map, survey, and explore farther back.

This particular opening had no water at the bottom of the hole, so it was necessary to carry a thirty-foot extension ladder to climb down with.

Exploration is a tough job. Jim and his helpers have so far found eleven entrances to Sac Actun and put down 13,400 feet of permanent line. It is possible to enter at one hole, swim 2,000 yards, and come up at another hole. No matter which hole you go in or come out by, Sac Actun is a beautiful place. It is a shallow cave system, thirty-to-fifty-feet deep; there is plenty of time and air without worrying about decompression stops. With all the different passages and so much line having been laid, it is impossible to tire of this dive. Even if you have gone down one passage ten times, you always see something different because it is so very dark down there. If you turn off your light, it is as dark as any place you have ever been. Swimming by with a flashlight you always miss something, leaving some neat formation to discover on your next dive.

Sac Actun has more formations of stalactites and stalagmites than any cave I have dived in. Most of the stalagmites are decorated with globs of limestone that look like butterscotch fudge flung out by a child having a tantrum. An interesting artifact near the main entrance is a crocodile skull and skeleton lying on the bottom where it obviously sank and decomposed. I've wondered whether there are live ones still in there some place.

Other artifacts have been found. In 1986, cave-divers Mike Madden and Parker Turner found the chamber of the ancients in the Carwash Cenote. I dove this room with Jim Coke and saw the fire pit. It is a hole hollowed out of a cone-shaped rock full of pieces of charcoal. It looks like, and probably is, a prehistoric barbecue pit. Ten thousand years ago, when sea level was lower, this might have been the temporary home for a roving band of hunter-gatherers. Why were they so deep? Perhaps to escape enemies, or animals. Maybe to get water, or maybe to stay cooler. We do not know for sure. Archeologists have indications that nomad groups have been in the Yucatán for as long as twenty thousand years.

There are very few records of these people. Substantial evidence indicates the beginning of an agricultural society about three thousand years ago. The hunter-gatherers laid down their roots and sowed their own seeds. But until the time of the Spanish conquest, we have only little pieces of their story.

Perhaps our story of the Yucatán Peninsula will last longer. If we take care of the land, the sea, and the life within them, it will.

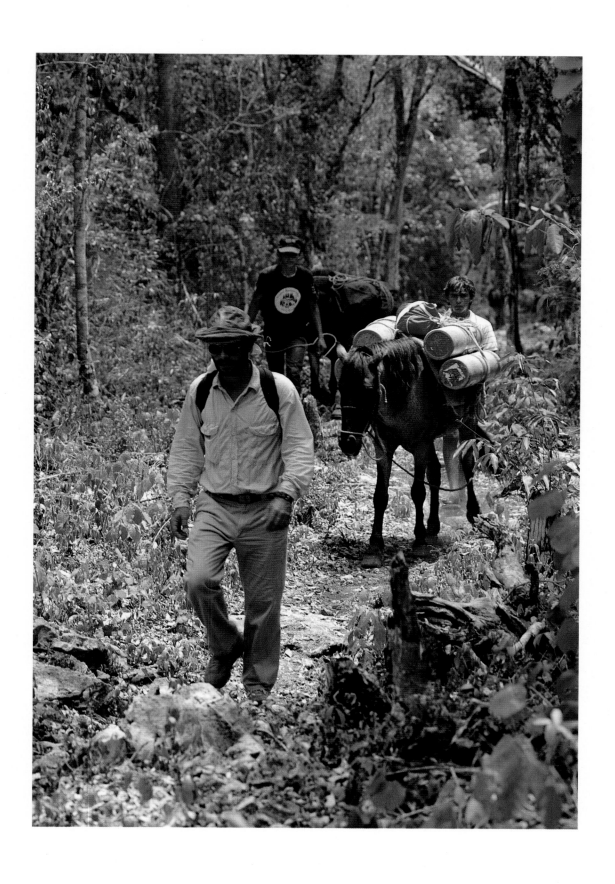

On a longer treck to Nohoch cenote, Mike Madden uses horses to carry our tanks.

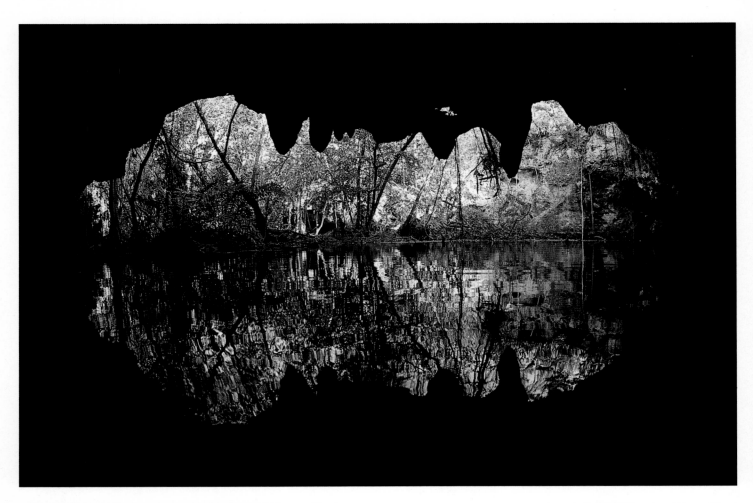

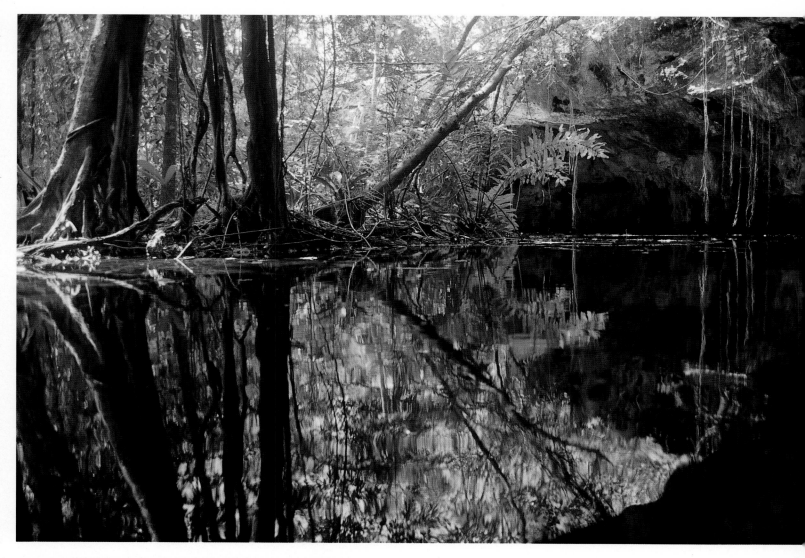

The main entrance to Sac Actun cenote is as mysterious as it is beautiful. How did a crocodile skeleton get fifty feet back in the cave? This photograph was taken underwater (left). Looking out of the cavern I imagined that I was in a jaguar's mouth (top left). The cenote is beautiful from above, with its mirror-like reflection (top), and likewise the underside offers a gorgeous view of water lilies (far left).

139

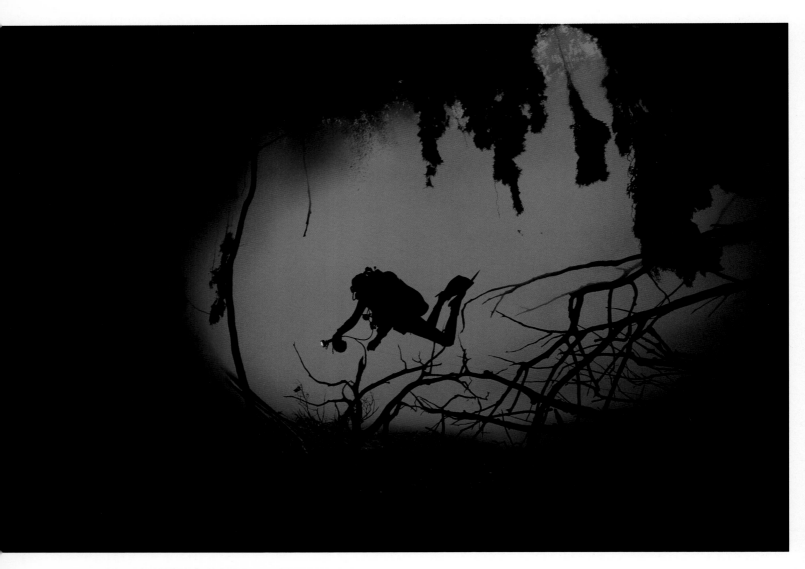

The Carwash Cenote, with its summer algae bloom causing a green-to-brown tint in the water, has an awesome entrance (above). Among the fish that live in the pool, there are large schools of mollies (top right) and in the dark zone various blind creatures. Here a blind fish swims upside down (left). A possible archeological site exists at a depth of ninety feet in this cenote. It was named the Chamber of the Ancients, because the fire pit was possibly used ten thousand years ago when sea level was lower (right).

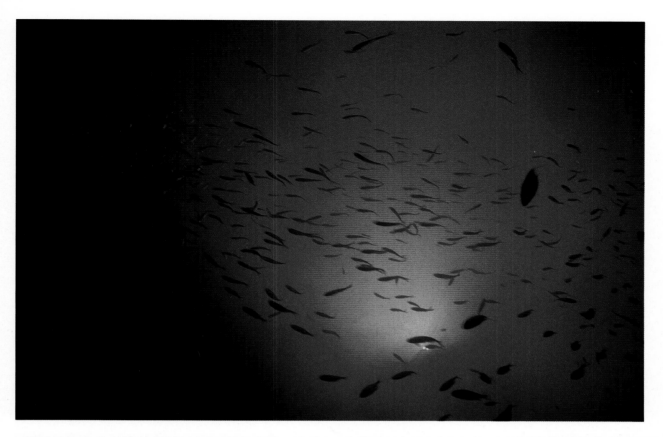

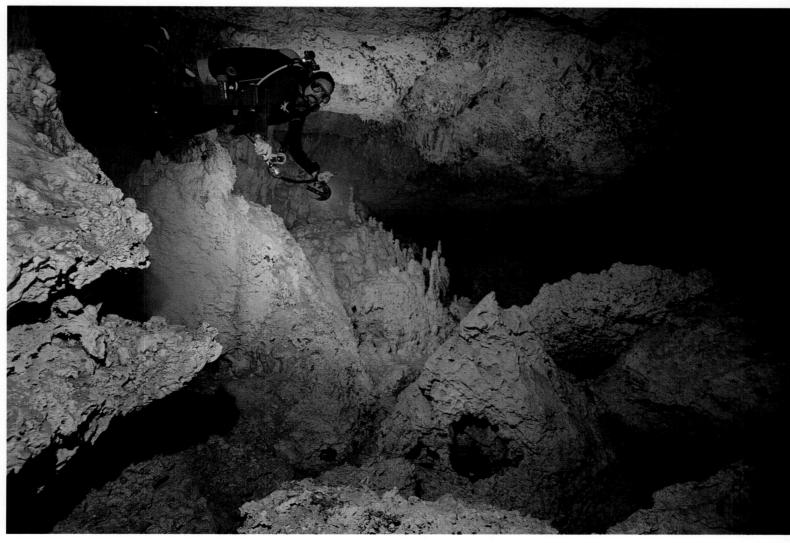

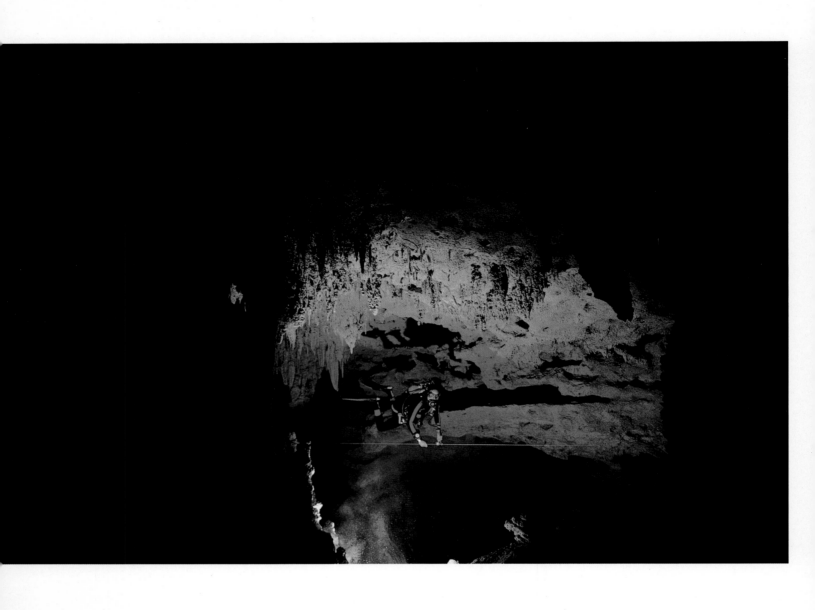

Jim Coke, following the permanent line in Sac Actun. Using a continuous line to the surface is one of the most important rules in cave-diving.

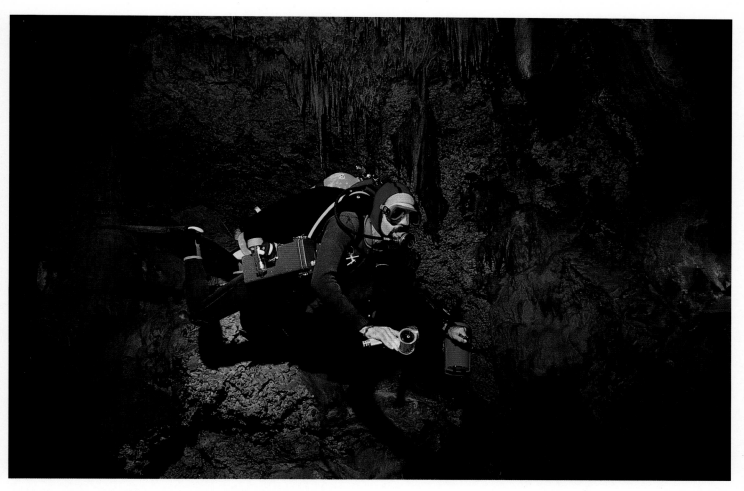

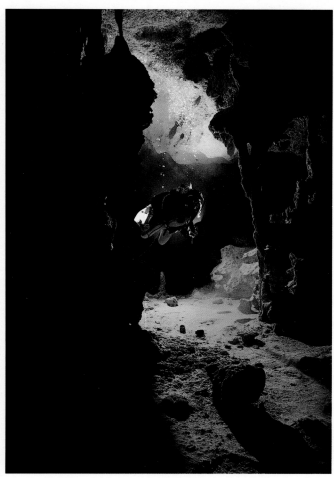

Looking as if he is suspended in air, Jim Coke is actually swimming in the perfectly clear waters of Maya Blue cenote (above). Backlit Mike Madden, at Nohoch cenote, portrays the excitement and adventure of cenote-diving (left).

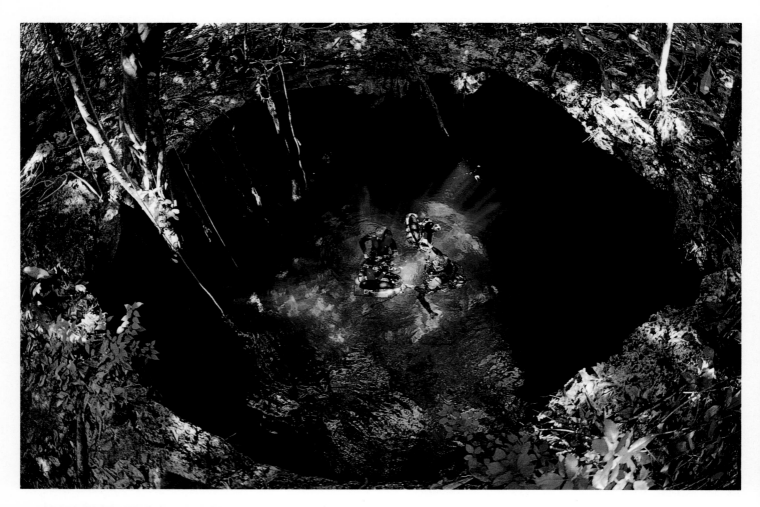

Looking down into the Temple of Doom cenote (above).
Stirring up the sediment on the cave floor can cause loss of
visibility, which is why cave-divers follow a continuous line
(left).

Selected Bibliography

Andrews, Anthony P. *Maya Salt Production and Trade.* Tucson Ariz., 1983.

Augelli, John P., and Robert C. West. *Middle America: Its Lands and Peoples.* 2nd ed. Englewood Cliffs, N. J., 1976.

Back, W., W. C. Ward, and A. E. Weidie. *Geology and Hydrogeology at the Yucatán and Quaternary Geology of Northeastern Yucatán Peninsula.* New Orleans Geological Society, New Orleans, La., 1985.

Calderwood, Michael. *Arrecife Alacráns.* Una Pub. de case de Bolsa Inverla, S.A. PECV. Producida Por Editorial Jilguero/Mexico Desconocido

Chalif, Edward L., and Roger Tory Peterson. *A Field Guide to Mexican Birds.* Boston, Mass., 1973.

Coggins, Clemency C., and Orrin C. Shane, III, eds. *Cenote of Sacrifice: Maya Treasures from the Sacred Well at Chichén Itzá.* Austin, Tex., 1984.

Flannery, Kent V., ed. *Maya Subsistence: Studies in Memory of Dennis E. Puleston.* New York, N. Y., 1982.

Gonzalez, Ricardo Espino-Barros. *Aspects of the Ecology of the Caribbean Flamingo in Yucatán Mexico.* Auburn, Ala., 1988.

Hamblin, Nancy L. *Animal Use by the Cozumel Maya.* Tucson, Ariz., 1984.

Henderson, John S. *The World of the Ancient Maya.* Ithaca, N. Y., 1981.

Jacona, Roberto Disoy Francesca. *Guia De Aves.* Spain: GRIJALBO, 1981.

Keep Tropical Forests Alive. Washington, D.C., 1985.

Leopold, A. Starker. *Fauna Silvestre de Mexico.* Instituto Mexicano de Recursos Naturales Removables, 1977.

Mercer, Henry C. *The Hill-Caves of Yucatán: A Search for Evidence of Man's Antiquity in the Caverns of Central America.* Norman, Okla., 1975.

Moseley, Edward H., and Edward D. Terry, eds. *Yucatán: A World Apart.* University, Ala., 1980.

Raven, Peter H. *The Urgency of Tropical Conservation.* The Nature Conservancy News, January-March, 1986.

Reddel, James R. *Studies on the Causes and Cave Fauna of the Yucatán Peninsula,* Bulletin #6, Austin, Tex., 1977.

Schueler, Donald G. *Adventuring Along the Gulf of Mexico.* San Francisco, Ca., 1986.

Scott, Peter E., and Robert F. Martin. *Clutch Size and Fledgling Success in the Turquoise-Browed Motmot.* Austin, Tex., January, 1986.

Shattuck, George C. *The Peninsula of Yucatán.* Washington, D.C., 1933.

Stephens, John Lloyd. *Incidents of Travels in Yucatán,* Vols. 1 and 2. Norman, Okla., 1973.

Morley, Sylvanus G., and George W. Brainerd; revised by Robert J. Sharer. *The Ancient Maya.* 4th ed.; Stanford, Ca., 1983.

Thompson, J. Eric S. *The Rise and Fall of Maya Civilization.* 2nd ed. Norman, Okla., 1966.

Tozzer, Alfred M., ed., *Landa's Relacion de las Cosas de Yucatán.* Vol. XVIII. New York, 1966.

Tozzer, Alfred M., ed. *A Maya Grammar.* Vol. IX, Cambridge, Mass., USA. Harvard New York: Museum of Mexican Archeology and Ethnology, Kraus Reprint Co., 1974.

Turner, B. L., II, and Peter D. Harrison, eds. *Pulltrouser Swamp: Ancient Maya Habitat, Agriculture, and Settlement in Northern Belize.* Austin, Tex., 1983.

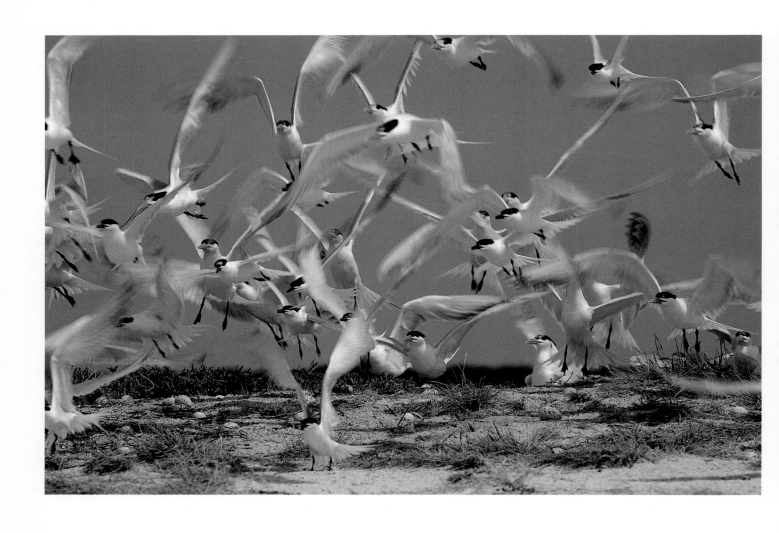

Notes on Photographs

Custom prints of all photographs used in this book are available. A limited quantity is printed in sizes 16 × 20 and 11 × 14. For information contact:

The Lockwood Gallery
Post Office Box 14876
Baton Rouge, Louisiana 70898

All photographs were taken with Nikon F3T 35mm cameras. The name of each photograph, along with lens, exposure, and film is listed below.

Jacket See page 50.
page i MotMot, Flamboyant and Date Palm Seed. 600mm f/5.6 Nikkor. f/8 @ 1/125. KR64. Tripod.
page ii Flag Reef Grunts. 15mm f/2.8 UW Nikkor. f/5.6 @ 1/60. KR64. Flash.
page iv Springtime. 200mm f/4 Nikkor. f/11 @ 1/30. KR64. Tripod.
pages vi,vii Celestún Morning. 80–200mm f/4 Nikkor Zoom. f/16 @ 1/8. KR64. Tripod.
page vii The Fisherman. 105mm f/2.5 Nikkor. f/5.6 @ 1/30. KR64.
page viii Akumal Moonrise. 55mm f/2.8 Micro-Nikkor. f/8 @ 30 sec. KR64. Tripod.
page 3 Temple of Doom. 15mm f/2.8 UW Nikkor. f/11 @ 1/60. KR64.
pages 4–5 Yellow Day. 80–200mm f/4 Nikkor Zoom. f/11 @ 1/30. KR64. Tripod.
page 6 Henequén Plantation. 35mm f/2.8 PC Nikkor. f/16 @ 1/60. KR64.
page 7 The Mayor's *Palapa*. 35mm f/2.8 PC Nikkor. f/11 @ 1/8. KR64. Tripod.
page 7 *Refresco*. 80–200mm f/4 Nikkor Zoom. f/8 @ 1/30. KR64. Tripod. Tripod.
page 8 Mottled Wood Owl. 600mm f/5.6 Nikkor. f/8 @ 1/250. CF1000. Tripod.
page 9 Terns Around Photographer. 600mm f/5.6 Nikkor. f/5.6 @ 1/30. KR64. Tripod.
page 9 Basilisk. 600mm f/5.6 Nikkor. f/8 @ 1/60. KR64. Tripod.
page 10 B.I.P. X. 300mm f/2.8 Nikkor. f/11 @ 1/60. KR64. Tripod.
pages 14–15 Perfect Morning. 80–200mm Nikkor Zoom. f/8 @ 1/15. KR64. Tripod.
page 16 Prism. 16mm f/3.5 Nikkor. f/8 @ 1/15. KR64.
page 17 Two Reds. 35mm f/2.8 PC Nikkor. f/16 @ 1/30. KR64. Tripod.
page 18 Mixed Grunts. 15mm f/2.8 UW Nikkor. f/5.6 @ 1/60. KR64. Flash.
page 19 The Big Blue. 300mm f/2.8 Nikkor. f/11 @ 1/60. KR64. Tripod.
page 20 Sooty Tern. 300mm f/2.8 Nikkor. f/11 @ 1/125. KR64. Tripod.
pages 20–21 Sunset Sixteen. 600mm f/5.6 Nikkor. f/8 @ 1/250. KR64. Tripod.
page 22 Staghorn Leghorn. 24mm f/2.8 Nikkor. f/16 @ 1/15. KR64.
page 23 Volleyball. 35mm f/2.8 PC Nikkor. f/8 @ 1/125. KR64.
page 23 Lobster Dinghies. 300mm f/2.8 Nikkor. f/11 @ 1/125. KR64. Tripod.
page 24 Pine and Noddy. 300mm f/2.8 Nikkor. f/8 @ 1/30. KR64. Tripod.
page 25 Nesting Noddies. 80–200mm f/4 Nikkor Zoom. f/11 @ 1/60. KR64. Tripod Fill Flash.
page 26 Desterrada Dunes. 24mm f/2.8 Nikkor. f/16 @ 1/30. KR64.
page 26 Sunken Sea Fan. 55mm f/2.8 Micro-Nikkor. f/16 @ 1/60. KR64.
page 27 Bobo Booby. 24mm f/2.8 Nikkor. f/16 @ 1/60. KR64.
page 28 Mighty Moray. 15mm f/2.8 UW Nikkor. f/8 @ 1/60. KR64. Flash.
page 32 Palanar Reef. 15mm f/2.8 UW Nikkor. f/8 @ 1/60. KR64. Flash.
page 33 Reef Fish. 15mm f/2.8 UW Nikkor. f/11 @ 1/60. KR64. Fill Flash.
pages 34–35 Snapper. 15mm f/2.8 UW Nikkor. f/11 @ 1/60. KR64. Flash.
page 36 Sandy Ray. 15mm f/2.8 UW Nikkor. f/8 @ 1/60. KR64. Flash.
page 37 Big Basket. 15mm f/2.8 UW Nikkor. f/8 @ 1/60. KR64. Flash.

page 38 Sharksucker. 15mm f/2.8 UW Nikkor. f/11 @ 1/60. KR64. Flash.
page 38 Big Eye. 35mm f/3.5 UW Nikkor. f/16 @ 1/60. KR64. Flash.
page 39 Pencil Thin Sunset. 600mm f/5.6 Nikkor. f/11 @ 1/15. KR64. Tripod.
page 40 Red Alert. 80–200mm f/4 Nikkor Zoom. f/16 @ 1/15. KR64. Tripod. Extension Tube.
page 45 Thin Island. 24mm f/2.8 Nikkor. f/16 @ 1/60. KR64.
pages 46–47 Sian Ka'an Aerial. 55mm f/2.8 Micro-Nikkor. f/4 @ 1/1000. KR64. Plane.
page 48 *Incenario*. 55mm f/2.8 Micro-Nikkor. f/16 @ 1/15. KR64.
page 49 Test Pit. 35mm f/2.8 PC Nikkor. f/8 @ 1/30. KR64.
page 50 Toucan. 600mm f/5.6 Nikkor. f/11 @ 1/60. KR64. Tripod. Fill Flash.
page 51 Ant Eater. 600mm f/5.6 Nikkor. f/8 @ 1/250. PKL200. Tripod.
page 52 Crock. 600mm f/5.6 Nikkor. f/8 @ 1/250. KR64. Tripod.
page 52 *Pelicano*. 600mm f/5.6 Nikkor. f/8 @ 1/250. KR64. Tripod.
page 53 Boat-billed Heron. 600mm f/5.6 Nikkor. f/8 @ 1/60. KR64. Tripod.
page 54 Lobster Bonanza. 15mm f/2.8 UW Nikkor. f/8 @ 1/60. KR64.
page 55 Sleeping Sharks. 15mm f/2.8 UW Nikkor. f/11 @ 1/60. KR64.
page 56 Tails. 55mm f/2.8 Micro-Nikkor. f/16 @ 1/30. KR64.
page 57 The Bounty. 55mm f/2.8 Micro-Nikkor. f/8 @ 1/125. KR64.
page 58 Grey Bay. 55mm f/2.8 Micro-Nikkor. f/4 @ 1/1000. KR64. Plane.
page 59 Cancun Blue. 55mm f/2.8 Micro-Nikkor. f/2.8 @ 1/1000. KR64. Plane.
pages 60–61 Tulum. 80–200mm f/4 Nikkor Zoom. f/11 @ 1/125. KR64. Tripod.
page 62 Misty Jungle. 300mm f/2.8 Nikkor. 1.4X Tele Extendar. f/8 @ 1/30. KR64. Tripod.
page 67 Kitchen Door. 80–200mm f/4 Nikkor Zoom. f/5.6 @ 1/5. KR64. Tripod.
pages 68–69 Green, White, and Blue. 80–200mm f/4 Nikkor Zoom f/11 @ 1/60. KR64. Tripod.
page 70 The Palace. 35mm f/2.8 PC Nikkor. f/16 @ 1/8. KR64. Tripod.
page 71 Jungle Green. 300mm f/2.8 Nikkor. f/8 @ 1/60. KR64. Tripod.
page 72 Ani. 600mm f/5.6 Nikkor. f/5.6 @ 1/60. PKL200. Tripod.
page 73 Fruit Loop. 600mm f/5.6 Nikkor. f/11 @ 1/60. KR64. Tripod.
page 74 Red Throat. 55mm f/2.8 Micro-Nikkor. f/11 @ 1/60. KR64.
page 74 Glittery Colors. 600mm f/5.6 Nikkor. f/11 @ 1/60. KR64. Tripod.
page 74 Bird Watchers. 24mm f/2.8 Nikkor. f/8 @ 1/30. KR64.
page 75 Egret Eye. 55mm f/2.8 Micro-Nikkor. f/16 @ 1/60. KR64.
pages 76–77 Becan Ruins. 35mm f/2.8 Nikkor. f/11 @ 1/15. KR64. Tripod.
page 77 Iguana on the Rocks. 80–200mm f/4 Nikkor Zoom. f/16 @ 1/30. KR64. Tripod.
page 78 Creeper. 600mm f/5.6 Nikkor. f/11 @ 1/125. PKL200. Tripod.
page 79 Mot and Mot. 800mm f/8 Nikkor. f/8 @ 1/125. KR64. Tripod.
page 79 Pretty but Poisonous. 55mm f/2.8 Micro-Nikkor. f/11 @ 1/15. KR64. Tripod.
page 80 Frilly Beard. 55mm f/2.8 Micro-Nikkor. f/8 @ 1/125. KR64.
page 80 Moon on a Bush. 55mm f/2.8 Micro-Nikkor. f/16 @ 1/60. KR64. Flash.
page 80 Orchid #1. 105mm f/2.5 Nikkor. f/11 @ 1/60. KR64. Flash.
page 81 Droopy. 55mm f/2.8 Micro-Nikkor. f/11 @ 1/8. KR64. Tripod.
pages 82–83 Marlboro Man. 80–200mm f/4 Nikkor Zoom. f/11 @ 1/60. KR64.
page 83 Tacky. 55mm f/2.8 Micro-Nikkor. f/11 @ 1/30. KR64.
page 84 Kitchen Comedy. 35mm f/2.8 PC Nikkor. f/8 @ 1/60. KR64. Flash.
page 84 Patty-cake. 55mm f/2.8 Micro-Nikkor. f/8 @ 1/30. KR64.
page 85 Chewing Gum on the Run. 24mm f/2.8 Nikkor. f/8 @ 1/125. KR64.
page 85 Chiclero. 80–200mm f/4 Nikkor Zoom. f/5.6 @ 1/30. KR64.
page 86 Jaguar. 600mm f/5.6 Nikkor. f/11 @ 1/60. KR64. Tripod. Fill Flash.

Notes on Photographs

page 87 Sad Scene. 55mm f/2.8 Micro-Nikkor. f/11 @ 1/125. KR64.

page 88 Parrot Portrait. 105mm f/2.5 Nikkor. f/16 @ 1/30. KR64. Tripod.

page 94 Lazy Monkey. 600mm f/5.6 Nikkor. f/8 @ 1/60. KR64. Tripod.

page 95 Lost My Colors. 600mm f/5.6 Nikkor. f/5.6 @ 1/60. KR64. Tripod.

page 95 Monkey Face. 300mm f/2.8 Nikkor. f/5.6 @ 1/30. KR64. Tripod.

page 96 Black and Yellow. 105mm f/2.5 Nikkor. f/11 @ 1/30. KR64. Tripod.

page 96 Big Boa. 55mm f/2.8 Micro-Nikkor. f/8 @ 1/30. KR64. Tripod.

page 97 Pinnated Bittern. 600mm f/5.6 Nikkor. f/5.6 @ 1/125. KR64. Tripod.

page 98 Fawn. 300mm f/2.8 Nikkor. f/8 @ 1/60. KR64. Tripod.

page 99 Yucatán Parrot. 55mm f/2.8 Micro-Nikkor. f/11 @ 1/30. KR64.

page 100 Spiney Pocket Mouse. 80–200mm f/4 Nikkor Zoom. f/11 @ 1/60. KR64.

page 101 Misty. 600mm f/5.6 Nikkor. f/5.6 @ 1/30. KR64. Tripod.

page 102 Black and Blue. 200mm f/4 Nikkor. f/8 @ 1/250. KR64.

page 103 Tern to See Flamingos. 600mm f/5.6 Nikkor. f/11 @ 1/60. KR64. Tripod.

pages 104–105 Río Lagartos. 55mm f/2.8 Micro-Nikkor. f/4 @ 1/1000. KR64. Plane.

page 106 Salt Pits. 55mm f/2.8 Micro-Nikkor. f/4 @ 1/2000. KR64. Plane.

page 107 Flamingos and Fisherman. 600mm f/5.6 Nikkor. f/8 @ 1/30. KR64. Tripod.

page 107 Salt Worker. 600mm f/5.6 Nikkor. f/8 @ 1/250. KR64. Tripod.

pages 108–109 Parade of Pink. 600mm f/5.6 Nikkor. f/11 @ 1/125. KR64. Tripod.

page 110 Fallen Leaves. 55mm f/2.8 Micro-Nikkor. f/5.6 @ 1/15. KR64.

page 110 Detritus. 15mm f/2.8 UW Nikkor. f/11 @ 1/60. KR64. Flash.

page 111 Mangrove Alley. 80–200mm f/4 Nikkor Zoom. f/11 @ 1/15. KR64. Tripod.

page 112 Baby-sitting. 600mm f/5.6 Nikkor. f/8 @ 1/250. PKL200. Tripod.

page 113 Banding Birds. 24mm f/2.8 Nikkor. f/11 @ 1/60. KR64.

page 114 Hawksbill. 15mm f/2.8 UW Nikkor. f/8 @ 1/60. KR64. Flash.

page 114 Turtle Eggs. 55mm f/2.8 Micro-Nikkor. f/11 @ 1/60. KR64.

page 115 Aborted Nest. 24mm f/2.8 Nikkor. f/11 @ 1/125. KR64.

page 115 Five Chances in One Hundred. 55mm f/2.8 Micro-Nikkor. f/8 @ 1/250. KR64.

page 116 Lipstick. 105mm f/2.5 Nikkor. f/5.6 @ 1/125. KR64.

page 119 Pepper Market. 80–200mm f/4 Nikkor Zoom. f/11 @ 1/30. KR64.

page 120 Beautiful Maya. 200mm f/4 Nikkor. f/5.6 @ 1/15. KR64.

page 121 Street Vendor. 80–200mm f/4 Nikkor Zoom. f/5.6 @ 1/60. KR64.

page 121 Poor Birds. 80–200mm f/4 Nikkor Zoom. f/8 @ 1/30. KR64.

page 122 School Daze. 55mm f/2.8 Micro-Nikkor. f/8 @ 1/60. KR64.

page 123 Domingo Noche. 80–200mm f/4 Nikkor Zoom. f/5.6 @ 1/60. PKL200. Tripod.

pages 124–125 Lazy Dog. 55mm f/2.8 Micro-Nikkor. f/11 @ 1/30. KR64. Tripod.

page 126 Maya Boy. 55mm f/2.8 Micro-Nikkor. f/11 @ 1/30. KR64.

pages 126–127 Thunderstorm. 35mm f/2.8 PC Nikkor. f/16 @ 1/15. KR64. Tripod.

page 128 Maya Shrine. 80–200mm f/4 Nikkor Zoom f/8 @ 1/60. KR64. Tripod. Flash.

page 129 Maya Moon. 200mm f/4 Nikkor. f/11 @ 4 minutes. KR64. Tripod. Multiple Flash.

page 130 Zayil. 35mm f/2.8 PC Nikkor. f/16 @ 1/30. KR64. Tripod.

page 130 Mask. 55mm f/2.8 Micro-Nikkor. f/16 @ 1/2. KR64. Tripod.

page 131 Maya Man. 80–200mm f/4 Nikkor Zoom. f/5.6 @ 1/30. KR64.

pages 132–133 Net Work. 55mm f/2.8 Micro-Nikkor. f/8 @ 1/250. KR64.

page 134 Hard Dive. 16mm f/2.8 Nikkor. f/8 @ 1/60. KR64.

page 137 Trek. 80–200mm f/4 Nikkor Zoom. f/8 @ 1/60. KR64.

page 138 Jaguar's Jaw. 24mm f/2.8 Nikkor. f/11 @ 1/30. KR64. Floating.

page 138 Beneath the Lilies. 15mm f/2.8 UW Nikkor. f/16 @ 1/30. KR64.

page 139 Still Waters #2. 24mm f/2.8 Nikkor. f/16 @ 1/15. KR64. Floating.

page 139 Son of Crock. 15mm f/2.8 UW Nikkor. f/11 @ 1/60. KR64. Flash.

page 140 Cave Silhouette. 15mm f/2.8 UW Nikkor. f/5.6 @ 1/30. PKL200.

page 140 Blind Fish. 35mm f/2.8 PC Nikkor. Extension Tube. f/22 @ 1/60. KR64. Flash.

page 141 Mollies in Algae Bloom. 15mm f/2.8 UW Nikkor. f/8 @ 1/60. PKL200.

page 141 Chamber of the Ancients. 15mm f/2.8 UW Nikkor. f/5.6 @ 1/60. PKL200. Flash and Slave.

page 142 Follow the Line. 15mm f/2.8 UW Nikkor. f/4 @ 1/60. PKL200. Flash and Slave.

page 143 Suspended in Air. 15mm f/2.8 UW Nikkor. f/4 @ 1/60. PKL200. Flash.

page 143 Spooky Alley. 15 f/2.8 UW Nikkor. f/5.6 @ 1/60. PKL200. Flash.

page 144 Above the Temple of Doom. 16mm f/3.5 Nikkor. f/5.6 @ 1/30. KR64.

page 144 Help Buddy. 15mm f/2.8 UW Nikkor. f/8 @ 1/60. PKL200. Flash and Slave.

page 148 Two Terns. 600mm f/5.6 Nikkor. f/5.6 @ 1/250. KR64. Tripod.

Index